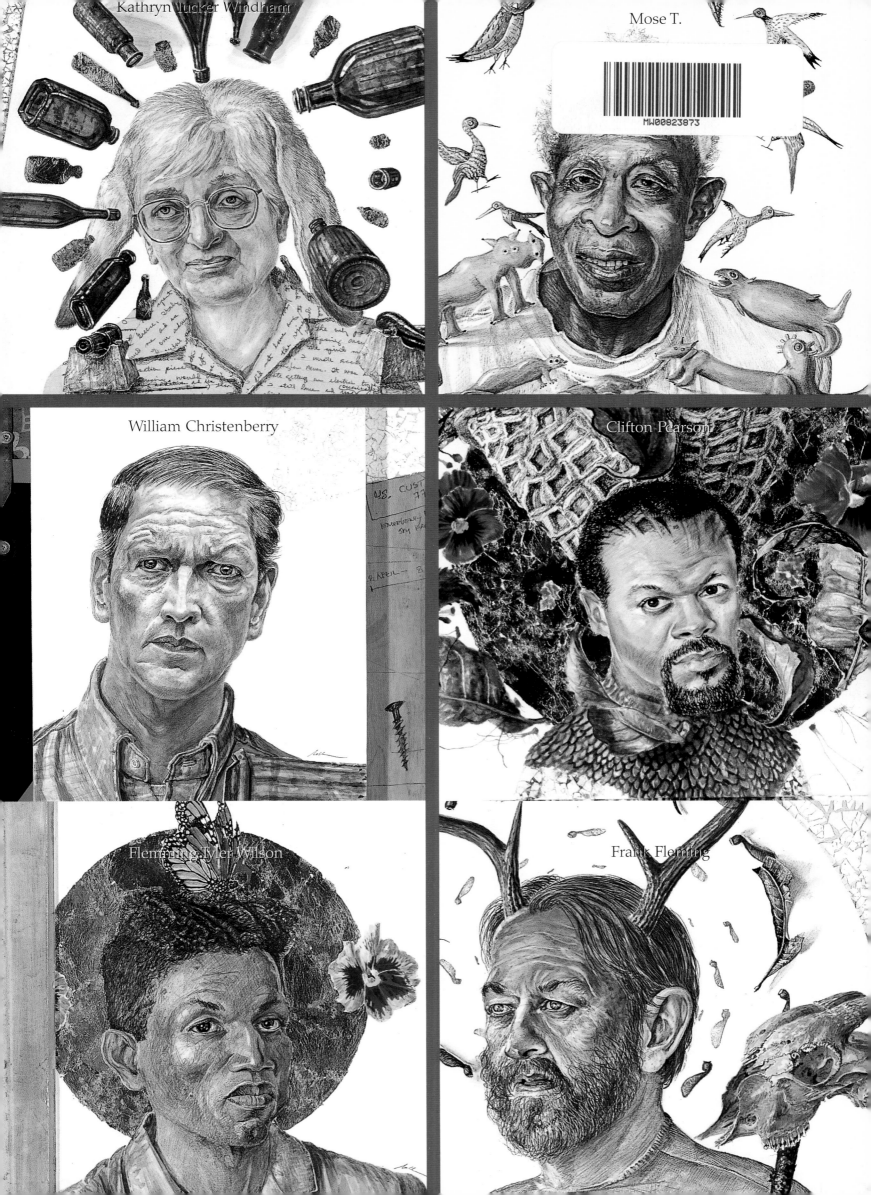

Kathryn Tucker Windham

Mose T.

William Christenberry

Clifton Pearson

Flemming Tyler Wilson

Frank Flemming

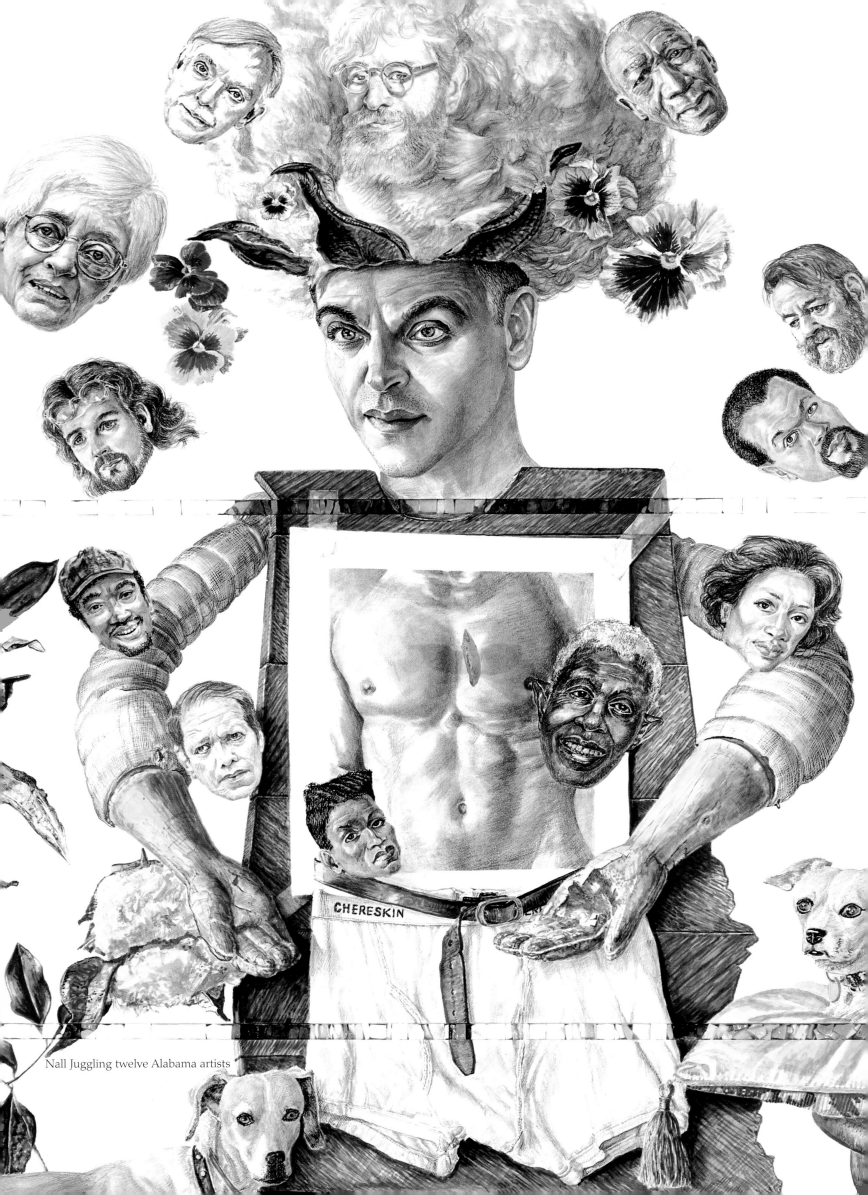

Nall Juggling twelve Alabama artists

ALABAMA ART

The Black Belt, defined by its dark, rich soil stretches across central Alabama. It was the heart of the cotton belt. It was, and is, a place of great beauty, of extreme wealth and grinding poverty, of pain and joy. Here we take our stand, listening to the past, looking to the future.

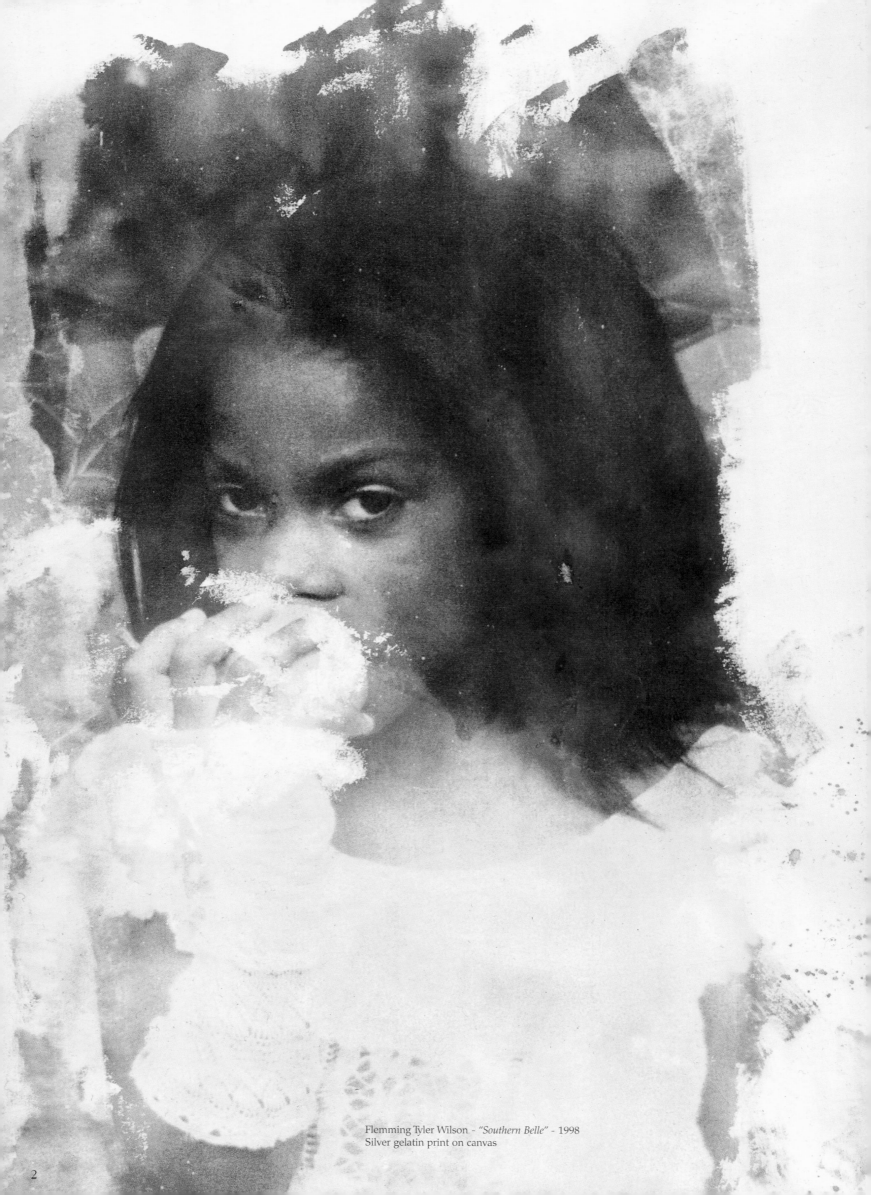

Flemming Tyler Wilson - *"Southern Belle"* - 1998
Silver gelatin print on canvas

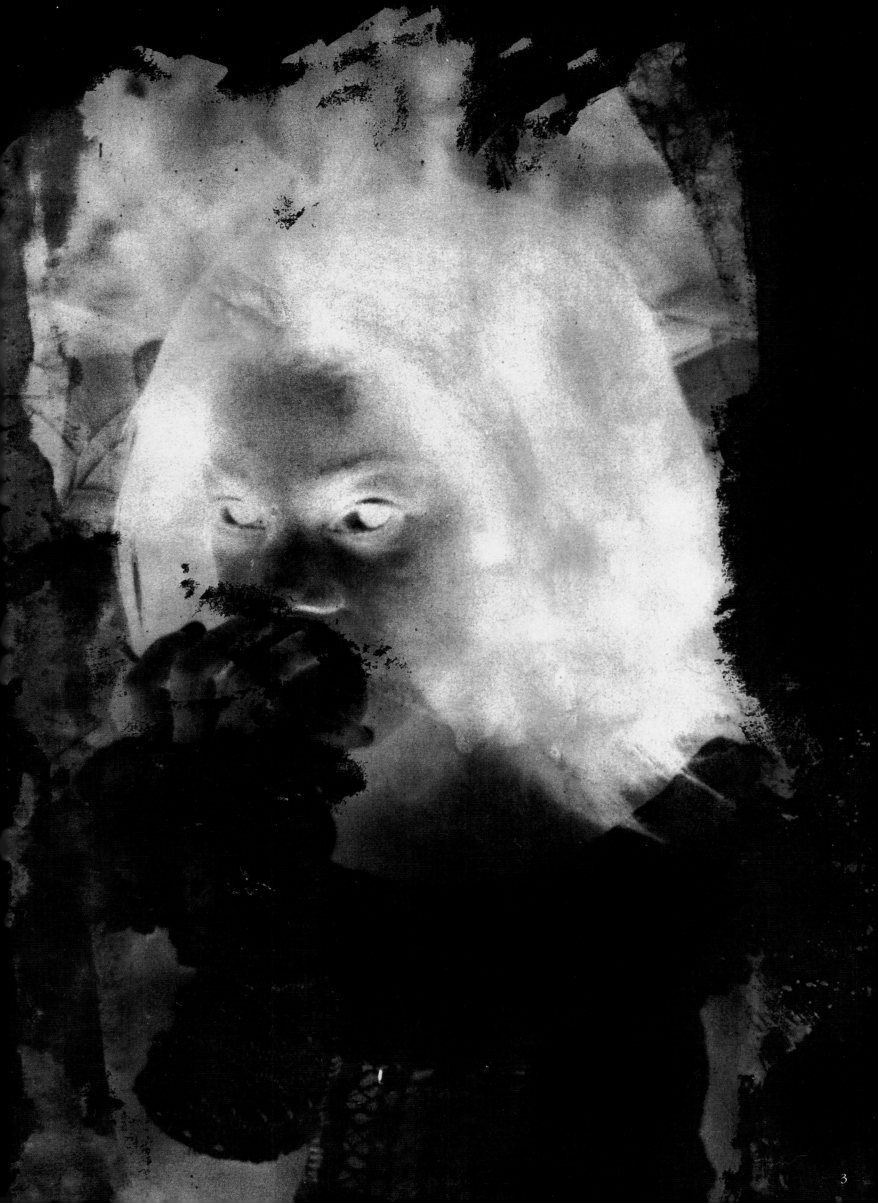

H.S.H. Crown Prince Albert of Monaco

The Principality of Monaco and the United States have for many years entertained a bond of affection, I am therefore delighted to see that Nall is presenting in the South of France the works of thirteen artists from Alabama. With his natural enthusiasm, Nall, whose second homes are Monaco and Vence, has created a grand show allowing us to discover through the works of painters, photographers, and sculptors the heart and soul of "his Alabama." At the dawn of the new millennium, Nall, whose only desire is to promote and sponsor the arts, has set the stage for us to enjoy this unique event.

Albert of Monaco

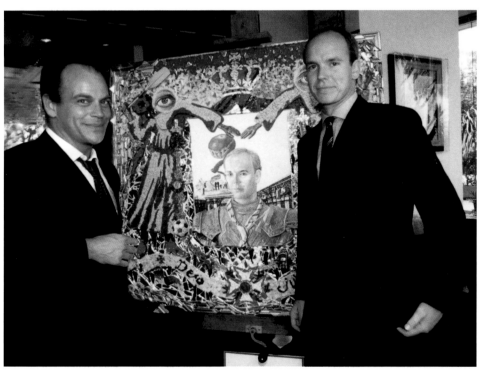

H.S.H. Crown Prince Albert of Monaco and Nall at the unveiling ceremony of his portrait - Nice, France

4

Governor Don Siegelman

Alabama is a state that takes pride in our history, culture, heritage, and our talented citizens. As governor, I am honored and proud to be able to share some of Alabama's talent. It is my sincere pleasure to introduce you to many of Alabama's fine artists.

We have a wide spectrum of artists who use their European, African, and Native American roots in classical, modern, and folk arts. I am confident that you will enjoy Alabama art.

Don Siegelman
Governor of Alabama

Lori Allen Siegelman
First Lady of Alabama

We have an immense amount of talent in Alabama. Our artists and our culture have so much to give to the rest of the world, and no one could be better qualified to show it off than Nall and his creative works. Nall's art is created through his spirit; he doesn't simply rely on thoughts or feelings. His courage comes from facing his soul; his range of artistic expression seems to have no boundaries, and the emotions evoked from his art fill our lives with great pleasure and passion.

Nall, we thank you not only for coming home as a guest artist to share your masterful gift with us and Alabama students, but also for sharing your energy, love, and enthusiasm with all of us, and for inviting other Alabama artists to bring their work to your second home in France.

Lori Allen Siegelman
First Lady of Alabama
Honorary President of the N.A.L.L. Foundation

Introduction :
Fannie Flagg

WHERE IS ALABAMA? It is in the deepest part of the southern United States, sitting between Mississippi and Georgia. So large that the northern part is mountainous and freezing in the winter, the southern part steamy, tropical, and hot.

It is a state of surprises. Our cultural heritage is Indian, Black, Irish, Scot, German, Greek, Italian, and everything in between. We are mostly Protestant, from the huge wealthy churches in the towns, to the backwoods snake-handlers of Sand Mountain, to the Catholic cathedrals and Jewish synagogues in the larger cities. We are a land of hardscrabble farms, rich cotton fields, and skylines of steel mills, shipyards, and space centers. A land of shrimp boats to the south and mountains of iron ore to the north. We invented Mardi Gras in

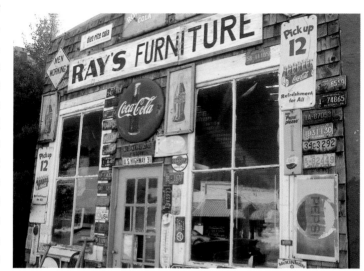
Chip Cooper - "Storefront" - Cibachrome

Mobile long before New Orleans. A land of voodoo, hillbilly music, blues, gospel, barbecue, fried catfish, gumbo, and pickled pigs' feet. Lakes, rivers, bays, bayous, and waterfalls. A land of lightning, wind, rain, and hurricanes, violent one minute, peaceful the next, with little in between.

Who are we? We are a people quick to love and quick to hate. Loyal to a fault and fiercely proud. Alabama was never rich enough to have the grand plantations of Georgia and Mississippi, and had few slaveholders compared to the rest of the South, but in the Civil War our soldiers fought bravely and with nobility to defend whatever patch of land they had scratched out for themselves. I am reminded of the boy of fourteen who stood alone, fighting the Union army unto death. When the Union soldiers reached him, barely alive, and asked why he had fought so hard for a lost cause, his last words were, "Because you are here, sir."

What is Alabama? Alabama is a state of mind. We were one of the only states in America ever defeated in war. Left with nothing but the unbending pride of our soldiers, and our families' real or imagined past glories. Brutally treated during Reconstruction by the U.S. government and battered by public opinion . . . and it has never stopped. In the early sixties we had our race struggles aired before the world in newsreels and newspaper headlines that screamed BIR-MINGHAM: MOST SEGREGATED CITY IN THE COUNTRY. Since that time Alabama has made tremendous strides in race relations; our natural closeness of the races has moved us beyond most northern cities where there are still ghettos and riots; and yet, at the slightest news of racial unrest around the world, the same newsreels are shown over and over again. Alabama is a state where, being so poor and living so close together, there were thousands of kindnesses between the races, both white to black and black to white. Kindnesses and sweetnesses that will never be known, because of the unending dark cloud of our troubled past, and, more often than not, never believed. Is it any wonder that Alabama is a state with a chip on its shoulder?

We have been the butt of jokes, made to feel like the stupid, backward cousin to the rest of the country far too long. But if we are to progress, we must look at the positive results. What has this done to us as a people? It has put us all in the mind-set of the underdog, the oppressed. Is it any wonder we cheer so loudly for our beauty queens and football players? We support and cheer our Alabama brothers and sisters and want to say, "See, we are as good and as talented as the rest of you."

In other words, we have something to prove, and we feel a deep bond with each other, black and white alike. But the positive result of coming to terms with our troubled history is that we realize, having been so low for so long, we have no place to go but up. Now Alabama is taking its rightful place in the New South. There is an emerging excitement of an entire state, like a newborn struggling to break through the eggshell to spread our wings and fly, higher and farther than ever before.

So when Nall asked me to participate in this book, showcasing Alabama artists, I was delighted to do so. My friend Nall is as large and alive and as colorful as his work. Who he is in the art world is clear. He is a major presence, brilliantly reviewed and admired, who leaves awestruck all who see his work. But this book is not entirely about Nall the artist. It is about Nall the man, because no matter what heights he continues to climb in the art world, he will always be first and foremost, lovingly and proudly, an Alabama boy. A true Alabamian, who at the core just happens to be a great genius. A native son bursting at the seams with so much energy he wants to pull us all up with him. This book is the generous, enthusiastic artist grabbing us and saying, "Look at the work of Chip Cooper, Charlie Lucas, Bill Nance, Mose T., Steve Skidmore, Jimmy Lee Sudduth, Kathryn Tucker Windham, Flemming Wilson., William Christenberry, and Yvonne Wells, Look; there is more where I came from! LOOK!"

Fannie Flagg
Author and Actress

Photos : Chip Cooper
Photo montage : Nall

Preface :
Rick Bragg

I used to believe I came from a place without art. My Alabama had been cotton fields that stretched so far, and so long, you wondered if there was anything at all on the other side, or if the world just ended there, like some map from the Middle Ages. Don't try to tell us, Bubba, that the world ain't flat. If it ain't, how come nobody who leaves this place ever comes back? Surely, beyond the pine barrens, the red dirt, the pipe shops and cotton mills and the hard-eyed preachers, there was a ledge that you would step right off of, and vanish.

This was a world of men who worked cussing under V8 engines hanging from tree limbs by a chain, their knuckles chewed to mush from a slipping wrench. It was a world of women who pierced their fingers with the sewing machine needle at the sweat shops, got a Band-Aid, and went back to work. They did not buy paintings or shop for sculpture. Most of our pictures were of Jesus, enshrined in a dime store frame and a film of dust.

Art? Who had time for art? Art was for the rich folks, who lived in the white houses, not the tarpaper ones, who paid for portraits of thin-nosed women and hung them on walls of eggshell white and delicate yellow. Art was for the mommas who had other people clean their floors, who taught their children not to touch us, and who would point with pride at the portrait of Great-Great Uncle So-and-So, who had survived the "War-ah"—the War of Northern Aggression—to die peacefully in his own big bed.

There were no portraits of us, no record of us at all, except maybe at the courthouse, when we got caught making whiskey or, as sometimes happened, we knocked some rich man off his horse. Instead of art, we had work. Instead of paintings, we had the calendars from our ten-dollar-a-month life insurance policies from State Farm. Instead of sculpture, we had a hoe handle, or a neck of a whiskey bottle. We were blacks, poor whites, faded gentry whose money had vanished or whose reputations had been somehow soiled, and a few Indians who had somehow evaded the Trail of Tears and genocide, and we powered the culture with our sweat and blood. Did we ever sit in a museum, admiring an Impressionist? We considered ourselves blessed if, when the sun finally sank into the pines, we could get someone to rub our back.

I am a grown man now, and I know better. I know I just wasn't looking hard enough.

Art was in the quilts my grandmother sewed from scrap, turning other people's leavings into precious keepsakes. It was in the stories my uncles told on the front porch, their words painting as rich and as vivid a portrait as any oils ever could.

It was in the baskets and fishnets the old men and women wove, the patterns as delicate as spider webs, and in the cornices and lattices my uncles carved and hammered into place, hanging from ladders, nails between their teeth.

No, we always had art in us. We may have had a secondhand sofa sitting on our front porch, but we had, by God, art.

When the painter Nall, who left Alabama a long time ago for fame and a life among art's world-class elite, first asked me if I would write something for this collection, I did not think I could. I did not think I was qualified.

But after talking with him, and learning how his own family had once been looked down upon in south Alabama because of a closet's rattling bones, I felt a little better. And when I got a look at the art of some of the pieces in this collection, at Nall's "Dogwood" that seems to drip blood, at the eerie beauty of Clifton Pearson's sculpture, I was convinced. This collection contains a little bit of everything, from artists whose works have hung in Paris, to artists whose works have hung on the back porch. It is done by people like Jimmy Lee Sudduth. No one taught him to paint. He just does, using six shades of mud, and pine needles and leaves and grass, to get colors that are probably not for sale in Soho. But it's art, I reckon, for sure.

Rick Bragg
New York Times correspondent,
author, and winner of the
Pulitzer Prize for Journalism

Contents :

△ Nall - *"Alabama Dogwood"*

◁ Clifton Pearson - *"Celebrated Figure"*

▽ Jimmy Lee Sudduth - *"Woman Milking a Cow"*

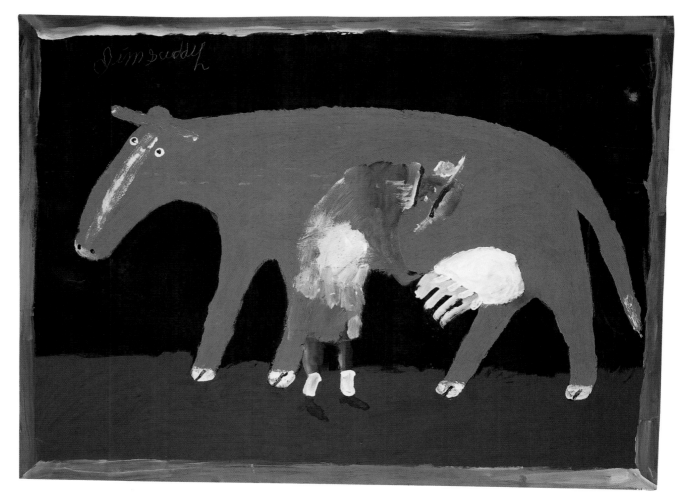

Kathryn Tucker Windham

PHOTOGRAPHER, WRITER, STORYTELLER
(BORN JUNE 2, 1918, THOMASVILLE, ALABAMA)

The photographs and stories of Kathryn Tucker Windham set the stage in the 1950s, as far back as I can remember; they are profound and simple and touch me with their poetry, mystery, and anguish of childhood. In black and white they show all the color of an epoch. The transition of a postwar culture coming to grips with the idea of victory, but confused as to why there are so few medals passed around.

Nall

The summer that I was twelve, I saw a sign in the window of Peoples Drug Company advertising free Brownie cameras for children born in 1918, the year of my birth. A Brownie was on display in the window, along with a notice that the store had a small number of the cameras to give away on the appointed date. I made daily pilgrimages to that drug store to gaze at the Brownie I intended to claim.

On the designated day, I woke up before the first singing of the birds, dressed quickly, ran to town, sat on the curb in front of the drug store, and watched the sun rise. I intended to be the first twelve-year-old in line when the store opened. And I was.

Mr. Theodore Megginson showed me how to load the roll of twelve-exposure film in my Brownie and how to look through the viewfinder. He told me to hold the camera steady and to remember to advance the film after taking each picture. Then I was on my own.

I took pictures of my playmates, Evelyn and Teace, about to board a World War I–vintage plane for their first flight; of Hiram Davis, an ex-slave, pausing to greet a friend on a Thomasville sidewalk; of a white-haired woman with a spinning wheel that had belonged to my grandmother; of Lige Danzy making a cotton basket out of white oak splits.

Mr. Rich Anderson, his hands stained brown by chemicals, developed and printed my rolls of film in the darkroom at his photograph gallery. I marvelled, as I still marvel, that Evelyn's smile and Hiram's ragged clothes and the sunlight on the old woman's hair and Lige's bare feet would be forever changeless, black and white images preserved exactly as I had photographed them.

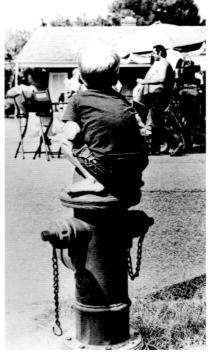

Other cameras, more sophisticated cameras, have replaced my Brownie, but the subjects that lure me are still the same.

As I grew older, I became more aware of the urgency of preserving on film the beauty of the countryside, the dignity of handed-down customs. So I have taken pictures of abandoned tenant houses, homecomings at rural churches, country stores, family picnics, baptizings in flowing creeks, Confederate reunions, graveyard cleanings, Sacred Harp singings, fishermen with cane poles, and even frizzled chickens.

Looking back, I remember with affection and gratitude the Brownie camera that inaugurated my lifelong devotion to photographing people and scenes in Alabama, the state I know and love.

Kathryn Tucker Windham

◁ *" Plug Percher"*
Spectators came from all over Selma to watch a Hollywood film crew at work. The year was 1972, the movie was "Payday" and the star was Rip Torn. It was not a good or successful movie, and the joke around Selma was that "Payday" drew more spectators for its filming than it did in movie theaters.

At the instructions of the movie makers, the observers gathered across the street, temporarily blocked off from traffic, to watch the action.

The filming had moved to the area where I lived when I took the camera and walked over to watch and to photograph. Although I took several pictures, the only one that told the story was of this barefoot boy percherd atop a fire plug. He had the best seat in the house.

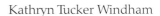

Nall - *"Portrait of Kathryn Tucker Windham"*
2000 - 101,5ᶜᵐ x 70,8ᶜᵐ x 12ᶜᵐ mixed media ▷

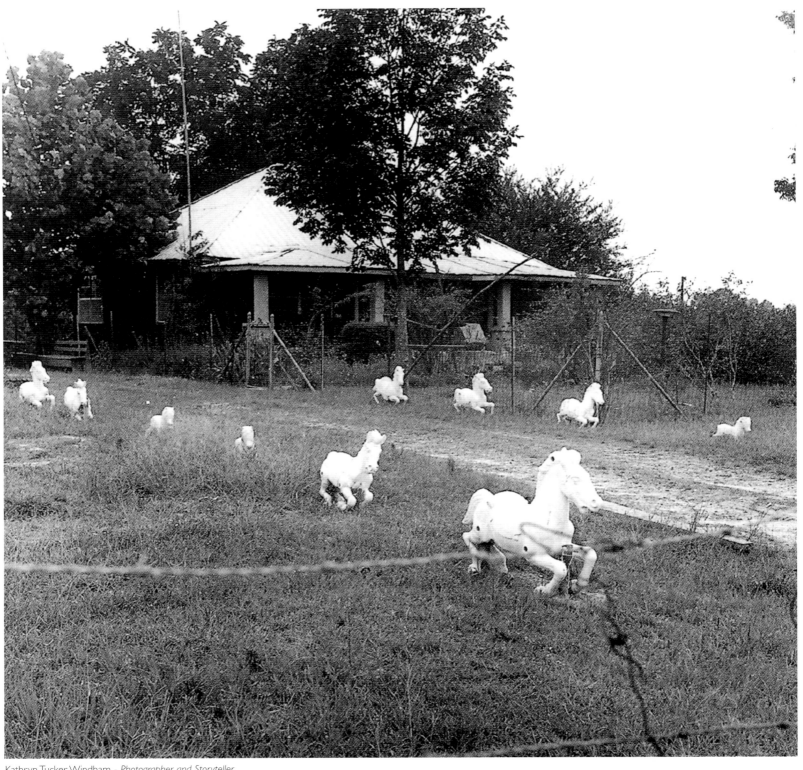

Kathryn Tucker Windham - *Photographer and Storyteller*

ALL THE PRETTY PONIES

For more than a week I had been driving around Mississippi looking for ghost stories to put in a new collection of folklore. It was the summer of 1973, and hot, the way Southern summers are supposed to be. As I drove along Highway 46, a Clay County back road, I began organizing in my mind the details of a ghost story I'd heard. What I really wanted at the moment was a cold drink, maybe even a grape Nehi, and a place to take a nap. I was trying to concentrate on the details of the ghost story when out of the corner of my eye I glimpsed an unusual yard decoration. However, I had gone a mile or so down the road before I suddenly thought, "You saw something very strange back there. You'd better go back and see what it was".

So I turned around in the next driveway and drove back to investigate. What I found were two lines of white ponies, their plastic hoofs frozen in motion, prancing down the grassy borders of a driveway. A barricade of barbed wire, as motionless as the horses themselves, prevented their escape onto the highway. I drove slowly between the lines of horses (certainly I did not wish to risk causing a stampede !), parked and walked up on the porch to inquire about the origin of the ponies. I was about to knock on the wide front door when I looked through its glass panel straight into the jolly face of a life size Santa Claus ! On the hottest day of the summer, he stood there in his red suit and hat, both with their proper fur trimming, as though he had just come down the chimney to distribute gifts. I'm sure his sack of toys was close by. I looked quickly back to the driveway to assure myself that they were indeed ponies and not reindeer I had seen.

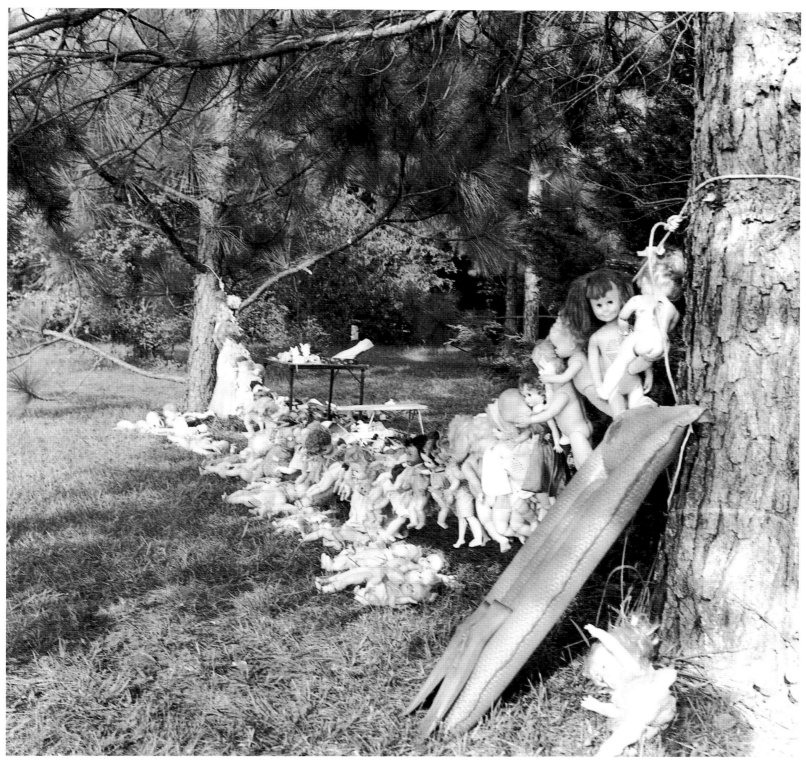

Kathryn Tucker Windham - *Photographer and Storyteller*

CLOTHES LINES

Clothes lines have many uses.

One day while driving through east Alabama (not on the interstate - few photographic opportunities flourish there), I happened upon a yard sale with one hundred dolls, many of them naked, strung up for display. It was a gruesome sight, rather like a mass lynching.

On a more cheerful note, to be truthful, the line of dolls amused me rather than depressed me.

Barbed wire fences serve as clotheslines, too, and serve well, One warm but blustery day in early spring I found a row of underwear dancing in the wind. The dancers might have gone cavorting across the pasture had not the sharp barbs of the wire fence tethered them.

Right now the clothesline in my back yard is lined with impatient birds, mostly sparrows, waiting their turns at the feeder. Now that I have a clothes dryer, I really don't need that line any more - but the birds and I like it.

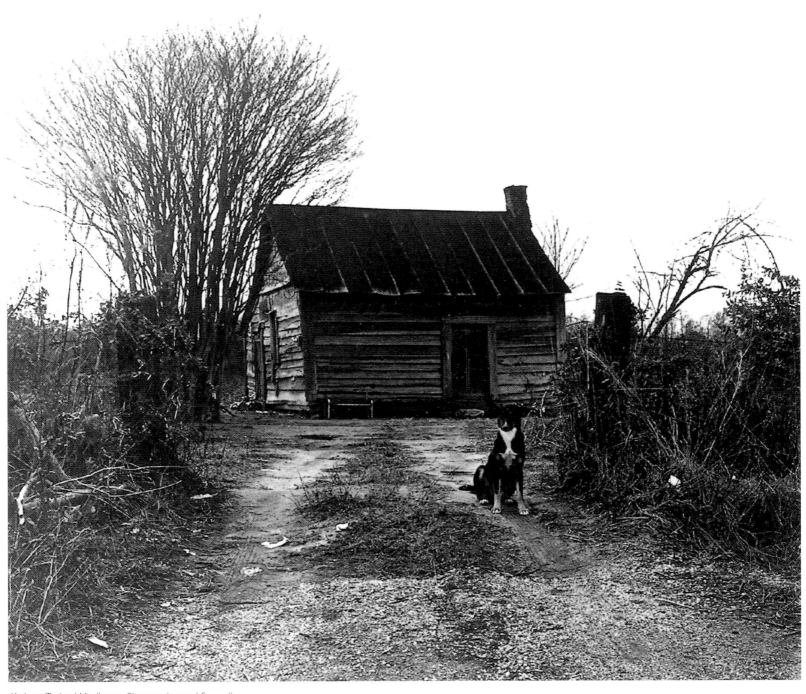

Kathryn Tucker Windham - *Photographer and Storyteller*

LONG WAIT

The house was on the road between Selma and Camden, a road I traveled often. There was little to set it apart from hundreds of other deteriorating tenant houses scattered throught the Black Belt except that it seemed a little more desolate and lonely than most. For a long time I thought it was unoccupied, but then I began to notice signs of life as I drove past : smoke rising from the chimney, fresh tire tracks in the littered yard, a child's plastic tricycle near the side door. Never did I see a human being on the place. I watched the house for a year or more, watched its metal roof become rustier and its rough board exterior turn grayer. "I must stop and photograph this place", I thought a dozen times. "It won't be here forever. "Then one cloudy day when there were no leaves on the trees and when I expected to see smoke coming from the chimney but did not, I saw a mongrel dog, black and tan with a white chest, sitting in the yard. "Now's the time for that picture", I told myself as I pulled off the road.

The dog did not run, as I had expected he might, nor did he come toward me. He did not wag his tail nor did he snarl or bark. Except for lifting his ears slightly, he sat perfectly still and stared directly at me while I took a picture of him and of the house. He did not move when I turned to leave. He did give me a quizzical look as though he wondered if I had come to give him news of the whereabouts of his owners or had come to take him to a new home.

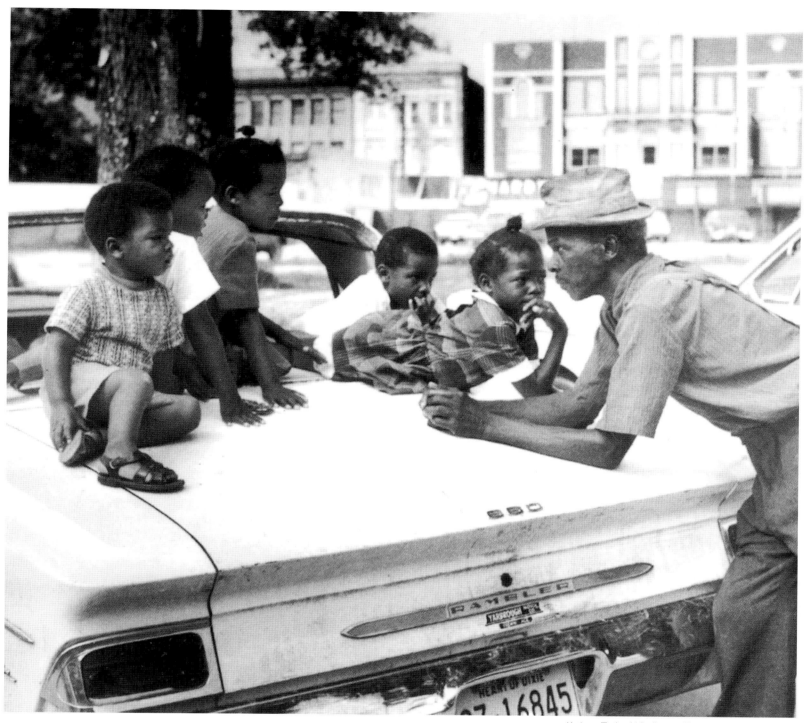

Kathryn Tucker Windham - *Photographer and Storyteller*

STORYTELLING TIME

Storytelling is the simplest of the arts.

Other arts require musical instruments, stages and costumes, paints and canvasses, lighting, sound systems and such, but with storytelling, all that is required is someone to tell and someone to listen.

This storyteller in downtown Selma had five listeners on the trunk of his car. He appears to be keeping his young charges entertained while their mother (mothers?) shops.

I wish I knew what story he was telling them.

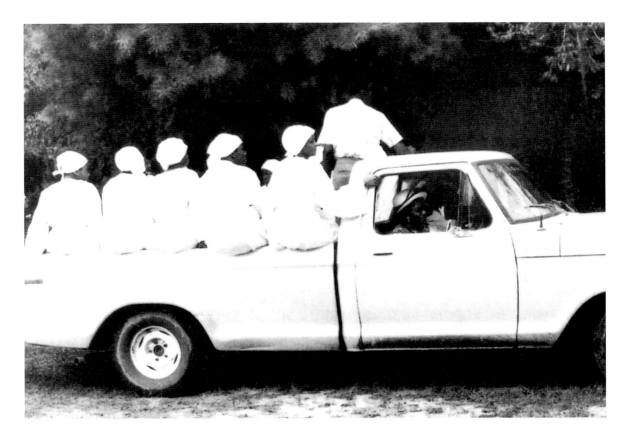

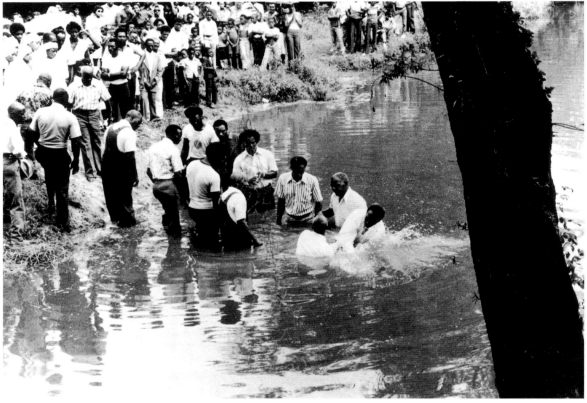

GEE'S BEND BAPTIZING

For as long as the oldest residents can remember, the second Sunday in August has been Baptizing Sunday for the Pleasant Grove Baptist Church in Gee's Bend.

Traditionally the baptizing was done in the creek, a mile or so from the church, but times have changed, even in that remote all-black community, and now the rite is carried out in a small concrete pool in the churchyard.

I was blessed to be able to attend and to photograph earlier baptisms at the creek. These pictures were taken in August 1980.

It was hot and still, as hot a Sunday as I ever remember, but the ten candidates in their long-sleeved white robes seemed unaware of the oppressive heat. When I first saw them, they were perched precariously along the sides of the bed of a pick-up truck that had brought them from the church to a bluff overlooking the creek.

Down below, standing along the curve of the creek, a hundred or more people waited. As the candidates, escorted by deacons and mothers of the church, followed their minister down the hill, singing welcomed them. Singing, chanting, humming, with sometimes a solo voice rising above the chorus, continued throughout the ceremony, swelling and ebbing and swelling again in musical patterns so familiar and yet so old that their origins are now forgotten.

When the group reached the creek, one of the deacons waded out with a long stick. Whether his mission was to measure the depth of the pool, to frighten

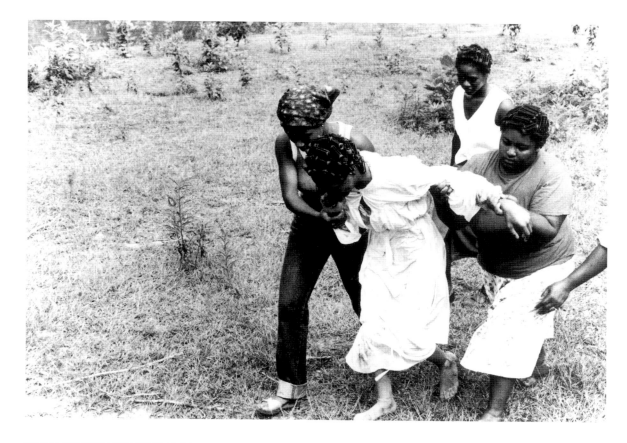

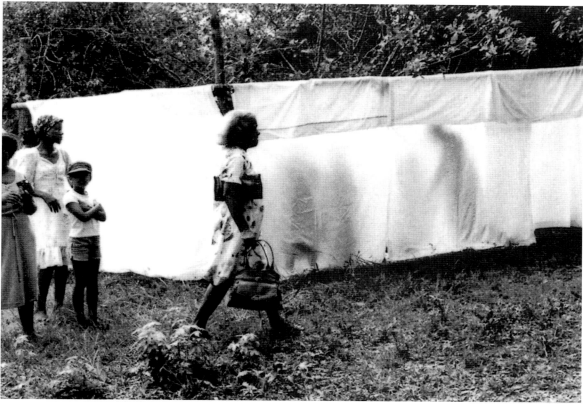

away moccasins or to carry on an ancient ritual of stirring the almost stagnant water, I do not know. Behind him came the minister, gazing heavenward and praying aloud as he walked out waist deep in the murky stream.

A double line of deacons guided each candidate into the creek to the outstretched hands of the waiting minister. And when the musical background softened, his words came strong and clear, "In obedience to the divine command and in accordance to the confession of your faith, I do indeed baptize you in the name of the Father, in the name of the Son, and in the name of the Holy Spirit. "Without exception, each newly baptized person came out of the water in a state of ecstasy, trembling and jerking and shouting for joy.

After the women and girls were baptized, they were helped up the hill to a makeshift dressing room made of sheets strung between pine trees. There they changed from their wet robes into their Sunday dresses in preparation for returning to the church to be received into full membership. Even as they dressed, they could hear the singing and the words of the preacher as he immersed the final candidates: "I do indeed baptize you. . . "

Chip Cooper

PHOTOGRAPHER
(BORN NOVEMBER 7, 1949, SAVANNAH, GEORGIA)

As a European aristocrat clings to his past, Chip Cooper's color photographs speak clearly of his own heritage, through rusted tin roofs and crumbling Doric columns. He bridges the gap between cracker shack and antebellum mansion, elite-art and art of the common man. In his black and white asylum images, he claws deeper into the Southern soul and uncovers the complexes that lurk in us all.

Nall

Chip Cooper is intrigued by the things we don't see. With painstaking patience he stalks both the light and the dark images of the South, presenting the mysteries and the contradictions of a land rich in myth. His lens gives us both the pastel, impressionistic scenes of a familiar natural beauty, and the wrenching, sometimes stark details that suggest loss. In every careful image there is the sense of a story waiting to unfold.

What draws him, for instance, to a ramshackle structure that once was a country home? Its boards are weathered nearly black, its stoop is sinking toward oblivion, and it seems to yield passively to time and a choking tangle of vines. Abandoned, desolate, disturbing, the structure would attract from most observers only a distasteful glance.

Cooper's photo, however, invites another look. Against the monochromatic grays of a facade being consumed by the landscape, he captures a delicate spray of color. With a backdrop of decaying boards, he focuses on grapelike clusters of wisteria blooms, their profuse color an insistent counterpoint to the home's inevitable loss. Who lived here?

Chip Cooper - *"Abandoned Car"*
1993 - Uriah, Alabama - Cibachrome

What became of the family who deserted this structure, its vacant stare now a mute acceptance of its loss? With one image, Cooper suggests both the tragedies of time and the hope of transcendence.

Poised between sometimes jarring dissonances of beauty and decay, his work resists typecasting. He is drawn to the fragile details of the South's abundant beauty, the brilliant reds of a fall orchard, the creamy pinks of spring's first blossoms, the imposing geography that helps define place. But Cooper just as often is drawn to the not-so-pretty details. In these photos, he insists that we look beyond our comfortable images to a Southern life replete with both irony and despair.

For these scenes a quick glance is not enough. In a photo of a weedy outdoor religious tableau, we see a tongue-in-cheek view that gradually suggests layers of meaning. Who designed this grouping of hand-lettered, overgrown artifacts declaring, "Jesus Loves You"? What does its ironic contrast with formal iconography suggest? Our initial amused reaction demands a second, a third look. The inelegant religious testimony in an unlikely spot offers a surface meaning that deepens with each re-examination. Seen out of context, the symbols invite us to examine our own iconography, freshly and unconstrained by appearances.

Most of Chip Cooper's photos, in fact, demand that we look more than once. Even an ostensibly simple image, a lone flower in an otherwise drab landscape, can suggest layers of meaning about time and place. Technically proficient, Cooper has said, "My primary goal in committing an image to film is not about technique. I am more concerned with producing images that provoke feelings."

That commitment begins with his own response to a scene. "I am drawn to my subject matter because it excites me," he has said. The interplay of light and color and pattern begin to suggest new qualities, and from the jumble of sensations, he begins to extract and select. "I have to separate elements from all of the visual chaos and disorder that we normally see," he explains. "I start to isolate my subject from this chaos even before I look into my viewfinder."

Like any artist, Cooper's goal is to interpret what he sees, challenging the viewer to participate fully in the process. To create the essence of a scene, he often focuses on the part rather than the whole. "My photographs are summed up as 'less is more,' " he says. A weathered windowsill supports opalescent panes of glass, the reflections a mosaic of colors and past lives; an abandoned, mottled delivery van takes on the character of an abstract painting—the close, poetic details of these images would be lost by stepping back to view the whole. These images, Cooper says, focus intentionally on the small rather than the great. They are, he says, "things most people would not stop to look at".

In searching for the things most of us don't see, Cooper gives us opportunities to see as though for the first time. His haunting, evocative photos of a passing South invite us to redefine our own sense of place. In these images he tells his stories of the South, and allows us to tell ours.

Cooper is a native of Savannah, Georgia, and was reared in Huntsville, Alabama. He is a graduate of the University of Alabama, where he is currently the director of photography. He has published three books of photography, Hunting: A Southern Tradition, "Alabama Memories", and "Silent in the Land". His forthcoming book in collaboration with Alabama writer Kathryn Tucker Windham is "Common Threads".

Cooper's work has appeared in publications such as Newsweek, Village Voice, and USA Today, and he has exhibited internationally.

Maridith Walker Geuder

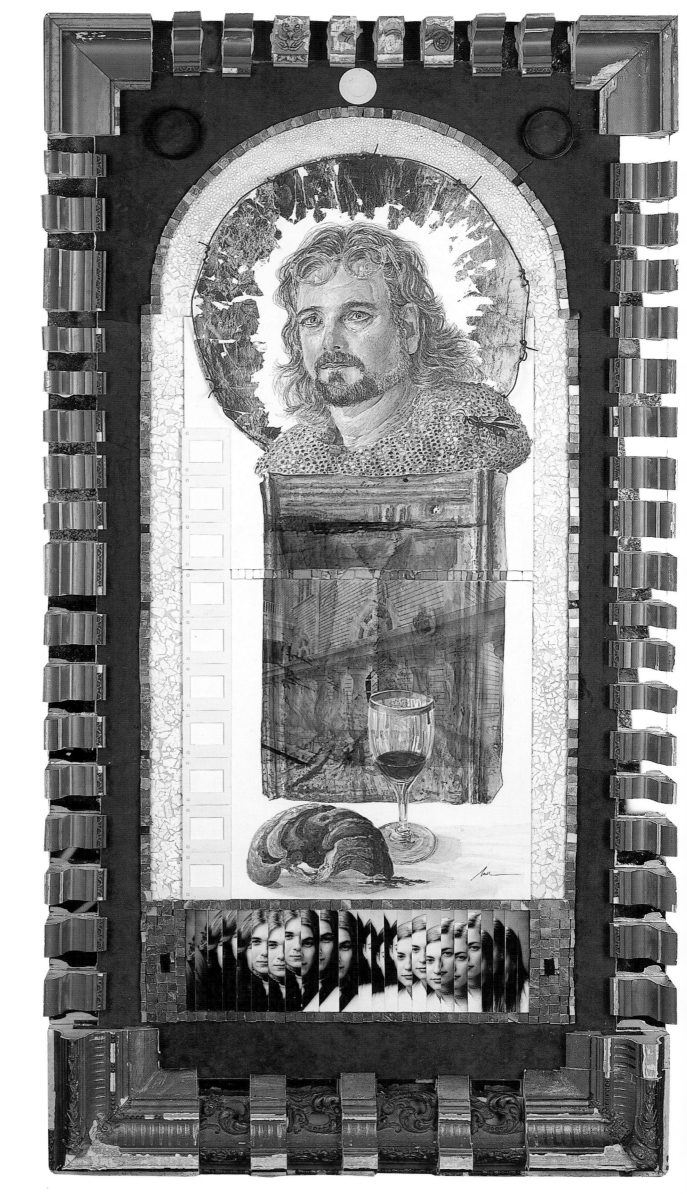

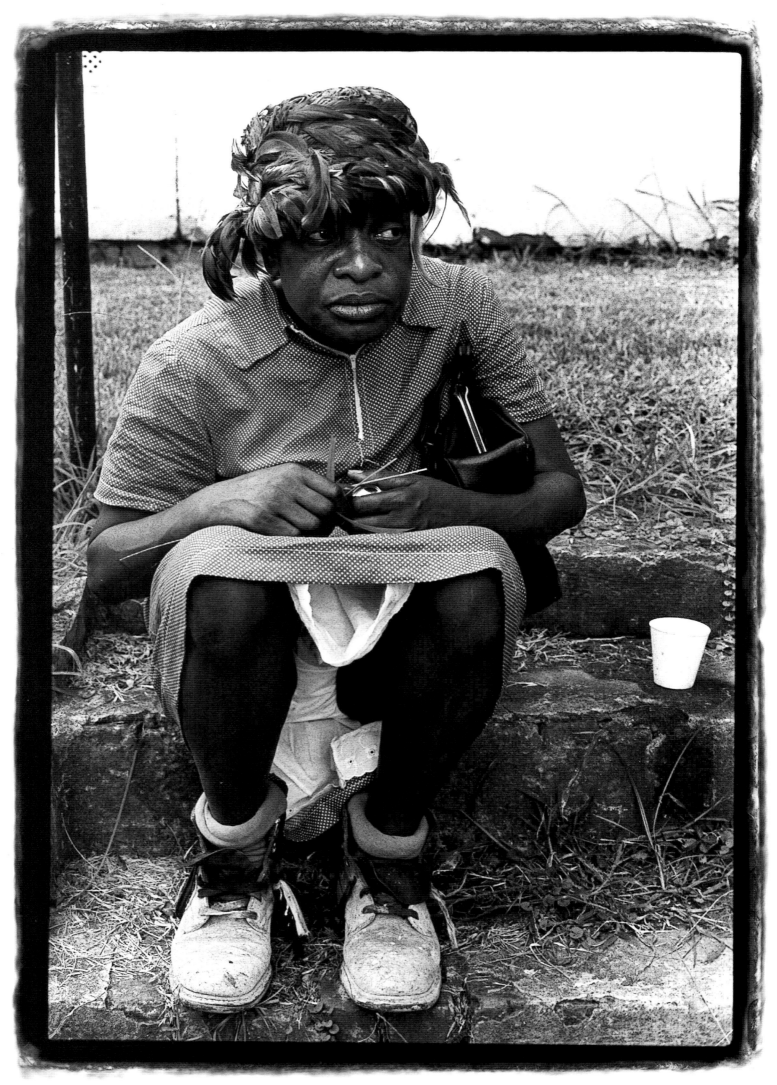

Chip Cooper - *From "Out of Darkness" Series*
Mentally ill patients - Woman 1976 △
Boy 1980 ▷

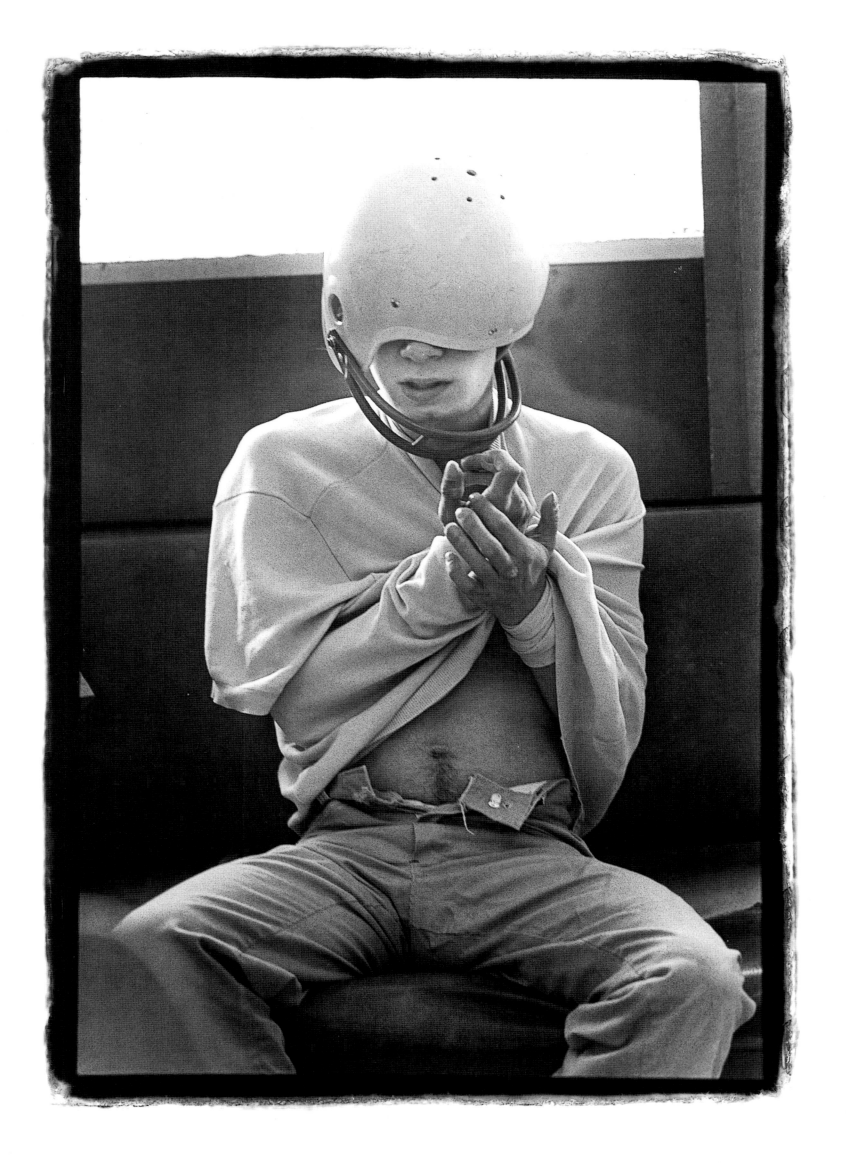

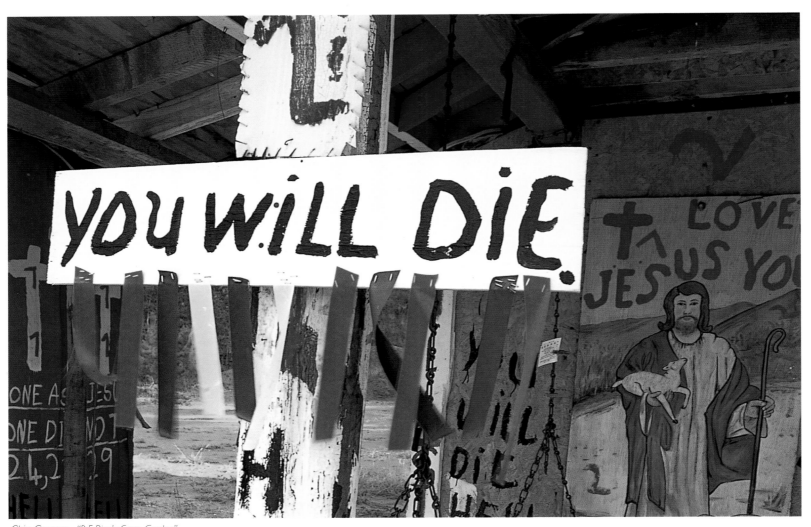

Chip Cooper - *"B.F. Rice's Cross Garden"*
Prattville, Alabama - Cibachrome 1998

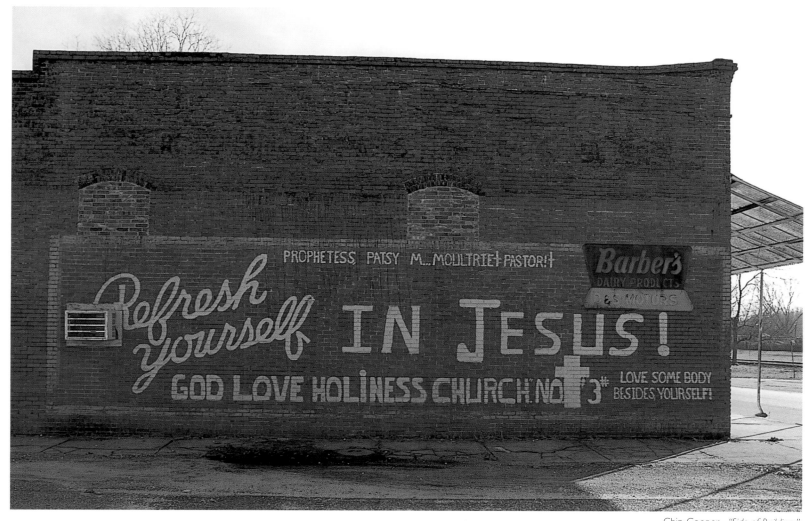

Chip Cooper - *"Side of Building "*
Rifle, Alabama - Cibachrome 1993

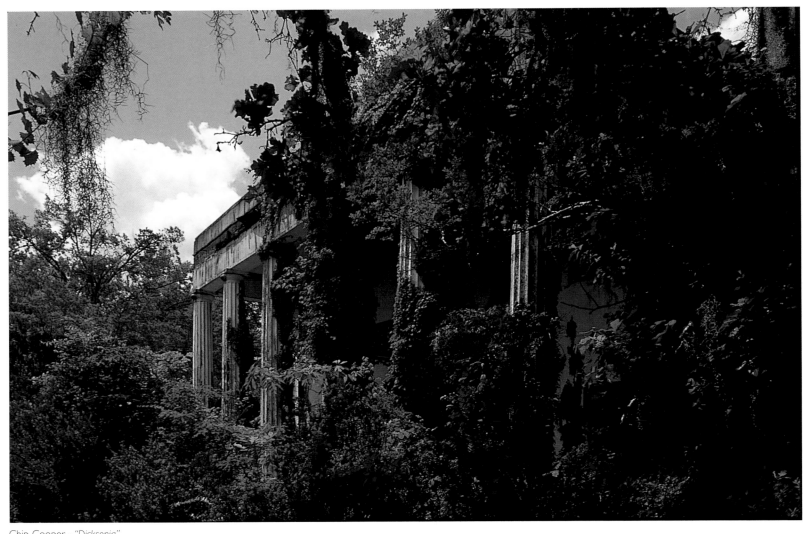

Chip Cooper - *"Dicksonia"*
Lownesboro, Alabama - Cibachrome 1992

Chip Cooper - *"Warehouse"*
Eufaula, Alabama - Cibachrome 1989

Flemming Tyler Wilson

PHOTOGRAPHER
(BORN JULY 31, 1949, TUSCALOOSA, ALABAMA)

Flemming Tyler Wilson has focused on a liberated, decadent South, and his work is honest to a fault. He sets up scenes for present-day icons which cavort and twist to massage his pain. For revenge he dresses the gods in contemporary clothes and hangs them out to dry. His symbolic black and white realism is mixed with an expressionist application on tombstones, bedroom curtains, and bathroom walls, incorrigibly, beautifully, penetrating our private lives.

Nall

Immediately after graduating from high school, Flemming Tyler Wilson fled to Chicago, where he lived for thirty years. He studied sociology and art at DePaul University, and studied at the Art Institute of Chicago and Columbia College, also in Chicago. He apprenticed with commercial photographer Peter Amft, where he first explored what is possible in a professional, working studio. Those early experiences led him to jobs with Sears, Spiegel, Bonwit Teller, and Nieman Marcus. He did almost everything that goes into the telling of stories with pictures: scouting locations, casting models, handling props and wardrobe, and designing and constructing sets. The stage was now set for Flemming to transfer what he had learned to his own work, his own art, and to add the one aspect that was missing: passion. Around 1980 Flemming began pushing his own product, and ten years later moved back to Tuscaloosa, where an affiliation with the art department at the University of Alabama enabled him to engage in extensive laboratory experimentation. His most recent work, "Sins", has been written up by internationally known and acclaimed Quentin Crisp and William Doty, and although Flemming is partial to certain of his sins, he doesn't hesitate to air them all.

"I am blessed to find in photography a means of expressing

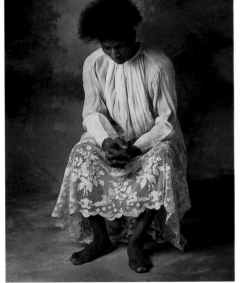

"Flemming Tyler Wilson" by Marc Hauser - 1990

myself; photography is my voice. I love everything from portraits to my stage-set-like scenes of mythology. There are two types of photographs; some you take and some you make. I stay out of the photograph until the individual is either relaxed or agitated enough so that they look right past me, and they're then confronting the person who will look at this photograph. If I spend time, however long, with concepts—stage sets, actors, etc. —in order to achieve my desired effect , then I consider that this is a photograph that I have made. My happiness depends on other people and the state of affairs with humanity. In this dance, I go back and forth between feeling blessed and cursed. As I go through life, I'm often perplexed of time spent on the contemplation of heaven and hell. My hands are full with the here and now. While it is my belief that beings of humanity are privileged to be charged with the duty to contemplate themselves, it seems we all too often want to shift responsibility for ourselves to powers either higher or lower, thus we picture gods and demons, heaven and hell. I look at the planet and its goings-on and wonder why anyone should need to dream of a place more heavenly than this one could be. My photography expresses the state of the world to show humanity something of itself: beautiful progressions and senseless digressions in spirit. "

Flemming Tyler Wilson

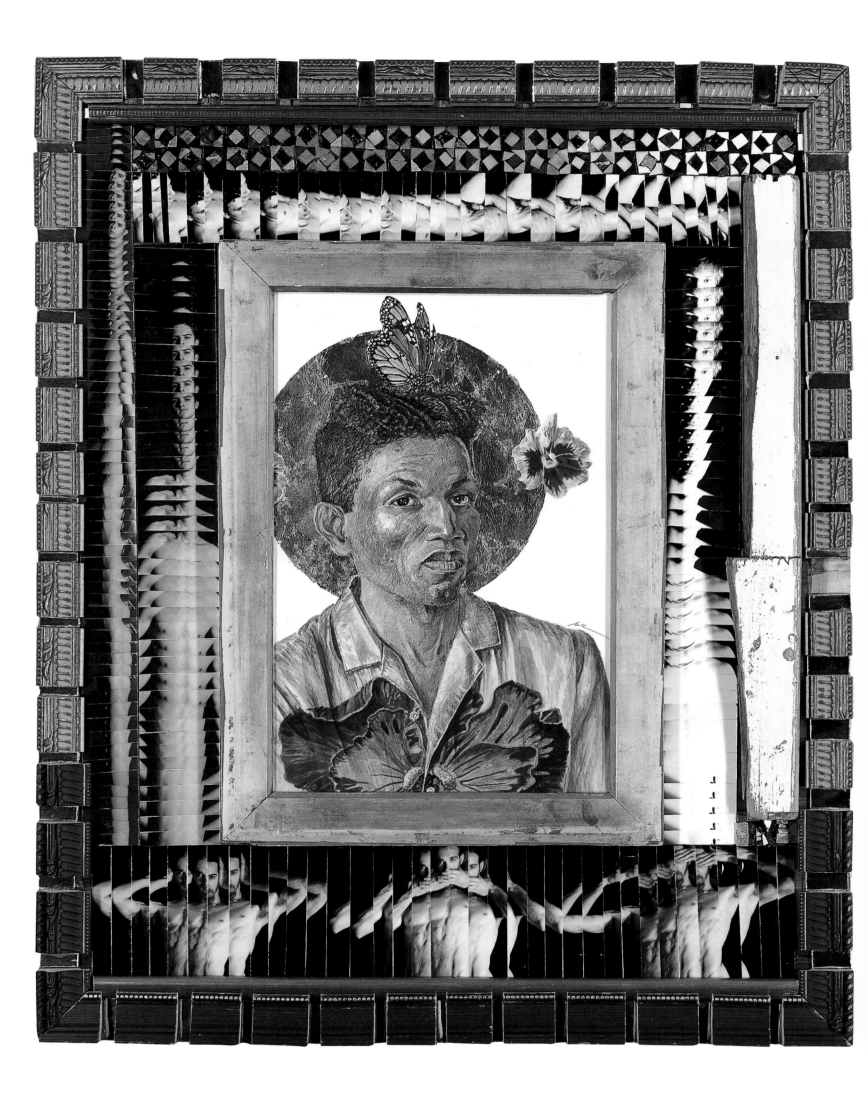

Flemming Tyler Wilson - *"My Mother, Lillian Kemp Wilson"*
Silver gelatin print - 1980

Flemming Tyler Wilson - *"Brandon Cooper"*
1997 - 11"x14" - Silver gelatin print ▷

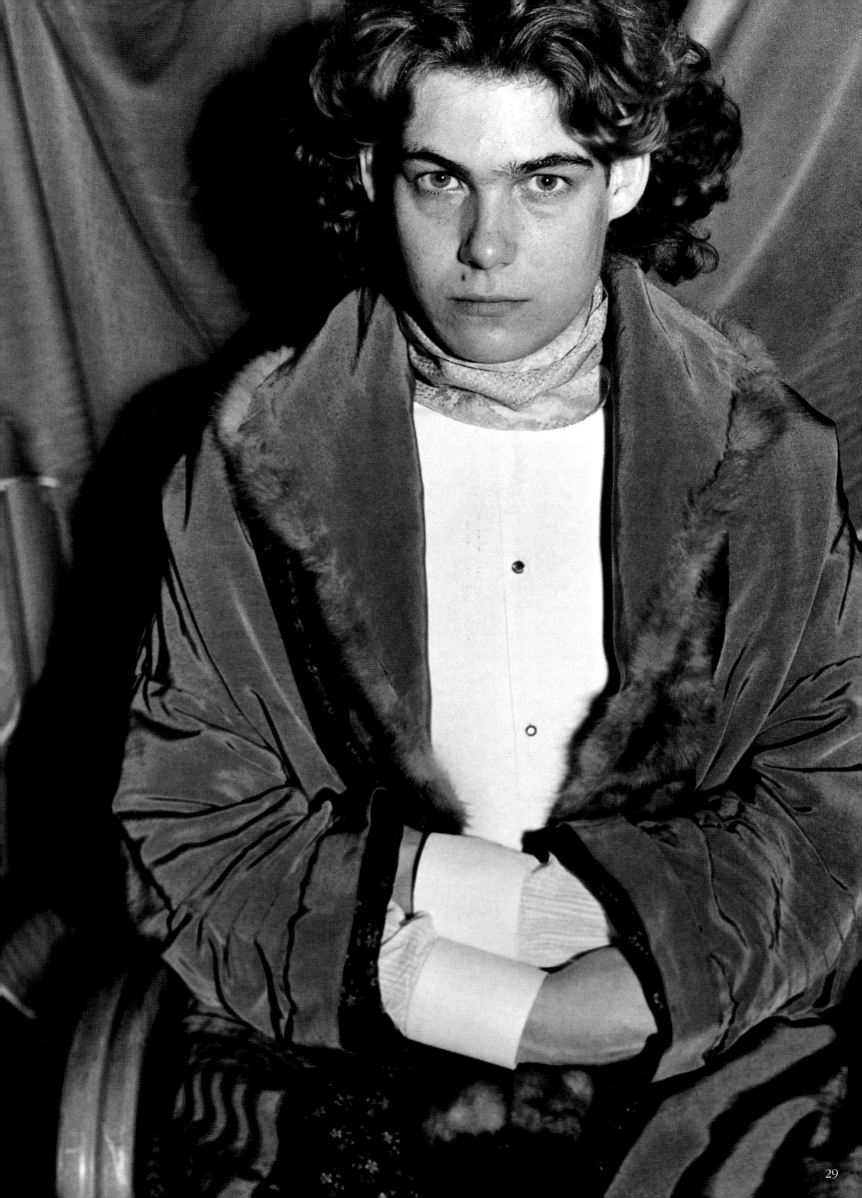

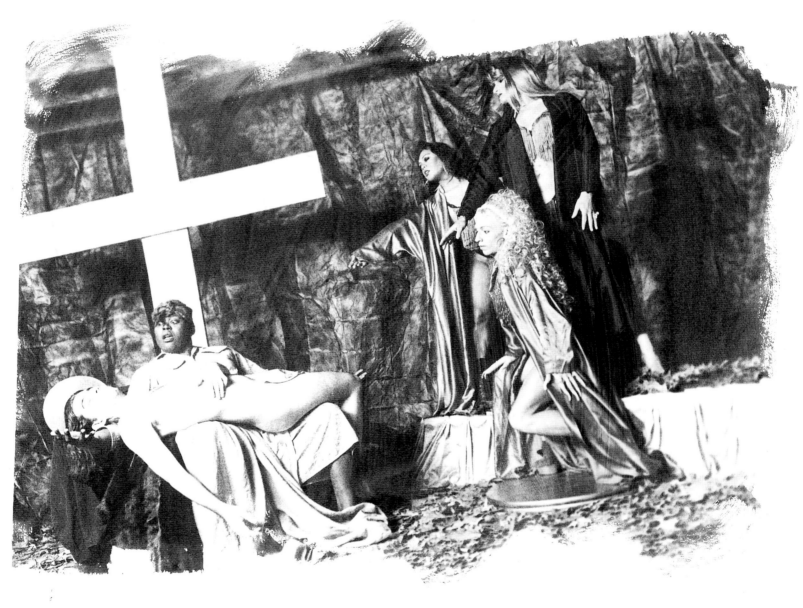

Flemming Tyler Wilson - "Pieta"
On arches paper - 22"x30" - 1995

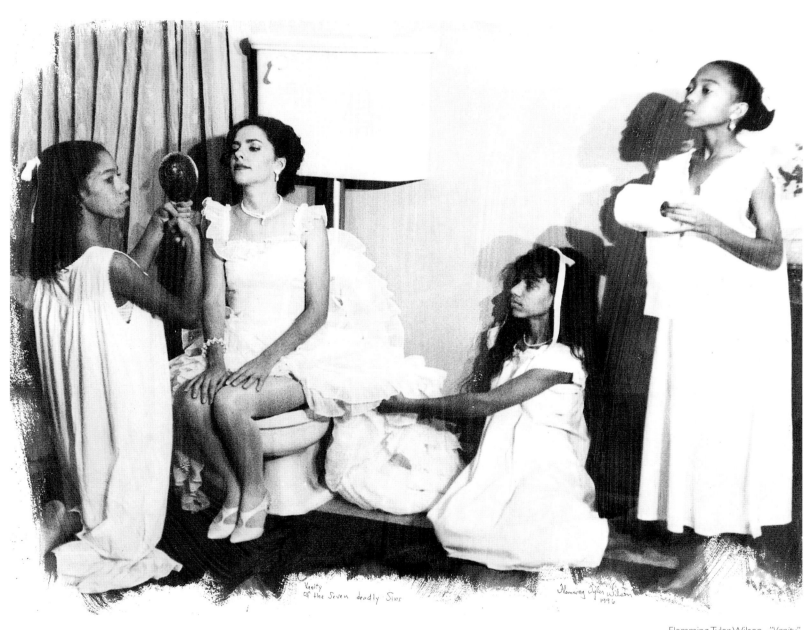

Vanity
of the Seven deadly Sins

Flemming Tyler Wilson
1996

Flemming Tyler Wilson - "Vanity"
From the 7 "Sins" portfolio - 22"x30" - 1996

Flemming Tyler Wilson -"*Andrew Mc Dade and Baby Joseph*"
Silver gelatin on arches paper - 11"x14" - 1994

Flemming Tyler Wilson -"*Envy*" *From the 7 "Sins" portfolio* ▷
Silver gelatin on arches paper - 1994

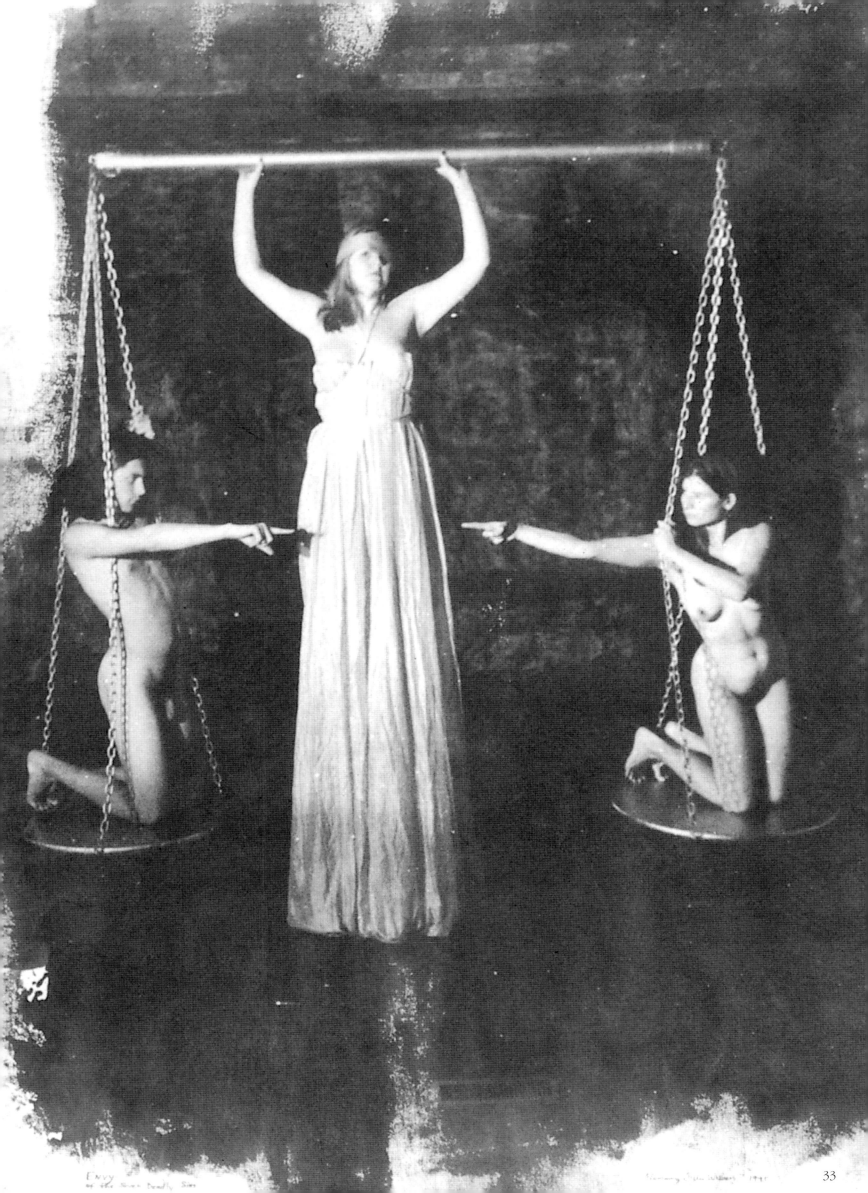

Envy *of the Seven Deadly Sins*

Bill Nance

PAINTER, SCULPTOR, GARDEN DESIGNER
(BORN OCTOBER 12, 1951, PULASKI, TENNESSEE)

Bill Nance has taken his sculptor's hands, his artist's eyes, and enlarged his canvas to gardens. His exquisite palette of bushes and shrubs, ground covers, and lanes weave around and through his geometrically abstract foliage. His yearning for the past and love of nature spoil us with Alabama gardens, and one can see, hear, taste, and smell his enchanting compositions.

Nall

Bill Nance came to Alabama and completed his BFA and MFA degrees at the University of Alabama in Tuscaloosa. He has studied in Mexico, been Artist in Residence for the state of Alabama, received two fellowships from the National Endowment for the Humanities, and participated in four Fulbright programs abroad. He is currently a Professor at Alabama A&M University, in Normal, where he has taught for the last twenty-five years.

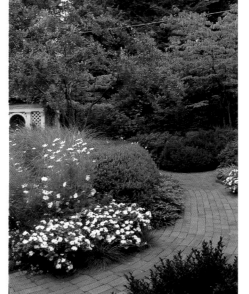

His artworks have been exhibited and collected throughout the Southeast and his gardens have been featured in Southern Living and Horticulture magazines. When he is not teaching, making art, designing gardens, or traveling, he gets really dirty in his own garden in Huntsville, Alabama.

Nance approaches the creation of a garden as he would any other work of art. To him a garden is a flooding of the senses, a three-dimensional painting that incorporates all of the elements and principles of design, but also allows the viewer to touch, smell, hear, and become a physical presence. From the reality of the South's hard red clay and hot humid air, he transports us to an ethereal dream world of the imagination.

His background in the fine arts and strong sense of design are evident in the gardens he creates. Though he may borrow from Greco-Roman architecture or emulate the inward-looking subtlety of Chinese Ming Dynasty gardens, these culturally diverse influences never intrude upon the Southern theme. His gardens feature a well thought out, tightly structured design, softened by loose, lush paintings to achieve what he calls a romantic balance. "The plant forms in a border should be like guests at a good cocktail party," he says with an impish grin. "Some should be standing stiffly erect, some should be swaying in the breeze, and a few should be falling down. "To Bill, humor is important in a person and in a garden.

Another desirable attribute he stresses is humility. Simple plants and common materials bring a garden down to earth and keep it from becoming too rarefied and contrived. The magic of a garden is contained in its details. A garden, like an intriguing person, should reveal itself slowly, always offering the searching and sensitive eye a multicourse feast for its effort.

Like many in the long tradition of artists as gardeners, Nance excels in this duality. He collaborates with clients that share his vision and sensitivity. Together they create his magical other world.

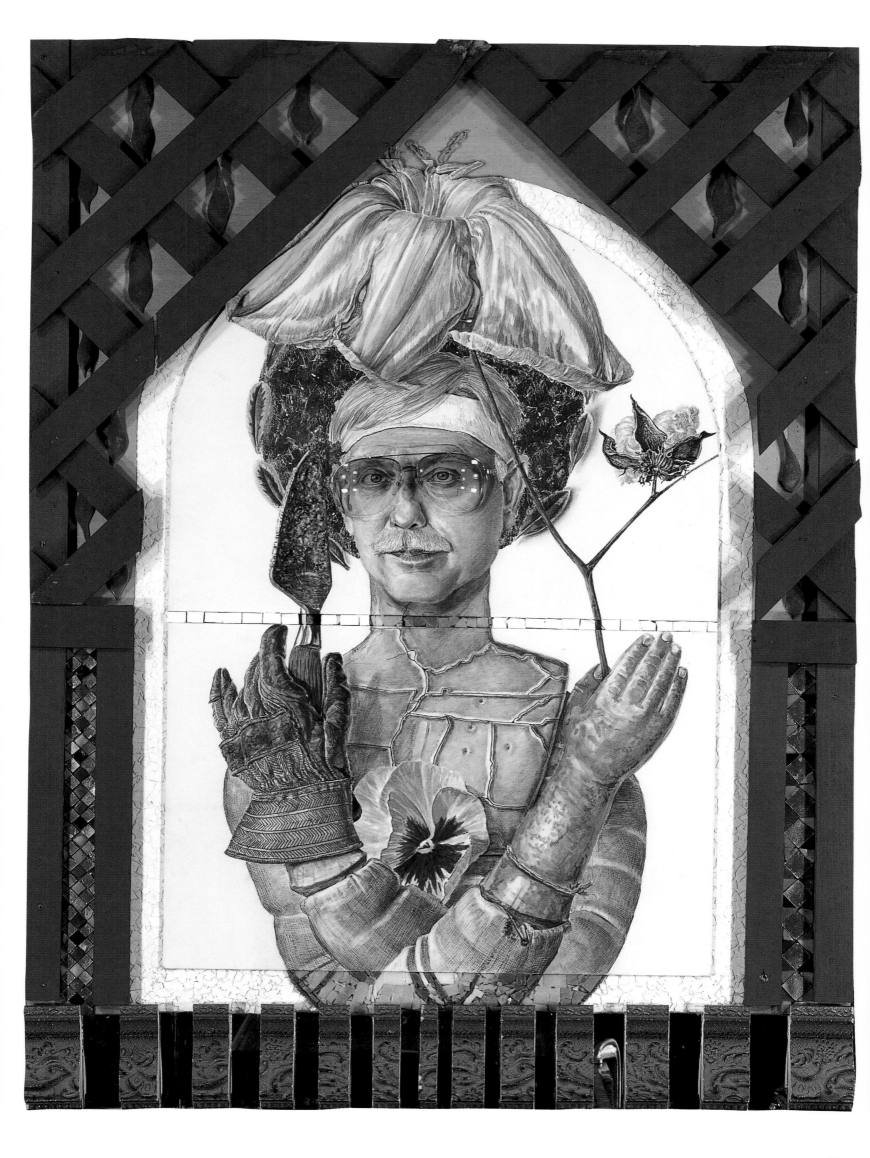

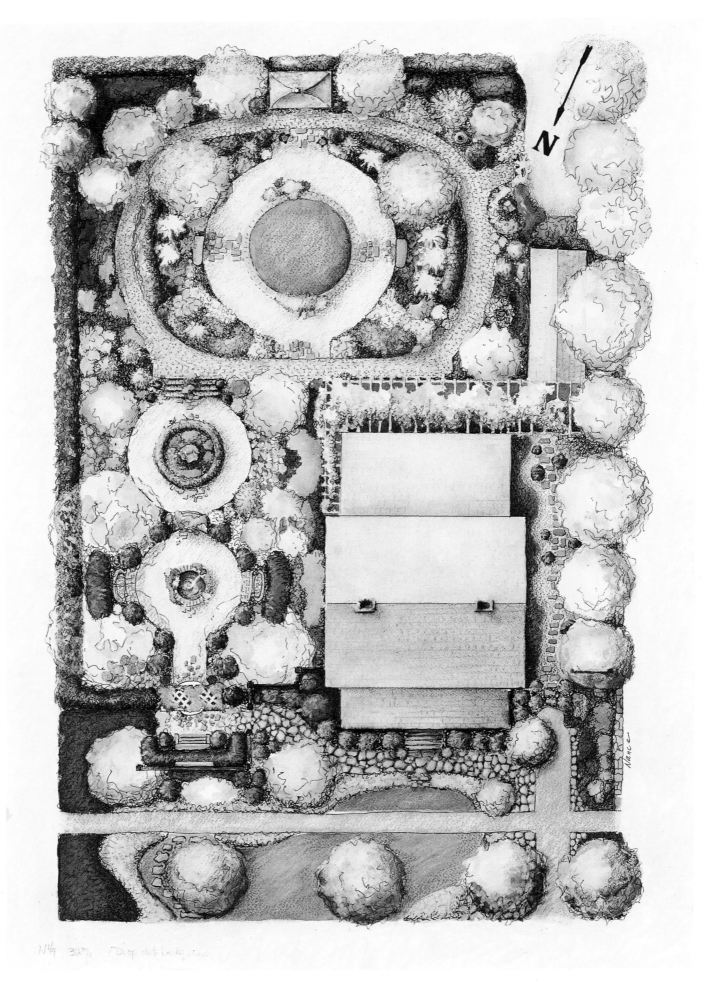

N

Bill Nance - *"Garden Design"* Watercolor
Huntsville, Alabama

"Clinton Street Garden"
Photo - Cover of Southern Living Magazine
April 1999

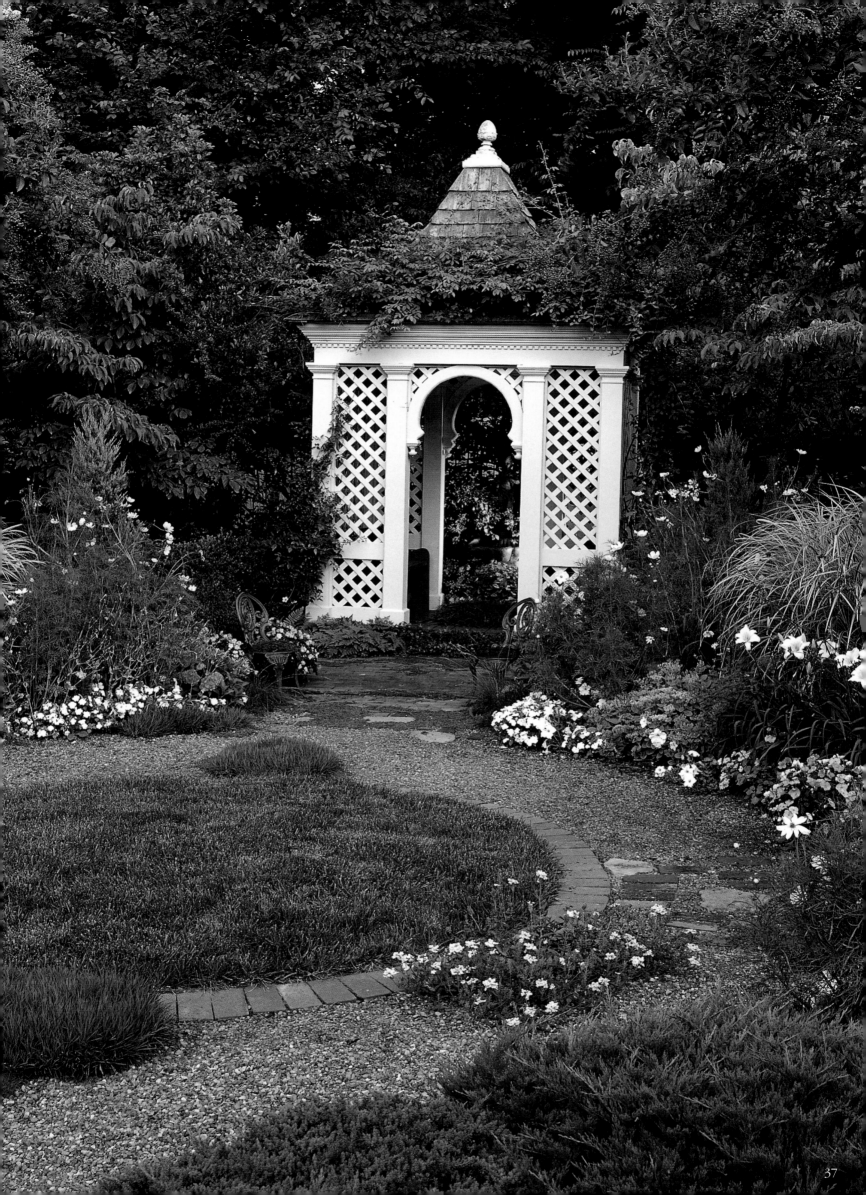

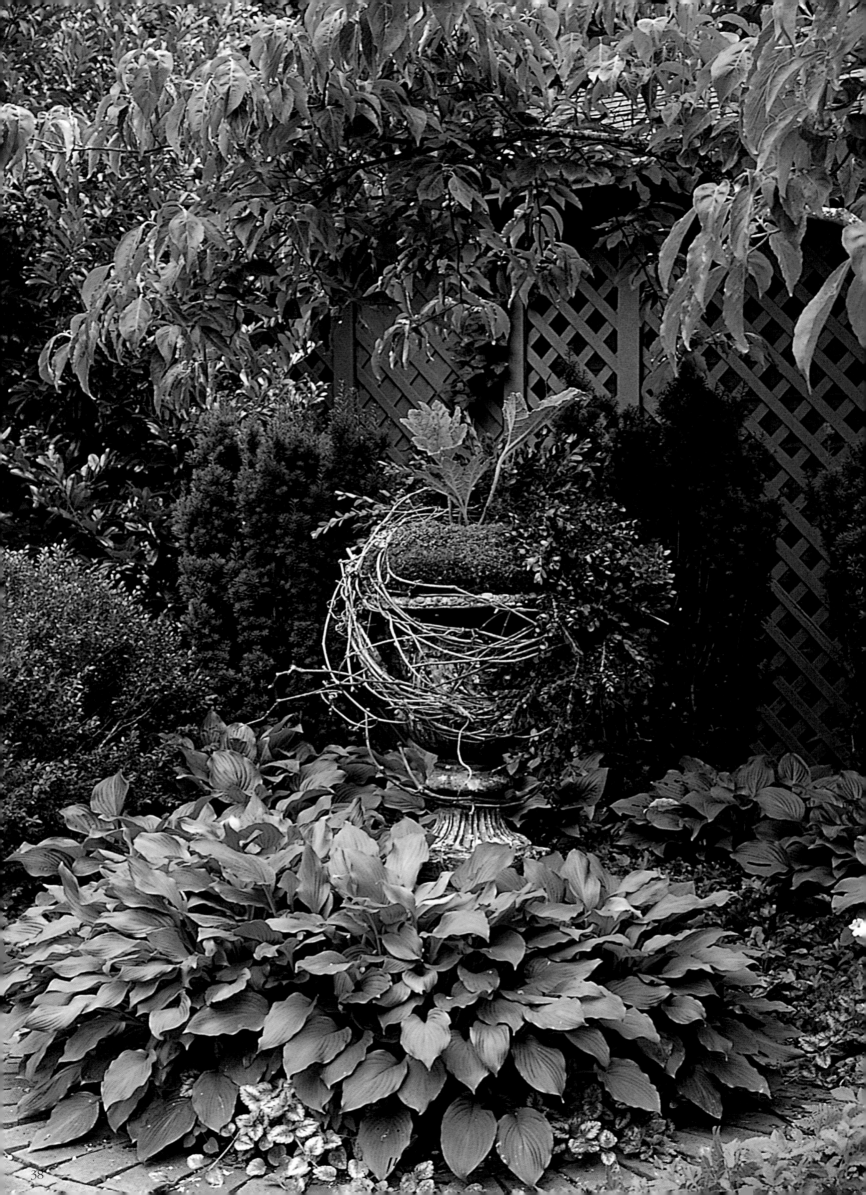

△
◁ "Clinton Street Garden"

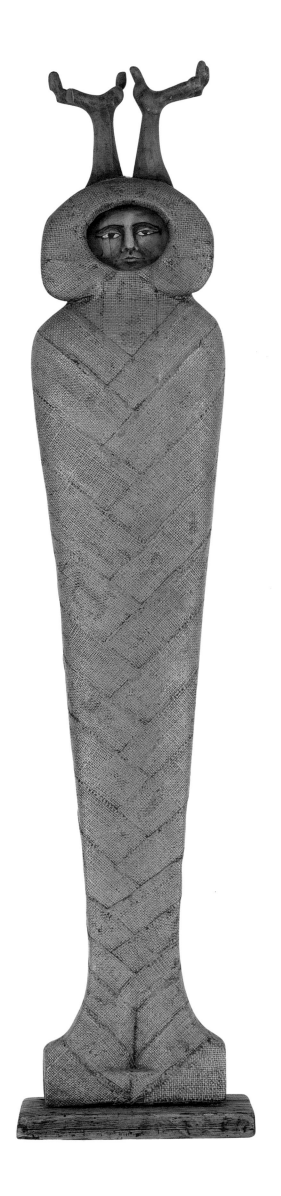

◁ Bill Nance - Sculpture "Mummy" - 1977

Bill Nance "Garden Door" ▷

William Christenberry

PAINTER, SCULPTOR, PHOTOGRAPHER
(BORN NOVEMBER 5, 1936, TUSCALOOSA, ALABAMA)

William Christenberry's photographs have brought to attention Alabama's *Arte Povera*, our everyday rust and ruins turned into art. Pioneer architectural structures parallel, eighteenth-century Neapolitan nativity scenes or Chinese Houses of Spirits, and remain monuments to our humble past. The love and sentiment of his work draws Christenberry back to Alabama, feeding his artistic expression, and renews Alabama's own strength and pride, meticulously reminding us that what we love is dear to our hearts, and should be protected and passed on as a family jewel.

Nall

William Christenberry is an internationally recognized interpreter of the American South. Through drawing, painting, sculpture, and photography, Christenberry reveals a stirring vision of the heritage that obsesses him. His original imagery and objects form a distinguished voice in American contemporary art. Addressing the experience of migration and the toll of regionalism on personal identity, he specifically describes and considers the social and material culture of the South.

Christenberry was trained as an abstract expressionist painter in the 1950s. He has lived in Washington, D. C. , since 1968 when he became a professor at the Corcoran School of Art. Influenced by early Pop Art, he took up representational art when he began using a childhood Brownie camera to record country scenes of his home region, including his parents' native Hale County, Alabama, immortalized by photographer Wallace Evans and writer James Agee in "Let Us Now Praise Famous Men".

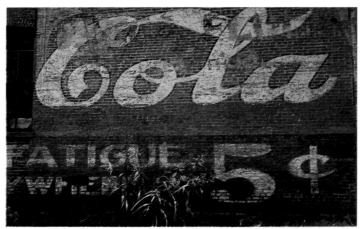

"5 cent Wall with Johnson Grass" Demopolis, Alabama - 1980

Evans was the first to consider young Christenberry's photos serious art. Inspired by the directness of photography, Christenberry made it a critical component of his work, a medium on its own, a seed for his painting and sculpture, and a tool for the documentation of his sculptural work. His pictures and sculptures of Alabama buildings constitute one of the most extended studies of vernacular architecture ever undertaken in the rural South.

Contemplating country stores, barns, houses, and churches for over three decades, Christenberry has documented the passage of time on the modest structures he equates with the waning spirit of country life. His surreal Dream Buildings and Southern Monuments combine farm-culture elements like metal advertising signs, hollowed-out gourds, and rough-hewn ladders with essential three-dimensional forms. The resulting sculptures commemorate an Alabama of both childhood memory and adult reflection.

The high-pitched conical roofs of the Dream Buildings foretell Christenberry's epic Klan Boom. Using dolls, drawings, photographs, and sculptural tableaux, he probes the evil of racism, the most difficult element of his background, exploring the pageantry and brotherhood of the Ku Klux Klan. Christenberry says this project "is a risky business. Not in terms of physical danger, but in terms of bringing it all together and giving the right message. There is a thin line between beauty and evil. "

The artistic vision of William Christenberry is most eloquent when seen in its entirety.

Christenberry has received numerous honors and awards, including a Guggenheim Memorial Fellowship, a National Endowment for the Arts Individual Artist's Fellowship, and a Lyndhurst Foundation Prize. His work has been widely exhibited and is included in many important museums and private collections.

Trudy Wilner Stack,
*Curator of Exhibitions and Collections
at the Center for Creative Photography,
University of Arizona*

Nall - *"Portrait of William Christenberry"*
1999 - 91,5cm x 76,2cm x 12cm mixed media ▷

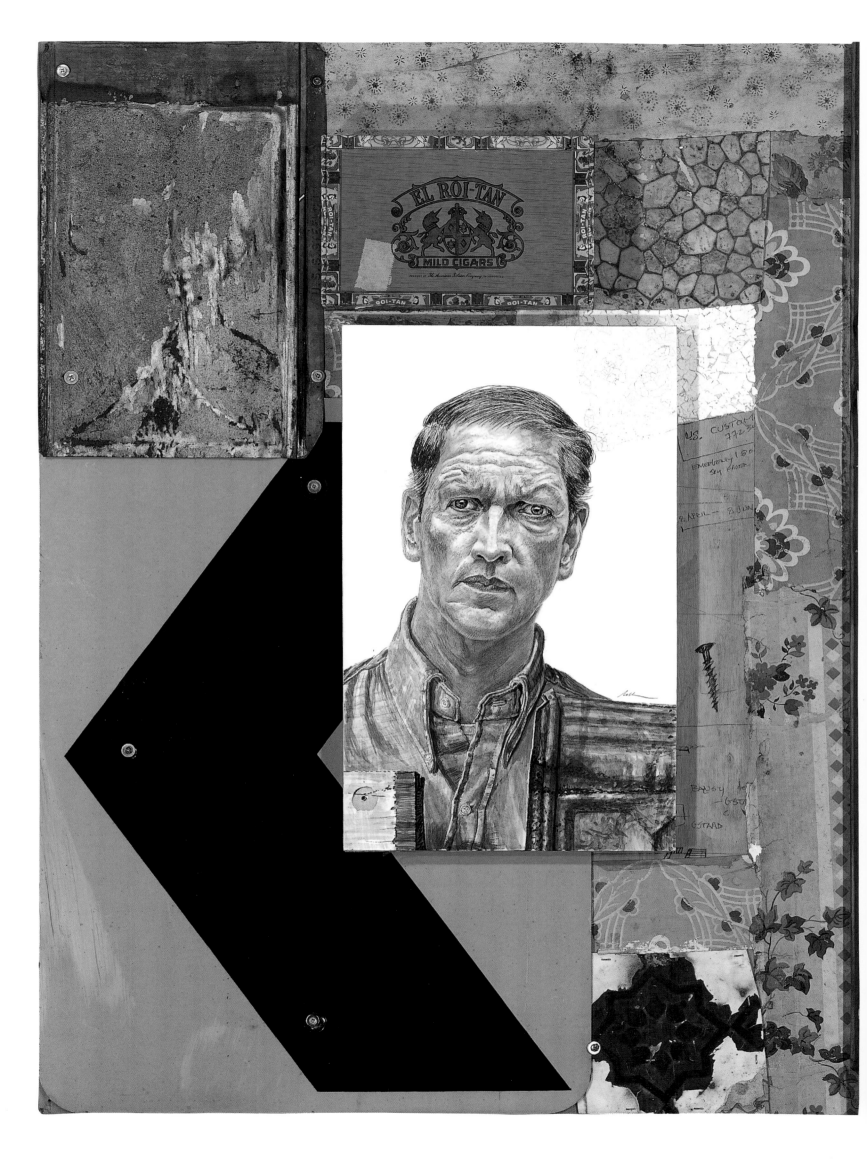

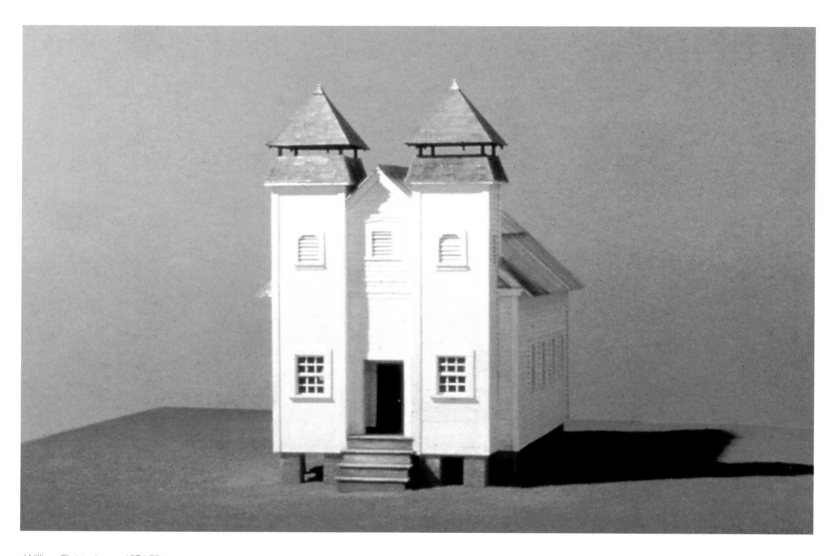

William Christenberry -1974-75
Installation - "*Sprott Church*"
Mixed media with red soil
Building - 24"x17"x30"

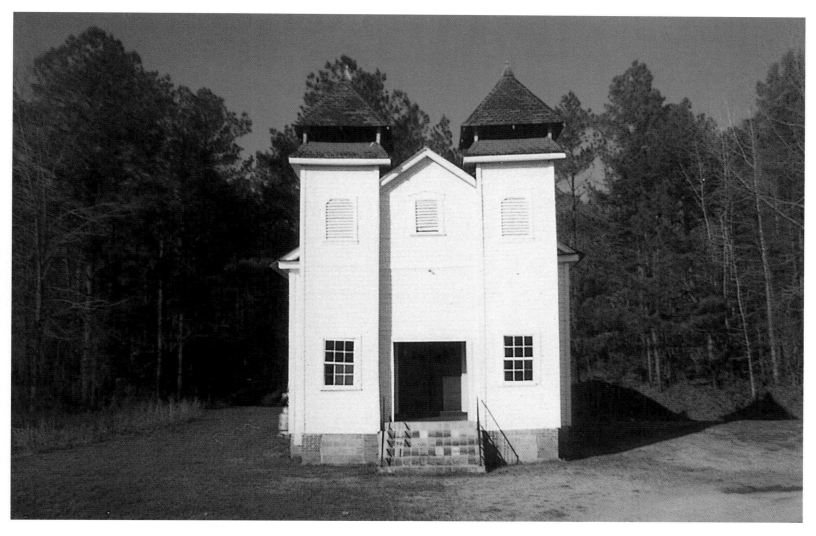

William Christenberry - 1971
"Church" Sprott, Alabama

William Christenberry - 1996
Drawing "K House"

William Christenberry -1994
"Dream Building XVII"
Installation with red soil
49"x23"x28"

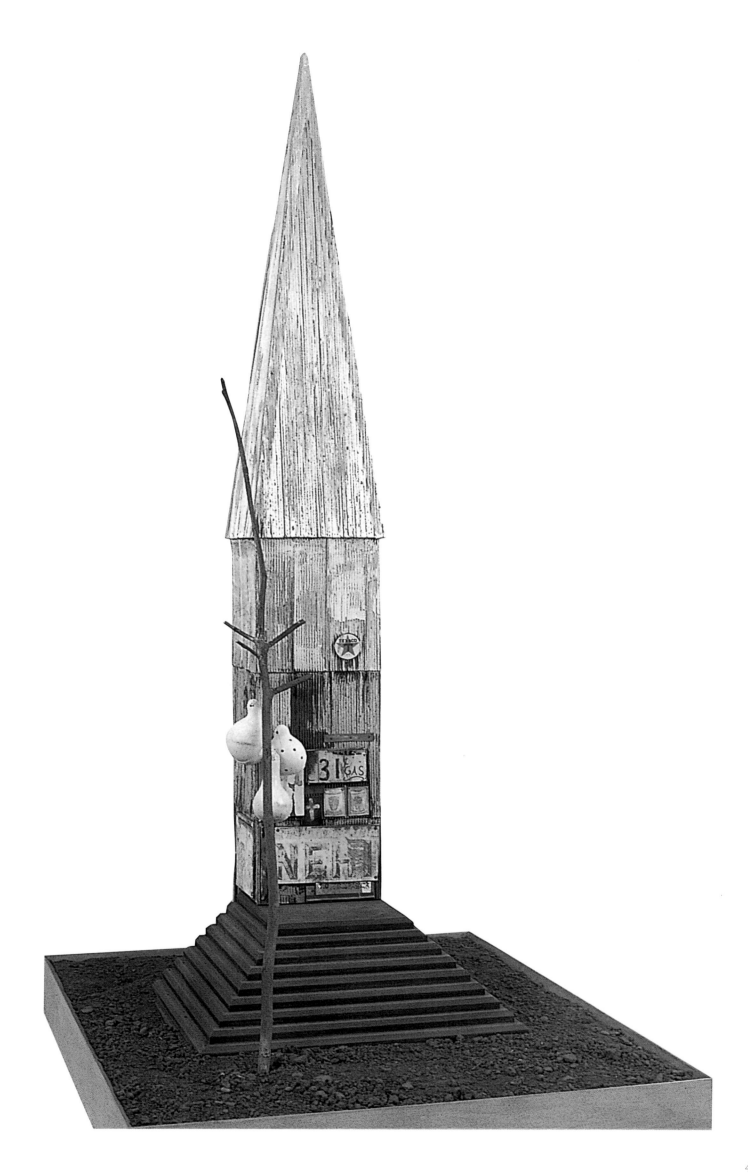

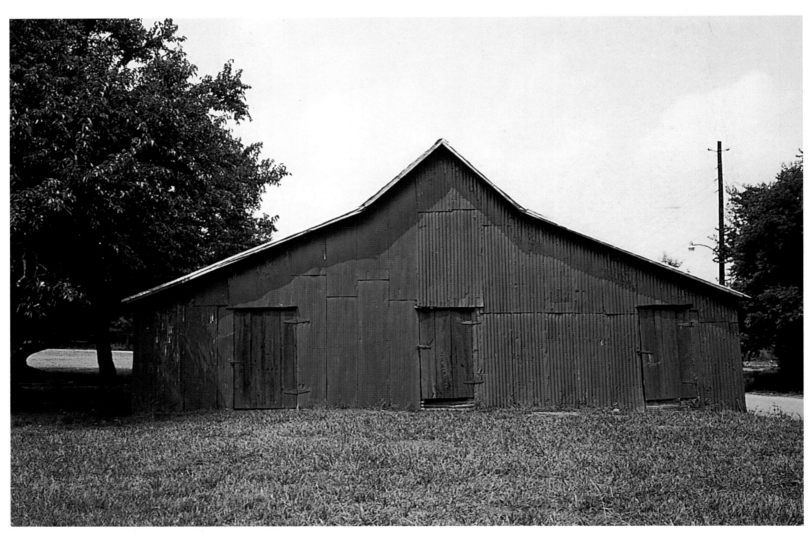

William Christenberry - 1978
"Green Warehouse" - Newbern, Alabama

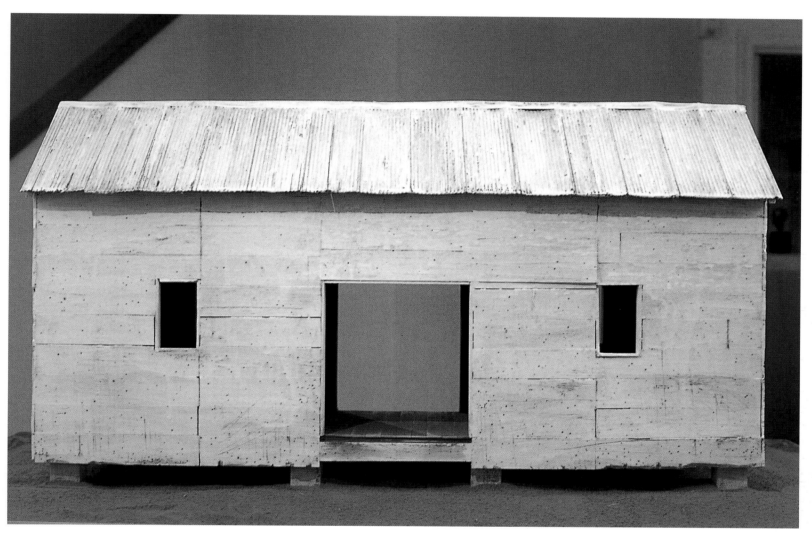

William Christenberry - 1994
"Ghost Form" Installation

Jimmy Lee Sudduth

PAINTER
(BORN MARCH 10, 1910, FAYETTE, ALABAMA)

I first saw Jimmy Lee Sudduth's work after a rainy day, leaning against a pickup truck parked in the mud under a tree at the Kentuck outdoor art exhibit, Tuscaloosa, Alabama in 1977. Mud in a ditch, mud on a painting. How natural, authentic, and brilliant. His images were raw and simple, like the familiar red clay of Alabama, and they touched my soul. I didn't know it then, but I had just been hooked on "Outsider" art. His work continues to compel me to admire the Native Americans' and African Americans' vital role in shaping the United States. Each of his paintings is about love and things close to home.

<div align="right">Nall</div>

Jimmy Lee Sudduth creates his paintings on plywood boards at his small home in Fayette, Alabama. He taught himself to use such materials for "paint" as mud, plants (turnip greens, watermelon vine, and berries), sugar, coffee grounds, and tobacco. In recent years he has also used house paint for color, with occasional touches of glitter. What began as personal expression when he started "drawing me pictures when I was three years old" is now sought by the world of museums, collectors, and galleries. His unique approach to both life and art has been featured at the Smithsonian Institution's 1976 Bicentennial Festival of American Folklife in Washington, D. C., on a 1980 segment of NBC's Today show, and in many major museum exhibitions.

Jimmy Lee generally blocks in his paintings on plywood with a "dye-rock" or with a pencil. Then he dips his finger into a bucket of mud mixture and begins to fill in the shapes. Watching him work is to watch the joy of creation and the certainty of skill. Bold, fluid movements create the form of an animal or a woman or a log house. His delight with both the process and the resulting picture is evident. "Look at that," he will say, or, "Hot dog!" He may be moved to pull out his harmonica for a burst of traditional blues. "I got

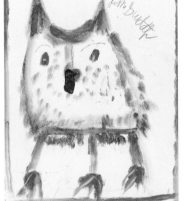

"Toto" mud on paper - 1999 - 31ᶜᵐ x 24ᶜᵐ

people coming to see me from New York and California—from the end of the world". And then he draws his signature as though it were also a painting. "You go up like this and back down. "

An African-American still painting at age 89, Sudduth's works have been collected since his first public exhibition at the Fayette Art Museum in 1971. In the past few years his health and energy have waned, but he remains a prolific artist, encouraged by a stream of visitors. He has painted seated Indians, innumerable self-portraits, and many renditions of his dog, Toto. The encouragement of collectors and dealers also includes suggestions about subject matter, giving a rise to a series of erotic female figures.

Sudduth received an award recognizing his artistic achievement at the 1995 black-tie gala of the Society for the Fine Arts of the College of Arts and Sciences at the University of Alabama. It was given because he "has contributed substantially to an important movement in late-twentieth-century American art" and because he "has brought many Americans a refreshing perspective on Southern life and creativity. "

More simply: Jimmie Lee has loved life and has shared that love and joy with us all.

<div align="right">

Georgine Clarke
Alabama State Council on the Arts
Creator of Kentuck Art Festival

</div>

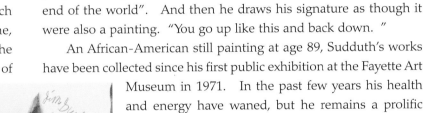

Nall and JLS - *"Portrait of Jimmy Lee Sudduth"*
1999 - 121,8ᶜᵐ x 87,5ᶜᵐ x 3ᶜᵐ mixed media

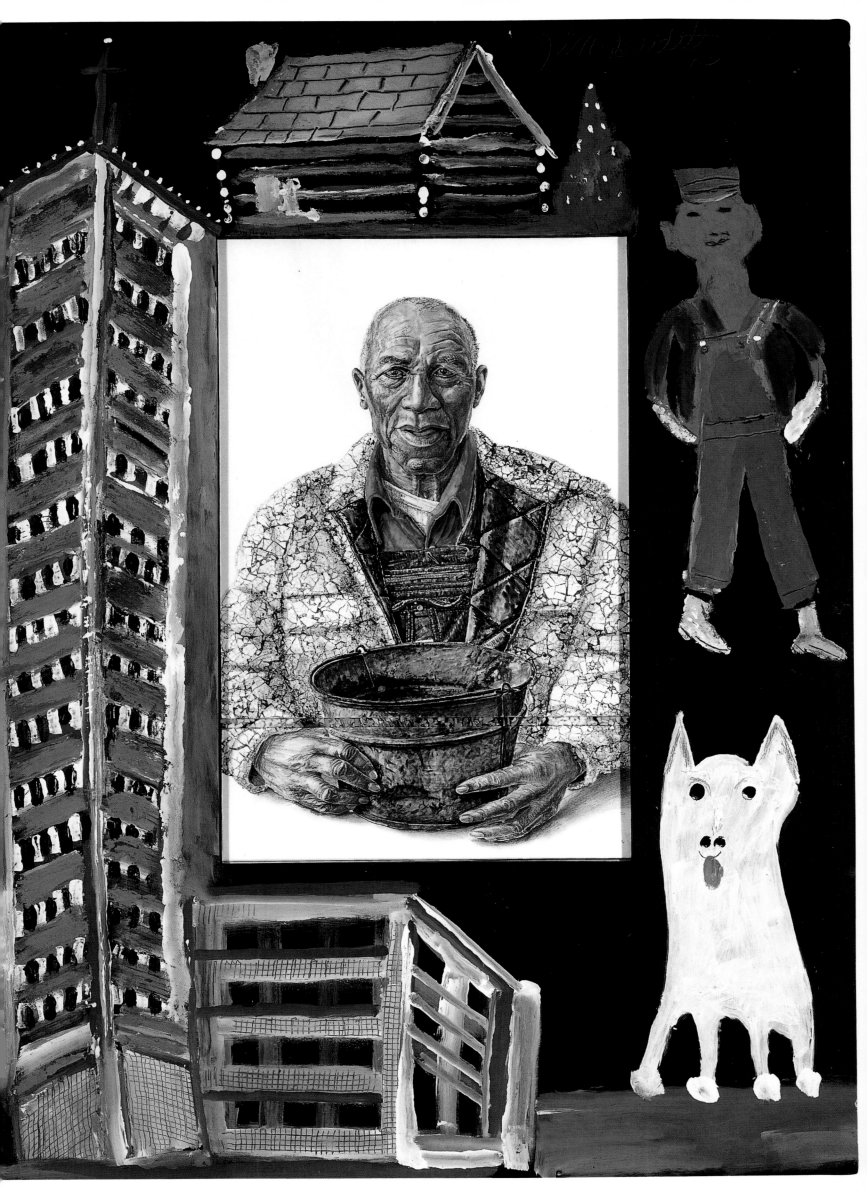

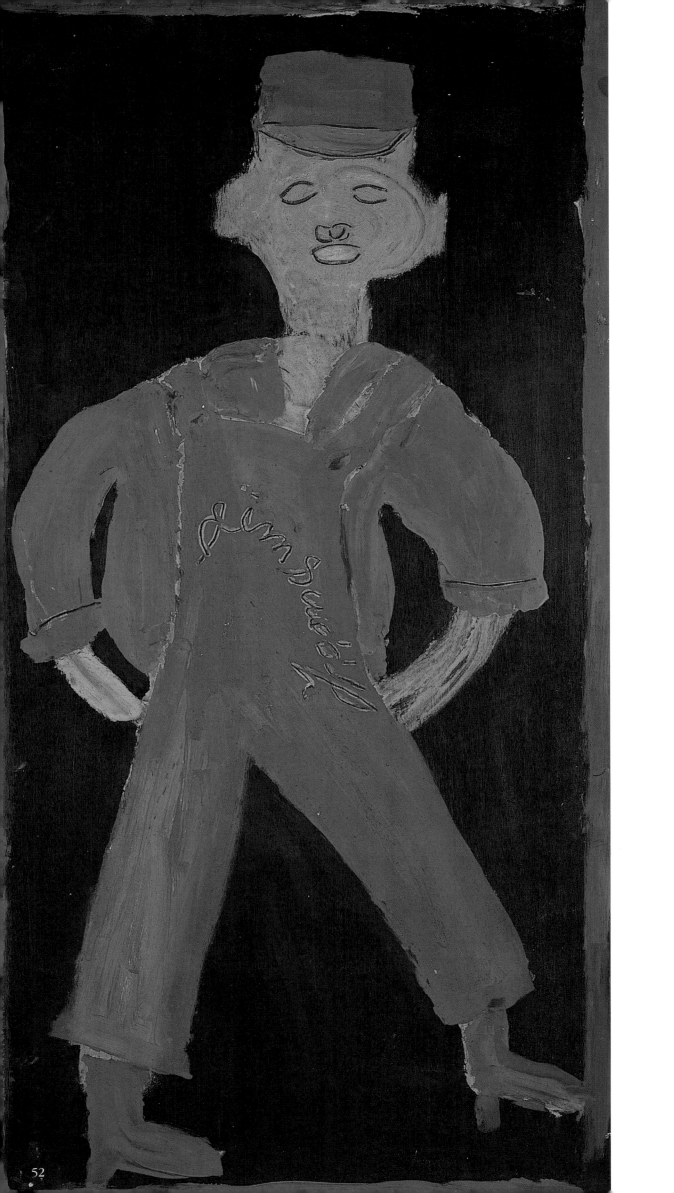

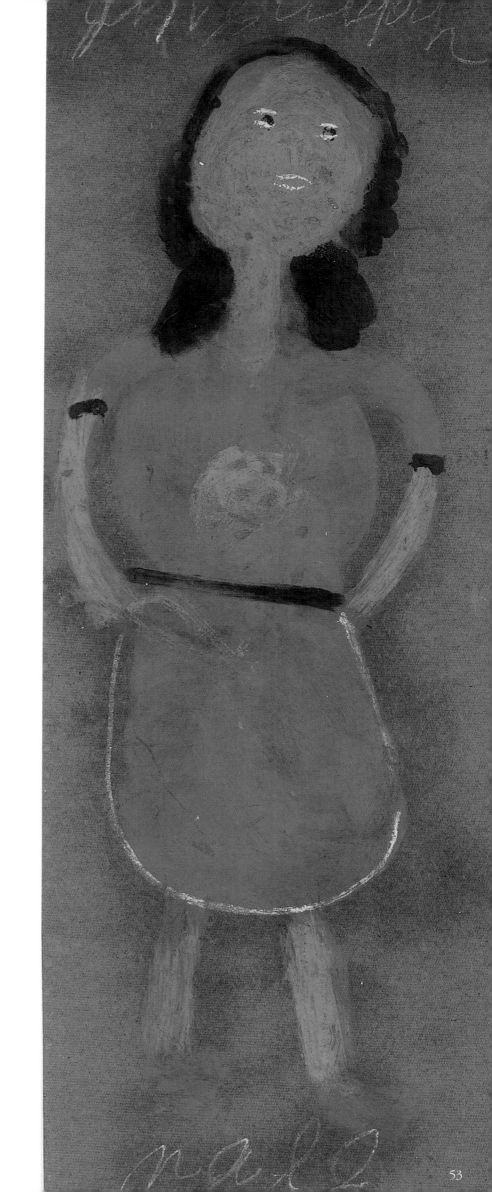

Jimmy Lee Sudduth " *Self portrait*"
1999 - mud, housepaint, pencil on plywood
122cm x 93cm

Jimmy Lee Sudduth - *"Cook"*
1977 - mud and chalk on plywood
102cm x 39cm

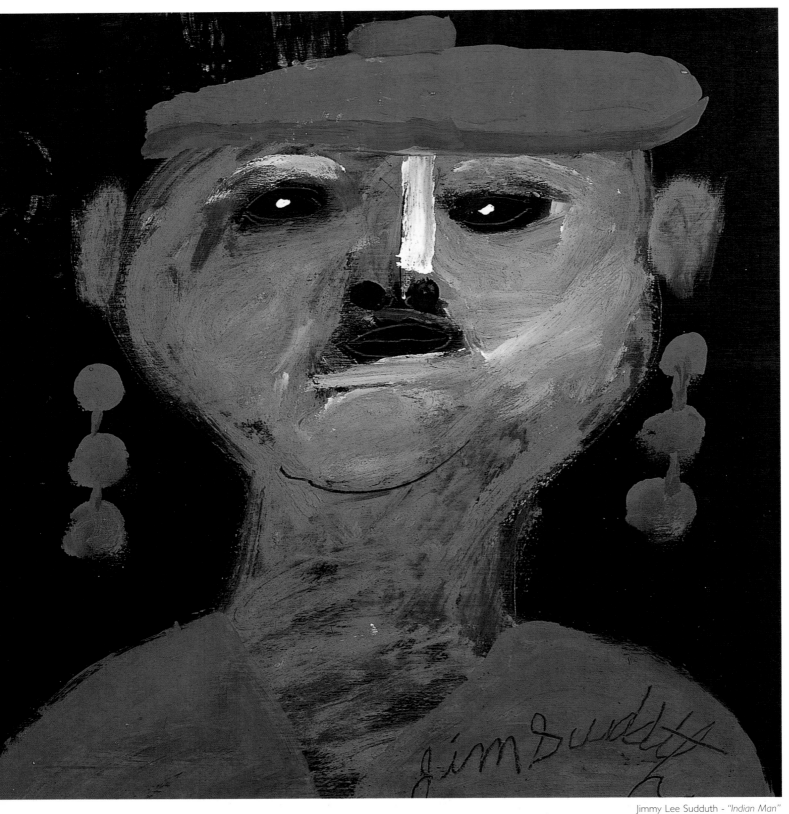

Jimmy Lee Sudduth - *"Indian Man"*
1999 - mud, acrylic, pencil on plywood
60cm x 60cm

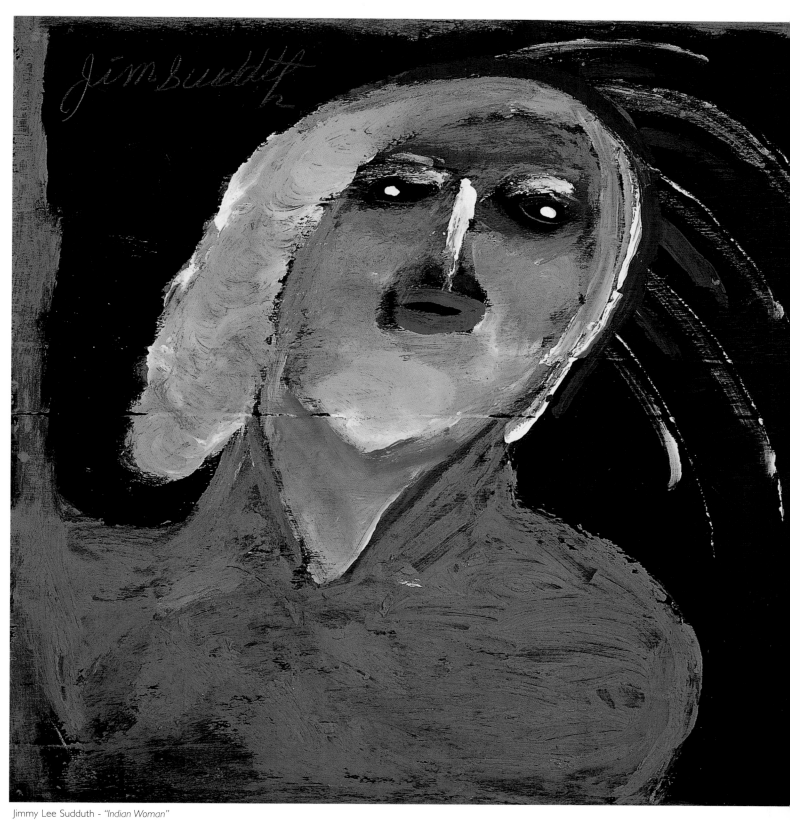

Jimmy Lee Sudduth - *"Indian Woman"*
1999 - mud, acrylic, pencil on plywood
60cm x 60cm

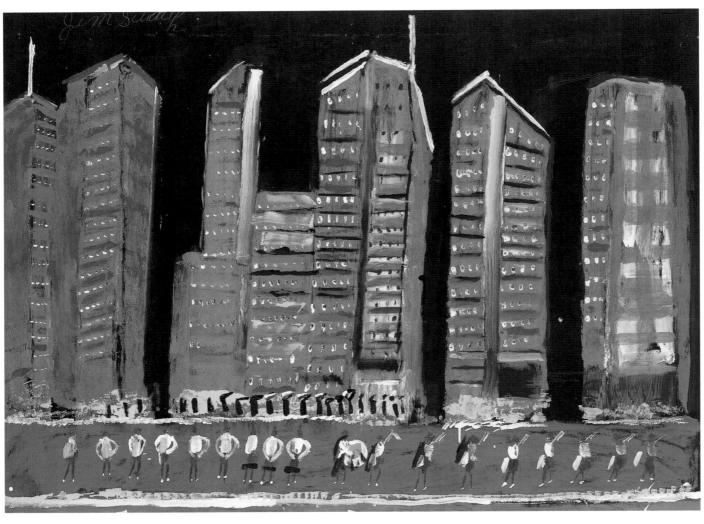

Jimmy Lee Sudduth - *"Cityscape"*
1999 - mud, acrylic, pencil on plywood
93cm x 122cm

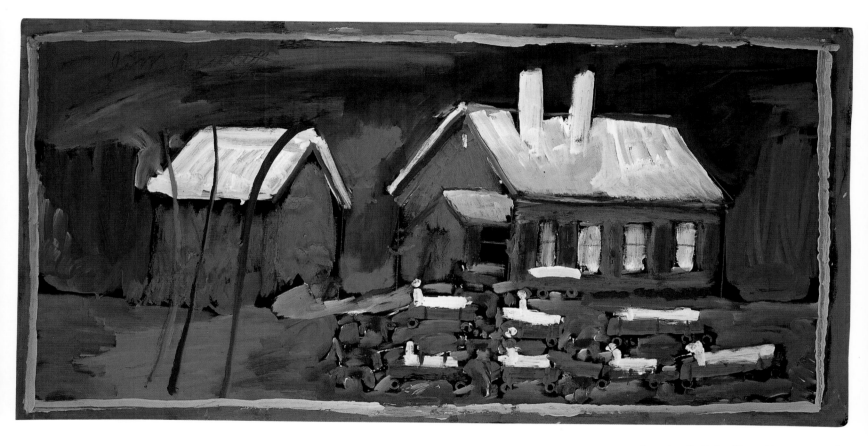

Jimmy Lee Sudduth - *"Farm with cotton wagons"*
1999 - mud, acrylic, pencil on plywood
61^{cm} x 122^{cm}

Charlie Lucas

SCULPTOR AND PAINTER
(BORN OCTOBER 12, 1951, IN ALABAMA)

Charlie Lucas's sculptures are like kudzu; they remold the silhouette of an object, casting it in a different light. His subjects are the African mask, the slave; chains from the past and to the industrial future. His totemlike figures trace Alabama's Indian culture through the blood-baths and bloodstreams, wrought and welded in iron and steel. His junkyard complex, comprising acres of rusting machine bits, sculptures, and the occasional grazing cow, is as terrifying as it is beautiful, and reminds us what happens to man and his inventions when nature has "had enough". In Lucas' case, it is just this isolation in nature that softens his work and teases us with its simplicity.

Nall

Charlie Lucas is a self-taught artist. He uses bicycle wheels, shovels, car mufflers, tractor seats, wire, and gears to create his sculptures, which become figures that stand like sentinels on his land in Pink Lily, Alabama. Formal art definitions have given his works names ranging from "scrap-metal sculpture" to "constructed assemblage". But their success is completely apart from the formal designation. It comes, rather, from the spirit, vision, and creative genius of the artist who made them, who saw that face smiling in the hood of a junked truck, that man's torso in a car muffler, and that camel when five railroad spikes were weld-ed together.

Using scrap materials and objects other people have thrown away is a most important part of Charlie's work. He sees the process as giving them a new life and new meaning. He believes they are recycled just like he has been recycled: following a disabling back injury in 1984, he credits God with opening his mind, slowing him down, and giving him a unique talent. From that time he began creating large pieces by welding found materials and adding details with a cutting torch.

His dream is not to sell art, only to be able to continue creating his environment of sculpture on his land. He wants to develop a kind of park where children and their families can come together; he knows how to inspire children, to encourage their efforts and to teach values.

Charlie Lucas' Studio - Prattville, Alabama - Photo Nall

Alabama art often reflects a love of telling stories, following a narrative tradition. Lucas makes sculpture that tells stories, in form and often in title. These pieces are based on his experiences, observations, and gentle wisdom. A sculpture with figures facing in opposite directions, bound together and yet moving apart, is titled: *"Mother and Father Raising the Kids"* and *"As They Was Raised Up They Went Out"* with *"Speaks a Different Language"*. All parents know the universal meaning and deep insight in that very personal story.

Lucas also pays homage to family and to his ancestry in his work. As a child he watched his great-grandfather, a blacksmith. His sculpture *"The Little Blacksmith: His Hands Was Gentle as a Surgeon"* honors that heritage. His grandfather wove baskets, and the inter-twined metal bands in Charlie's work reflect that tradition. He says, "I give the old ancestors the respect for what I learned from them. "

Charlie Lucas gives us art with many levels of meaning. The visual impact and sculptural line are elegant. From the time he was a child creating his own toys out of scraps of metal, he has been making gentle pieces with powerful messages, full of wisdom and delight.

Georgine Clarke
Visual Arts Program Manager
Alabama Council on the Arts

Nall and Charlie Lucas - "The Tin Man"
1999 - 133ᶜᵐ x 113ᶜᵐ x 10ᶜᵐ mixed media

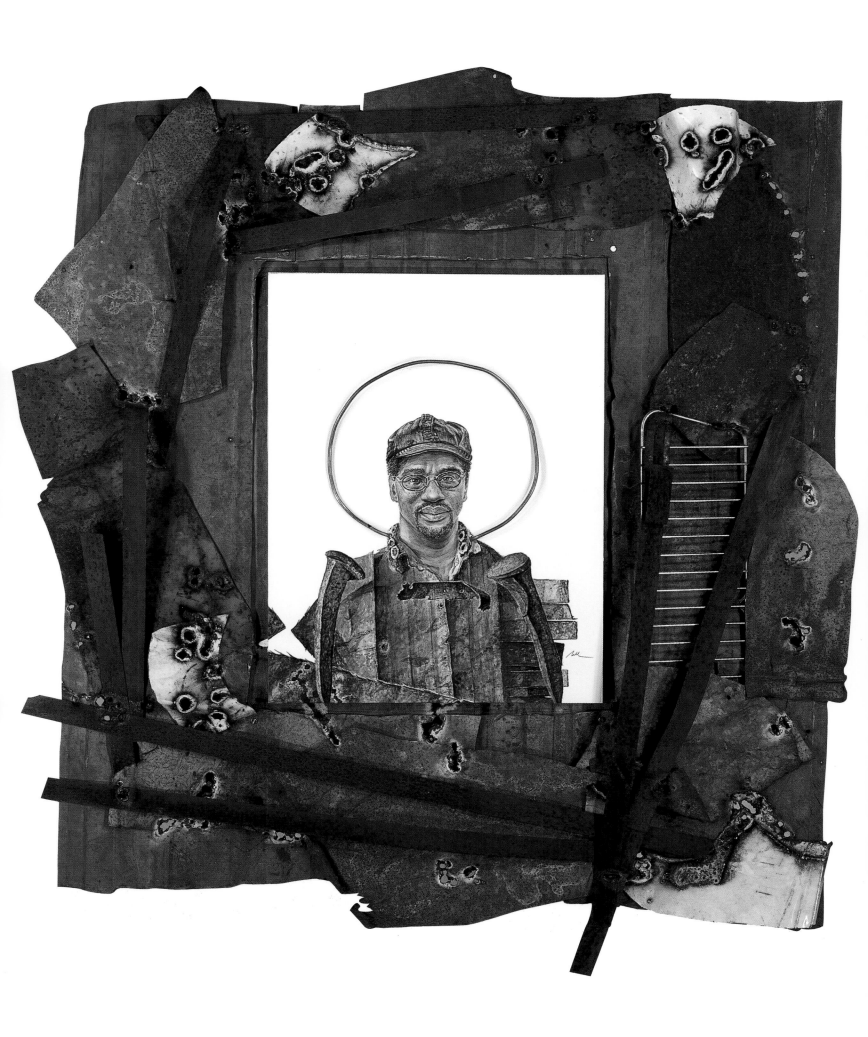

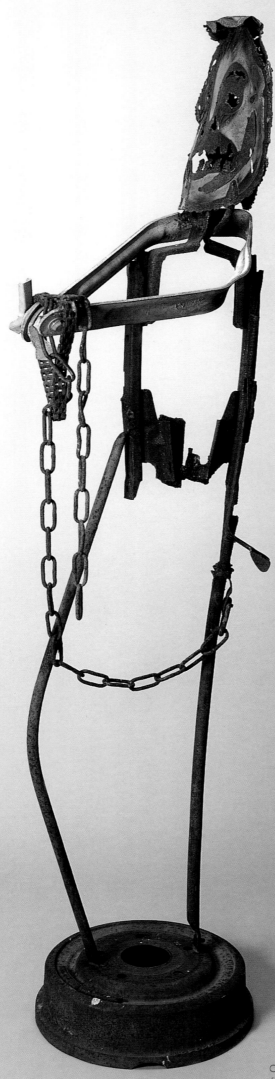

Charlie Lucas - *"I am a chained man"*
60"x22"x13" mixed media

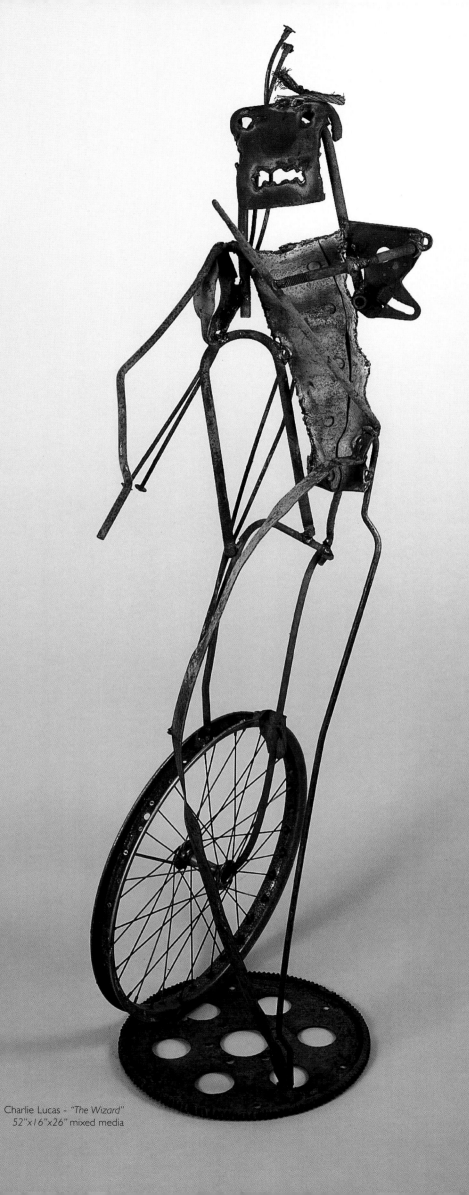

Charlie Lucas - *"The Wizard"*
52"x16"x26" mixed media

Charlie Lucas - Spray paint, House paint on plywood

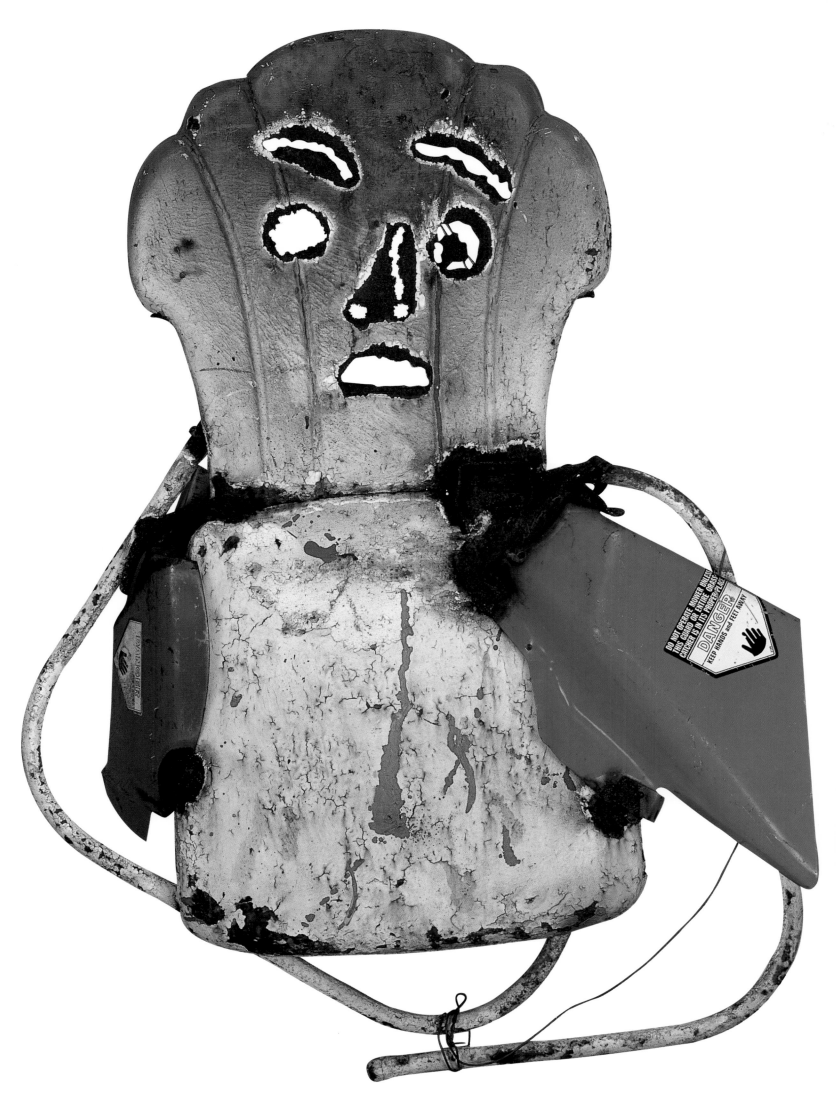

Charlie Lucas
1997 - "Cinderella meets Little Red Riding Hood"

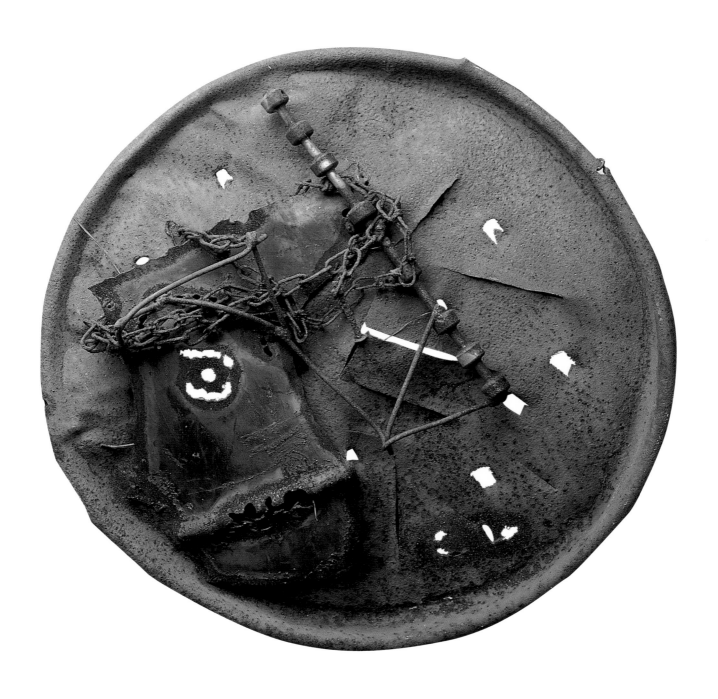

△ Charlie Lucas - *"Change Your Mind"*
23"x23"x7" mixed media

Charlie Lucas - *"Burning Force"* ▷
55"x21"x6" mixed media

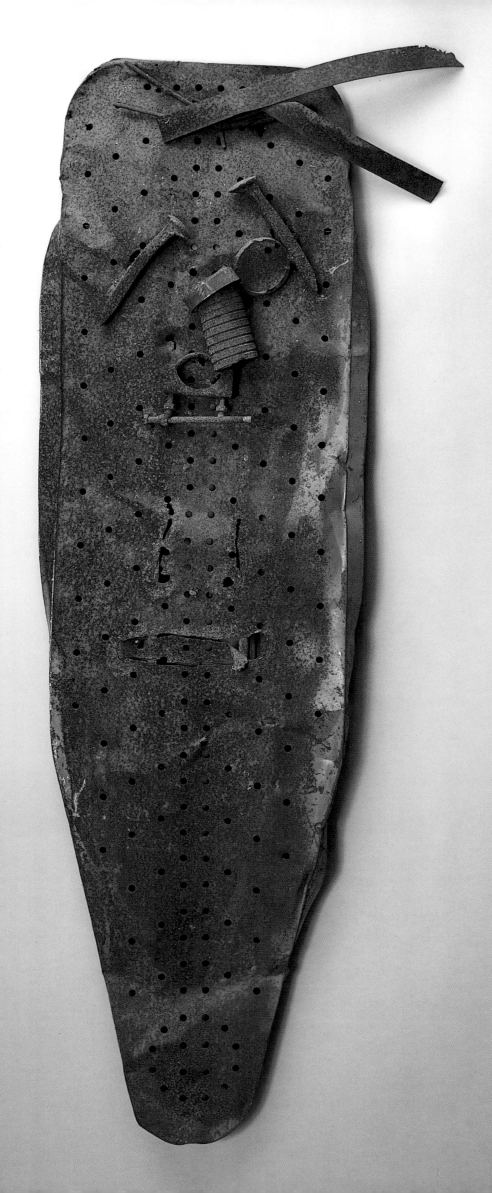

Yvonne Wells

QUILTER
(BORN IN TUSCALOOSA, ALABAMA)

The patchwork quilt has long been synonomous with "Southern heritage," or scraping together an artistic bent, just to keep warm. Yvonne Wells takes it miles further and defines the quilt as contemporary art. As a law-abiding physical education instructor, her artistic soul delivers the social punch of Angela Davis. While treating us to an unusual and colorful palette, she rips and tears away the docile mask the African-American has been forced to wear for hundreds of years, and throws the quilt as a blanket of roses on the coffin of her past.

Nall

As a child, Yvonne Wells watched her mother cut and sew old clothes and other fabrics into quilts for daily use. In 1979 she made her first quilt, a simple block design, out of the necessity of keeping warm by the fireplace while her house was being renovated. She didn't take a class. She just did it, and with that simple coverlet she embarked on a journey of discovery that has led to her international recognition as an artist.

Yvonne does not make traditional patterned quilts. Although she has chosen to use primarily fabric as her medium, she uses long, free stitching, and is more concerned with artistry, design, and message in the creation of her art than with sewing technique. Each piece is sewn by hand using a wide range of fabric and other materials: buttons, zippers, tape measures, and flags. She searches fabric stores, flea markets, and trash piles for materials, and she has been known to barter with a student for the shirt he was wearing, because it had a particular design she needed for a current piece.

Yvonne's hand-stitched fabric constructions use rich symbolism and vivid

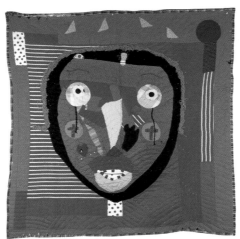
Yvonne Wells - *"Me Mask I"* Quilt

colors to tell stories and to offer succinct comments on social and political issues. Her works require patient, sensitive viewing and often a contemporary historical framework for complete understanding. Her reflections on civil rights history in the South include such pieces as "Attitude Adjustment", depicting the struggle to remove the Confederate battle flag flying over the Alabama

capital building; "Nor Iron Bars a Cage" and "Portrait of a King", each telling part of the story of the life of Rev. Martin Luther King, Jr. ; and "Feeding Time", white hands holding a black child above the mouth of a crocodile. Her pictures include symbolic images of lynching, of four girls killed in a church bombing, and of vicious dogs attacking marchers.

Yet these harsh statements are more than balanced by Yvonne's positive outlook, humor, and gentle observations. Other themes show children playing, baseball games, and Elvis. Each quilt is marked by at least one triangular piece of fabric sewn into the border. These she calls her "friends," and they represent the Trinity and her very strong faith. Purple fabric represents Christ. Yellow fabrics are very obvious, often depicting the sun and always representing hope. Braided white and black yarn depicts unity of the races. Flowers and butterflies often float across the surface of her pieces, and bright green seems to be new grass.

Yvonne Wells has found that fabrics are perfect materials and allow her the freedom to express many ideas. Her quilts have no consistent size, and some even appear to have an afterthought bulge on one edge. All her choices are made because, as she says, "It fits. "Her work is very definitely about the South, but more importantly about her life, her experiences, and her soul. She has shown us a fresh approach and a new vision.

Georgine Clarke
Visual Arts Program Manager
Alabama State Council on the Arts

Nall and Yvonne Wells - *"Portrait of Yvonne Wells"* ▷
1999 - 65" x 48" mixed media

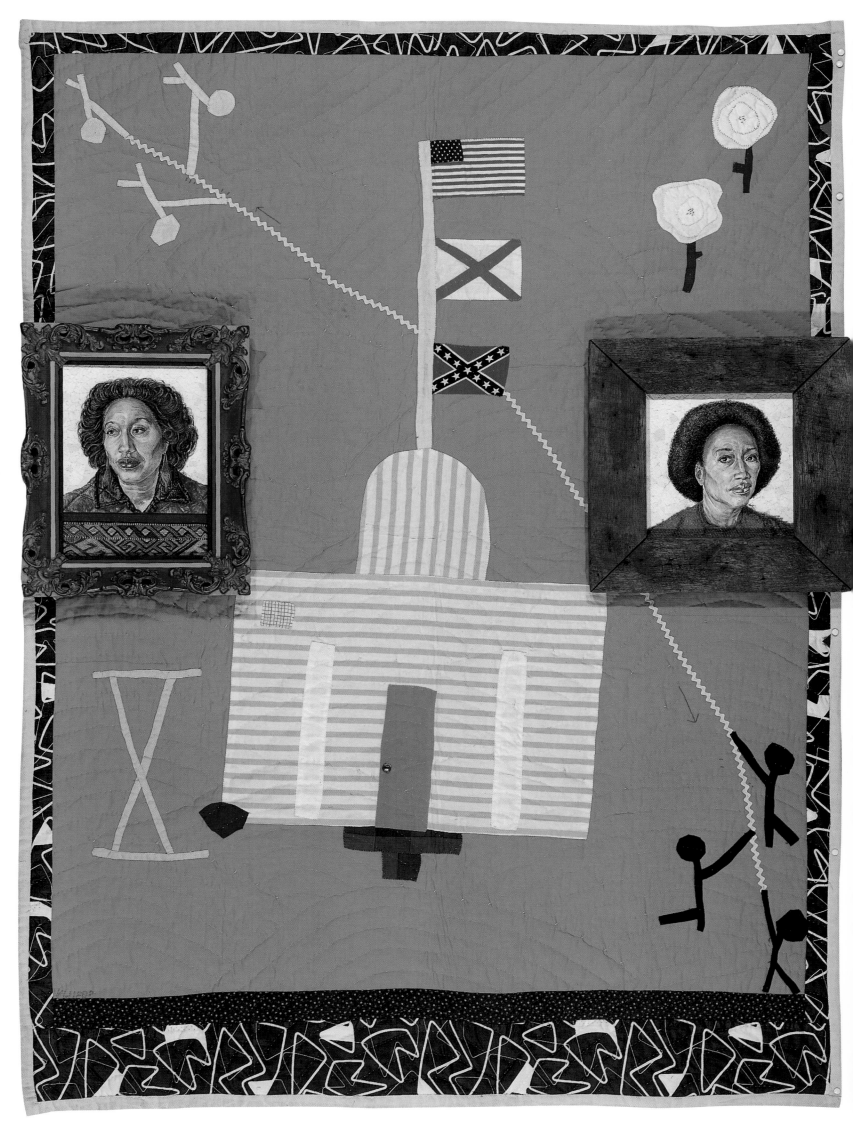

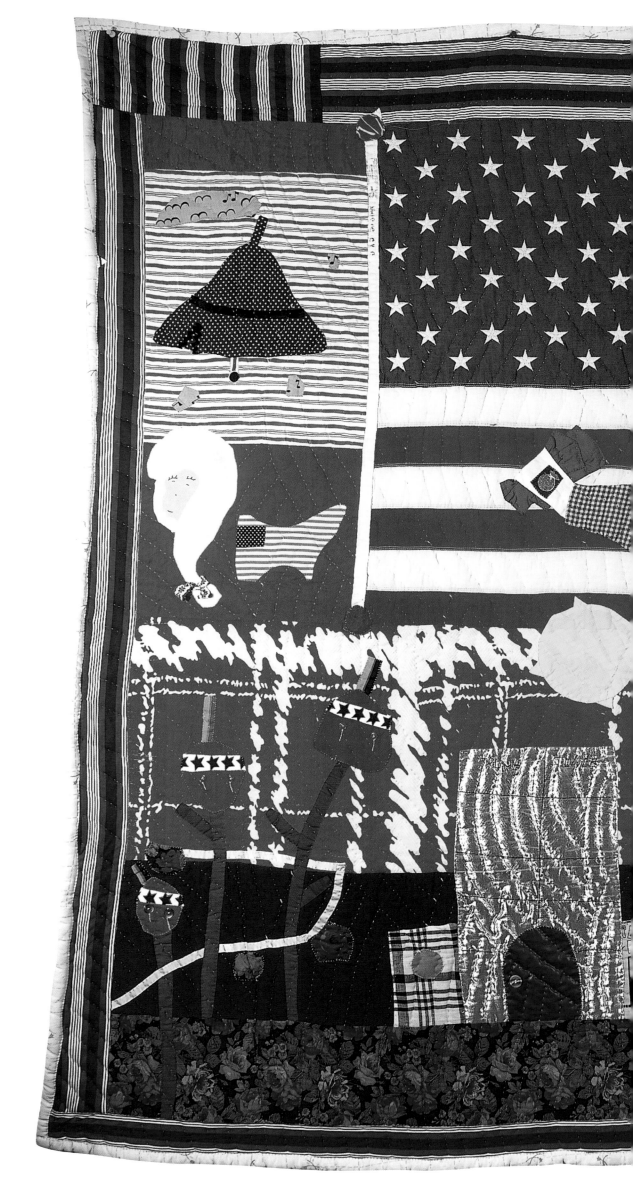

Yvonne Wells - "B.I.T.C.H."
(Being In Total Control of Herself)
1990 - Quilt - 71"x80"
(Corduroy, buttons, earrings, nite gown,
cotton and cotton blend, rick rack, felt)

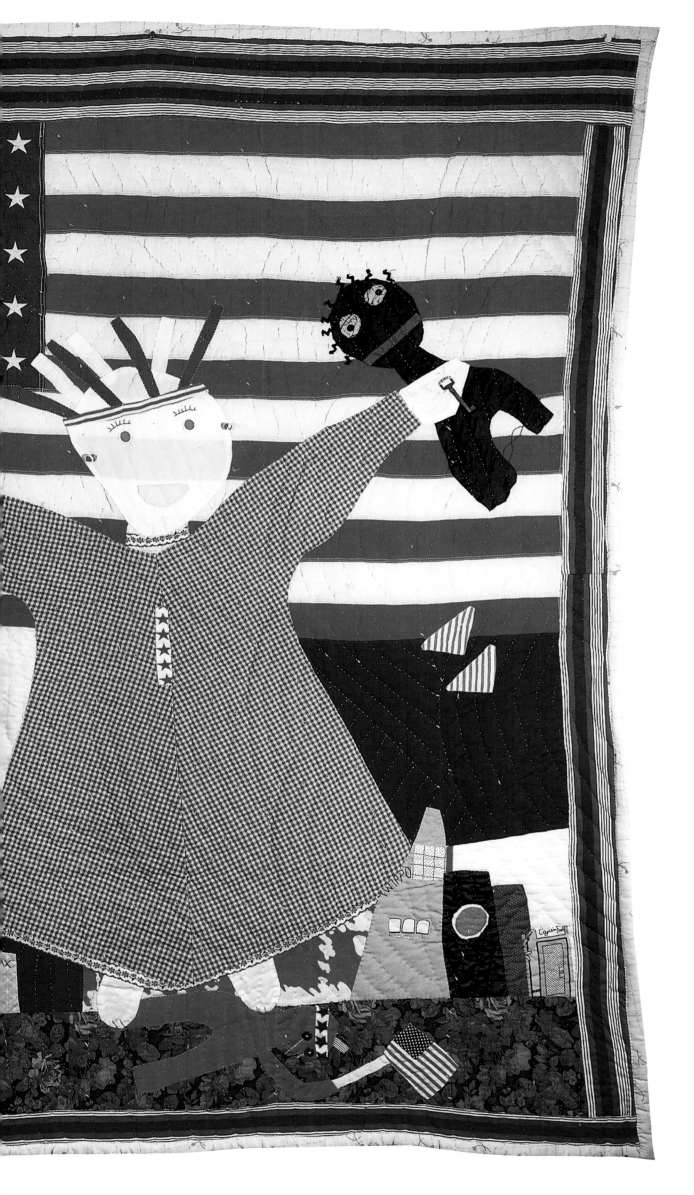

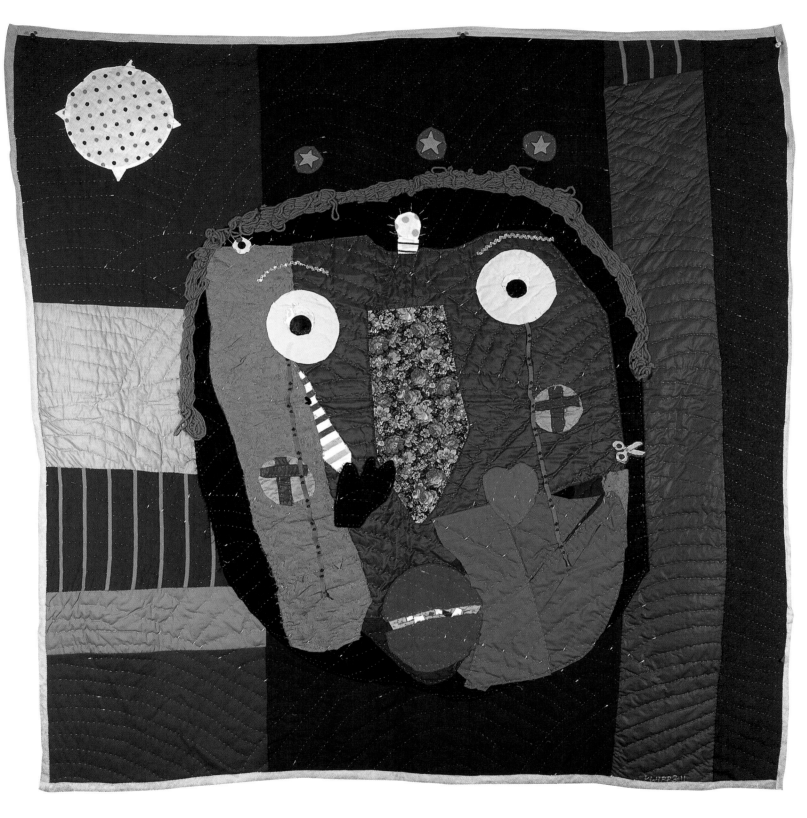

Yvonne Wells - *"Me Mask II"* - 1993
Quilt - 60''x58''
(Satin, cotton and cotton blend, shoestring, fabric)

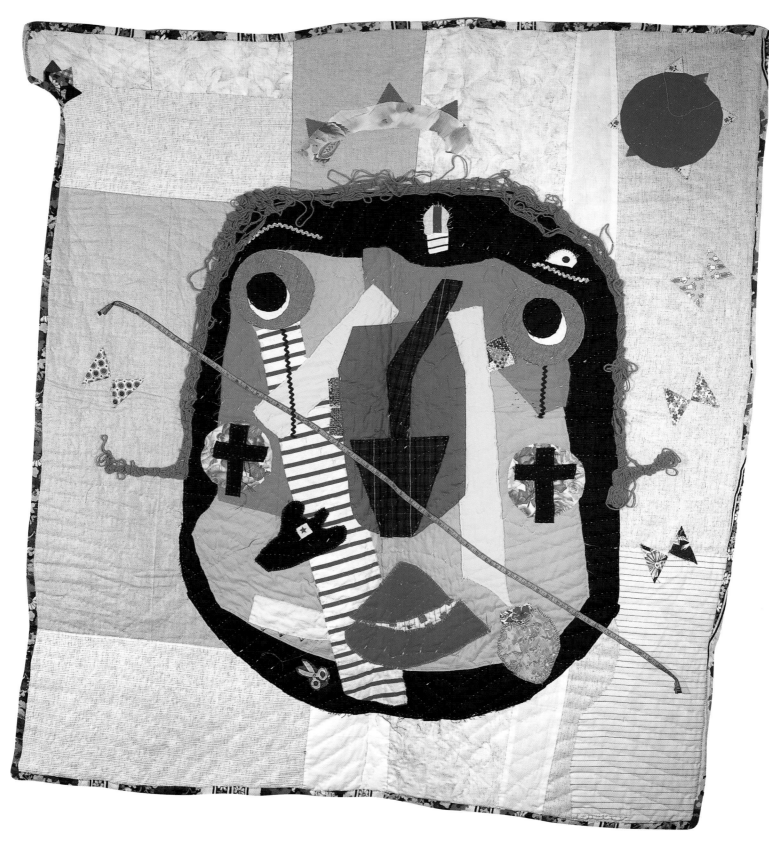

Yvonne Wells - *"Me Mask III"* - 1993
Quilt - 61"x60"
(Tape, cotton and cotton blend, rick rack)

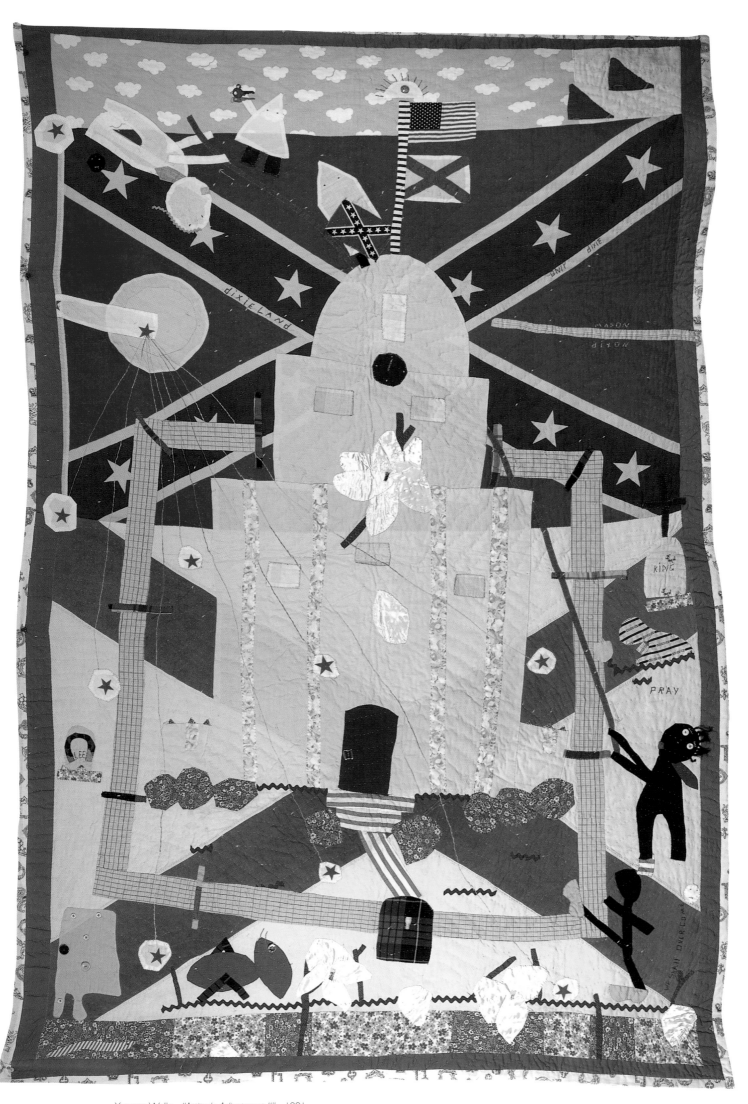

Yvonne Wells - *"Attitude Adjustment II"* - 1991
Quilt - 96"x62"
(Satin, ribbon, cotton and cotton blend, key, rick rack, buttons)

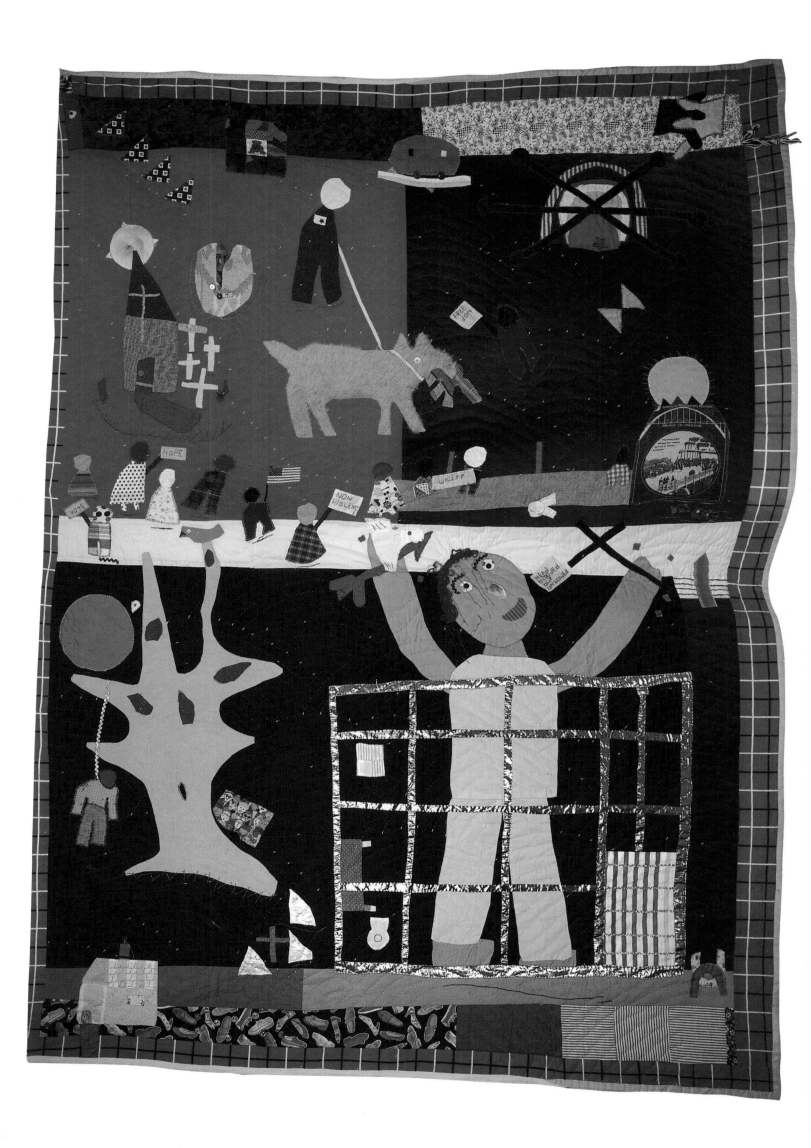

73

Mose Tolliver

PAINTER
(Born July 4, circa 1920, Montgomery, Alabama)

In 1984, having been a friend and collector of Mose T . for many years, I gave him a poster of my work entitled "Southern Belle," which he had thumbtacked in front of his bed. My name was printed in large letters on the poster and later appeared as the title of a series of his works—but misspelled. These portraits were christened as "Noll's" until one of his clients bought the poster and Mose T. found another subject. His colors are Gauguin's, his figures more Paul Klee. But unlike these European magicians, Mose T. has only been influenced by his soul, a genetic memory, and a turbulent past. He has buffered his pain with wine, women and song, and with a tongue-in-cheek mumble-jumble of symbols and colors has delighted and excited his fans.

Nall

The story of Mose Tolliver's development as an artist is now familiar, and parallels many self-taught artists. He was born the twelfth child of sharecropping parents, worked a variety of jobs in the Montgomery area, and was permanently disabled when a load of marble fell from a forklift and crushed his left ankle, damaging muscles in both legs and consigning him to crutches for the rest of his life. His former employer, Raymond McClendon, an amateur painter, took Mose to an art exhibit and encouraged him to take classes and try his hand at painting. Tolliver wisely decided that he did not need any instruction and began teaching himself; much of his life since the late 1960s has been spent painting. His work has met with a wide and appreciative audience, and he still welcomes a steady stream of visitors and collectors to his home.

Tolliver, often called Mose T. , began his career using castoff materials, and continues to prefer them for his work. He paints with house paint on a variety of surfaces: plywood, masonite panels, boxes, pieces of furniture, and other materials brought by friends and collectors. The paintings are usually hung from a soda or beer-can ring, and his frames are painted borders around the edges of his panels.

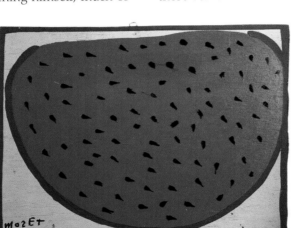

Mose T. - "Watermelon"
1977 - House paint on plywood - 26ᶜᵐ x 36ᶜᵐ

Tolliver's earliest images were of birds, which, along with highly decorative, sensuous plant forms, remain among his most engaging subjects; they also illustrate his style of filling the picture plane. His images, especially flowers, trees, and watermelons, seem to press against the edges of his frame, trying to grow beyond the edges. Because of his disability he paints sitting down, and works from the edge of his bed with the boards or panels on his lap most of the time. This made it necessary for him to paint on smaller boards that can be manipulated from his sitting position. Perhaps his confinement and his physical limitations have influenced the organic, fluid forms that move effortlessly across the panel, ready to burst the boundaries at any moment.

Tolliver paints flat, frontal views of figures against a plain, painted background. His images range from the fanciful to the representational; one finds depictions of George Washington and other recognizable individuals and places. He also has executed a series of self-portraits, his figure usually full-length, with his crutches supporting short, slender legs, and his large head and penetrating almond-shaped eyes dominating the image. There are other self-portraits illustrating only the head with a gaping, screaming mouth, demonic and chilling.

His paintings rarely address sociopolitical concerns, but one cannot look at his buses without remembering the significance of the bus in Montgomery's history. He creates a joyous feeling in these vehicles with their swelling, rounded forms and large wheels, the side wall cut away to reveal the interior. Although the images were painted after the era of the bus boycott, Tolliver intended viewers to remember the role of buses in civil rights. "There was a boycott, so I didn't put people on the buses. But people wouldn't buy my pictures, so I painted people inside the buses. Then they started to sell,"he says this with a laugh, but he expresses the pain of the period and the victory of the moment.

Among his most well-known images are the many variations showing a female figure with legs spread, wrapped up around the sides of her head, astride a phallus, or with some unexplained contraption attached to her genitalia. He takes great delight in these sexual fantasy paintings, enjoying the resulting chuckle or discomfort of the viewer. Tolliver's paintings employ a limited color palette, partly from using materials at hand, but also reflecting his innate sense of color. He layers thin washes of color on his boards, blending shades that unite what may seem improbable combinations: pink, blue, and gray; brown, maroon, and green. The result is sophistication, boldness, and, in the case of many self-portraits, a haunting, ghostly quality imbuing the faces with a power and immediacy that belies their seeming simplicity.

Tolliver is known for his distinctive style, his unique handling of color, and his robust approach to painting. In thirty years he has created a body of work notable for its arresting images and powerful visions.

Gail Trechsel
Director
Birmingham Museum of Art

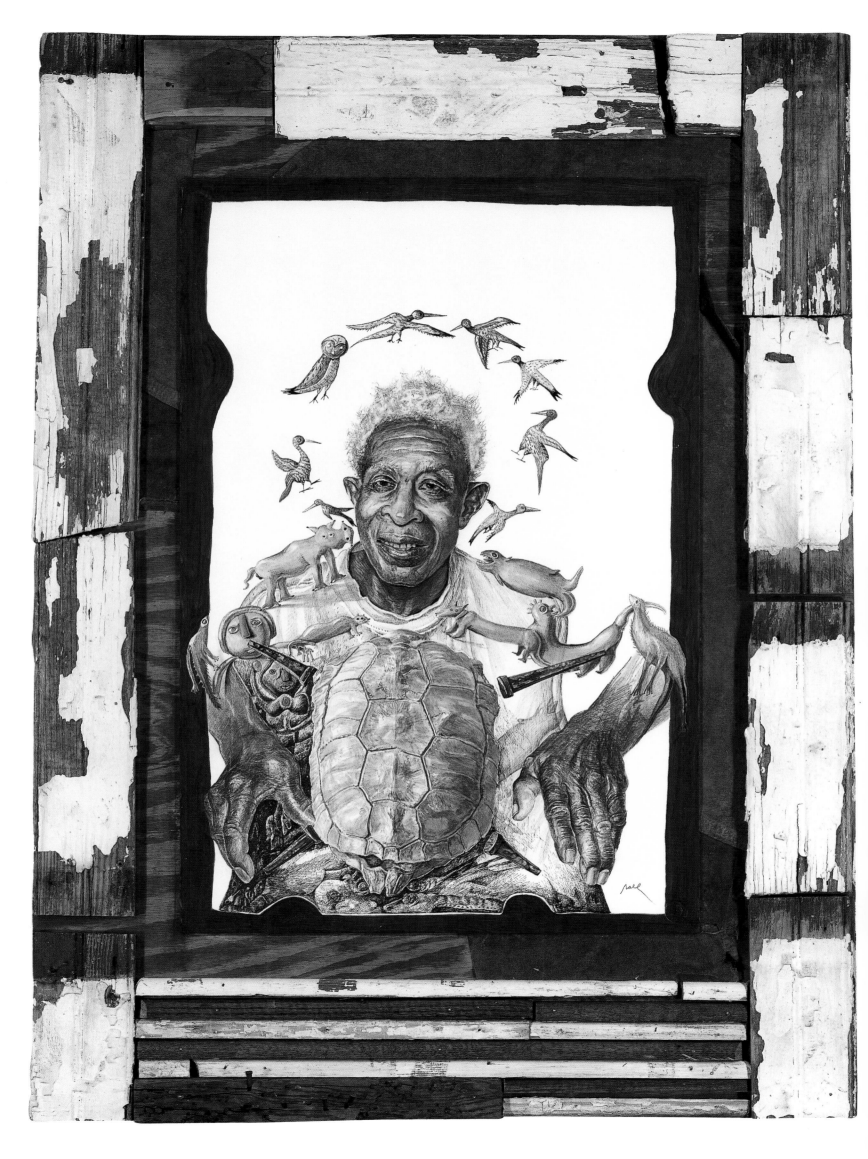

Mose T. - *"Self Portrait"*
1974 - House paint on plywood - 51ᶜᵐ x 39ᶜᵐ

Mose T. - *"Voodoo Woman"*
1972 - House paint on cardboard with masking tape frame - 45cm x 30cm
Collection Randy Trotman

77

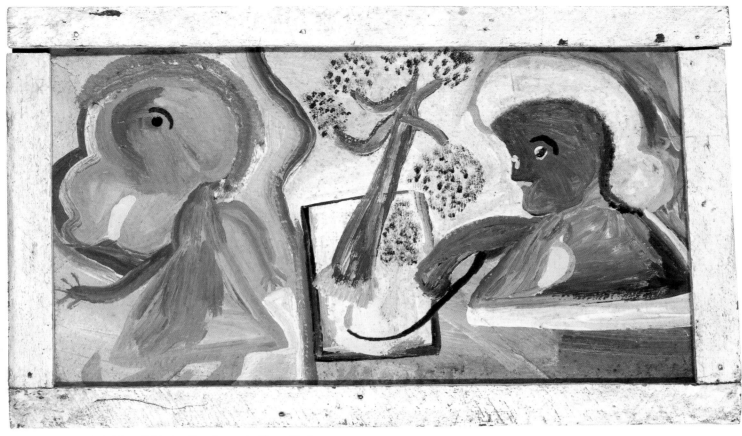

Mose T. - *"George Washinton Whipping Houseboy under Cherry Tree"*
1971 - House paint on masonite panel - 35cm x 58cm
Collection Randy Trotman

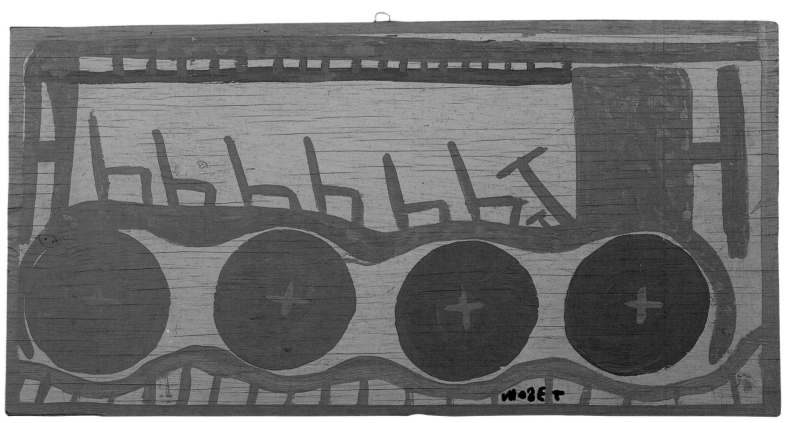

Mose T. - *"Bussing"*
1974 - House paint on plywood
37cm x 73cm

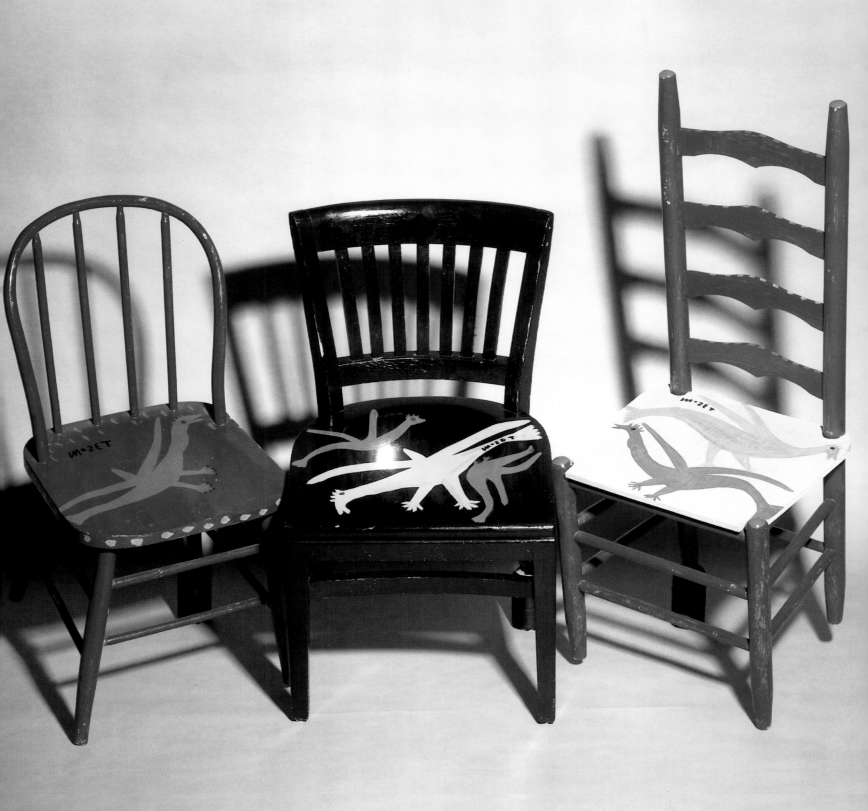

Mose T. - *"Three Chairs"*
1998 - House paint on chairs

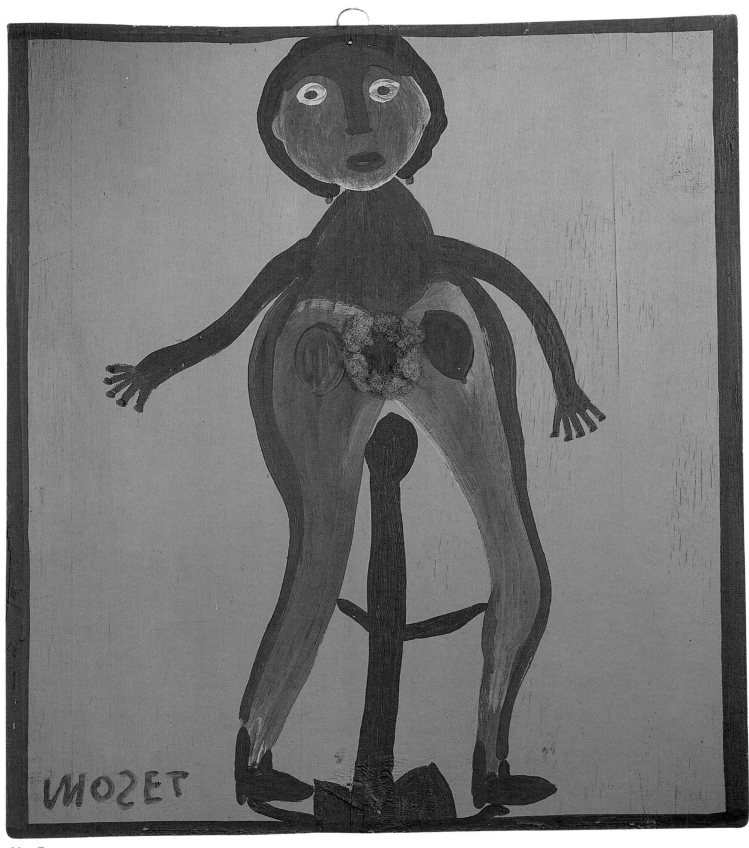

Mose T.
1974 - House paint on plywood
50ᶜᵐ x 44ᶜᵐ

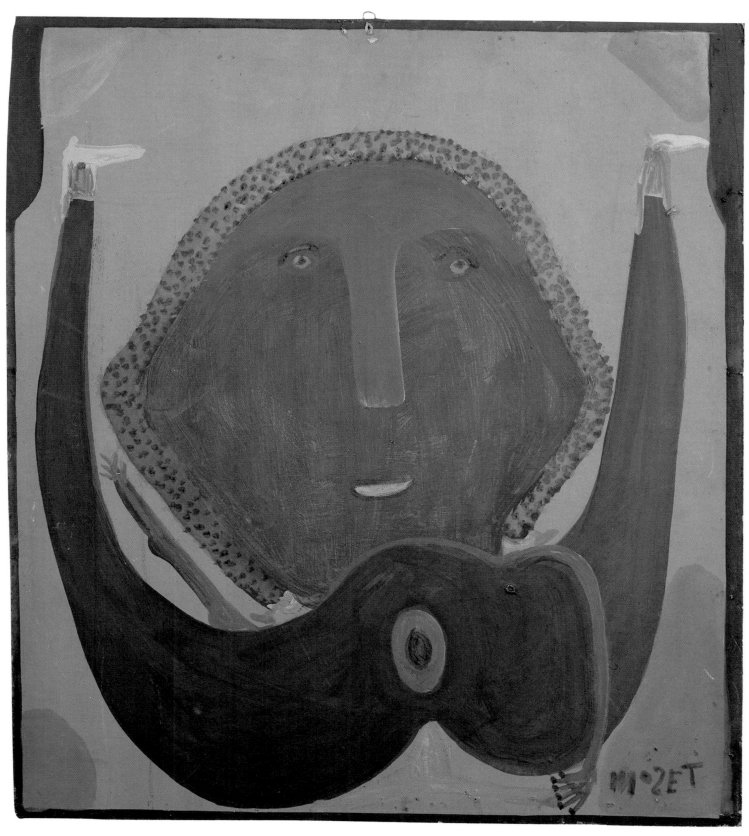

Mose T.
1974 - House paint on plywood
50^{cm} x 44^{cm}

Clifton Pearson

SCULPTOR
(BORN JUNE 24, 1948, BIRMINGHAM, ALABAMA)

Clifton Pearson has revered his past and his passions through Southern stoneware. His glazes are red, white, and black, symbolic of the mixture of the "American race". His own portrait, as beautifully sculpted as the Carpeau "Negress," tops each figure as a testimony to the dignity and morality that African Americans and Native Americans maintain from their cultural roots. Pearson embellishes each "Celebrated Figure" with a sophisticated decoration of scales, tendons, and honeycomb patterns. But the headdress is worn like a crown defying equality and returning us to a tribal system. African influence in all its forms has been feeding American society, nurturing and babysitting her soul.

<div align="right">Nall</div>

Clifton Pearson has spent most of his life in Huntsville, either studying or teaching art. He completed doctorate and master's degrees from Illinois State University. He is currently Artist in Residence at his alma mater, Alabama A&M University, in Normal, where he taught for twenty-five years.

Pearson's ceramic and glass works have been exhibited mostly in the Southeast. His ceramic sculptures are included in several collections including the Illinois State Museum, Springfield; Fisk University, Nashville, Tennessee; Columbus Museum of Art, Columbus, Georgia; and the Huntsville Museum of Art.

Pearson's engaging works occupy an interesting zone between representative and imagined reality. His recent figural sculpture is formally conceived and highly stylized, yet through gesture and attitude he convincingly summons the interior psychology of a real human presence. Details of physiognomy as well as hair, costumes, and jewelry stem from the artist's keen interest in African and other non-Western cultures, yet these elements are rarely literally transcribed. Instead, the works become cross-cultural fusions influenced by Pearson's active, free-

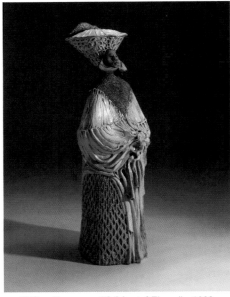

Clifton Pearson - *"Celebrated Figure"* - 1998
Glazed Stoneware - 33" x 8" x 10" mixed media

floating imagination and strong sense of form and design. They are particularly resonant when arranged in groups, where they evoke the haughty dignity of tribal elders gathered for an important ceremonial event.

Pearson's "Celebrated Figures" series features vertically attenuated, emotionally expressive personages ranging in height from approximately two-and-a-half to three feet. Like the Tanagra figurines of ancient Greece, their bodies are enveloped and revealed by layers of heavy drapery that cling, as if wet, to shoulders and folded arms.

Pearson's love of refined texture, clearly inspired by classical African works from Ife and Benin, is allowed full expression here. Throughout the series, the artist sets deep pleats and fluid folds against shallowly incised rib, net, and scale patterns, which in turn gain visual relief from adjacent areas left deliberately smooth.

Textural contrast is further emphasized in the astonishing array of adornments, ranging from chunky outsized earrings, fantastic headpieces, and elaborate hairstyles to a brightly colored raffia boa that enhance and underscore the character of each figure.

<div align="right">

Peter Baldaia
Curator
Huntsville Museum of Art

</div>

<div align="right">

Nall - *"Portrait of Clifton Pearson"*
1999 - 100ᶜᵐ x 80ᶜᵐ x 12ᶜᵐ mixed media ▷

</div>

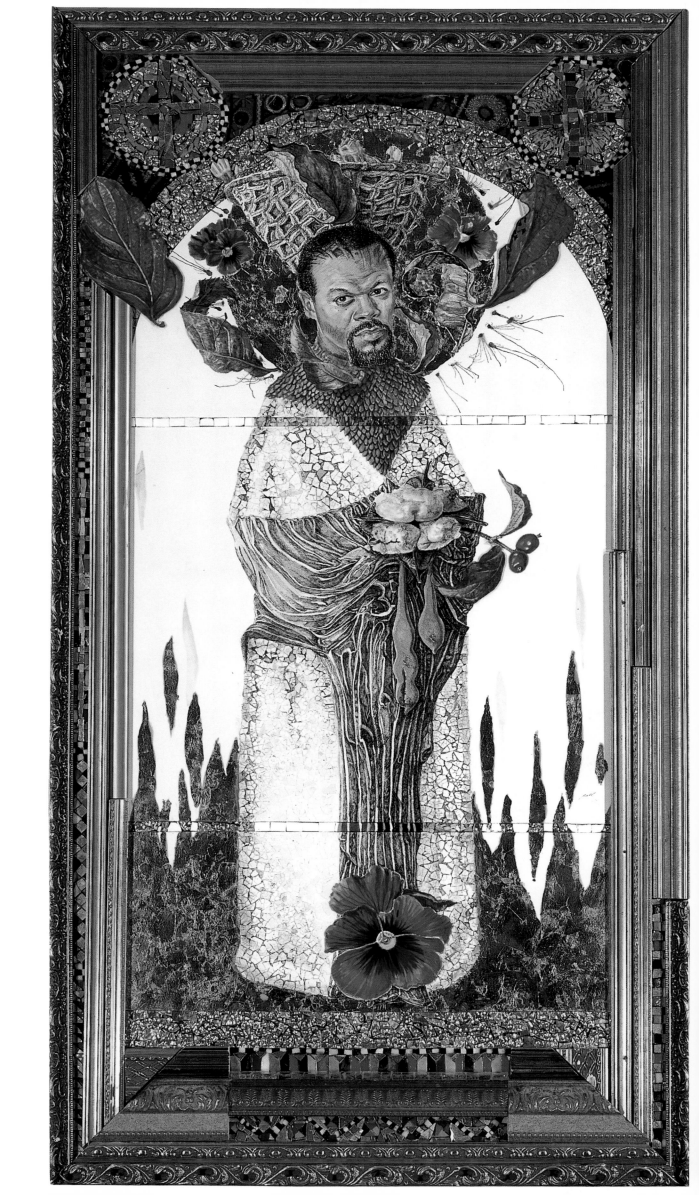

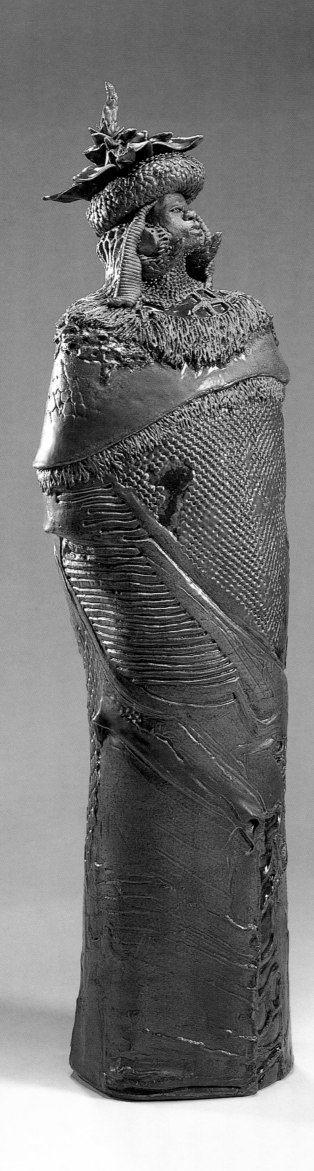

Clifton Pearson - *"Celebrated Figure VII"*
Glazed Stoneware, 1998
32" x 7" x 12" mixed media

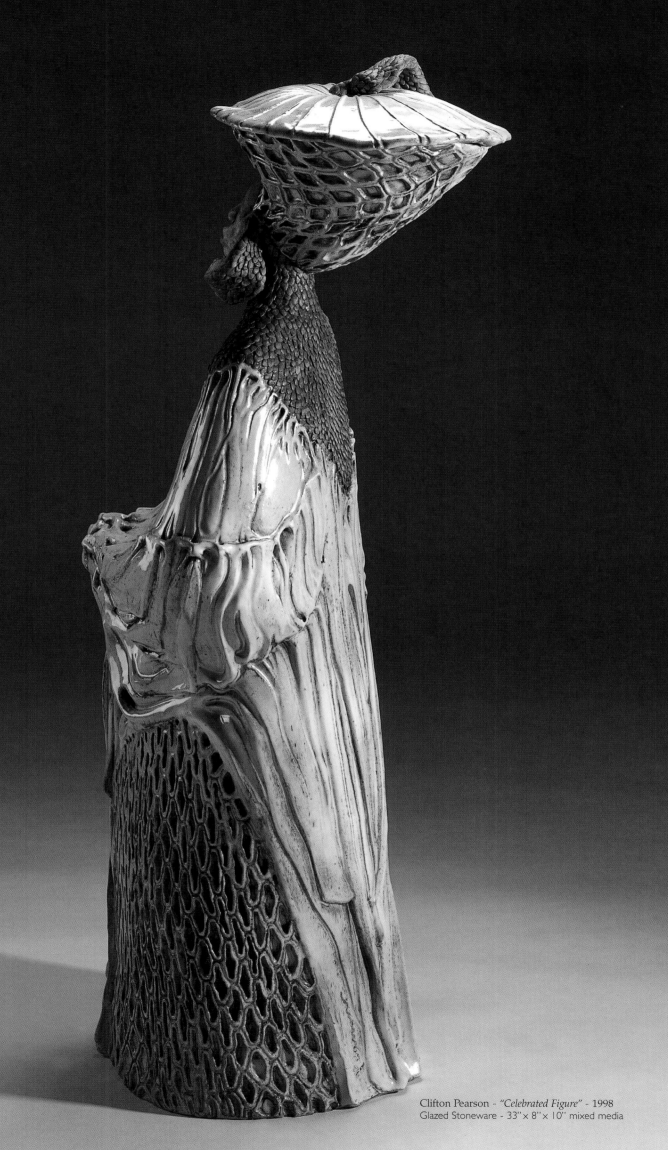

Clifton Pearson - *"Celebrated Figure"* - 1998
Glazed Stoneware - 33" x 8" x 10" mixed media

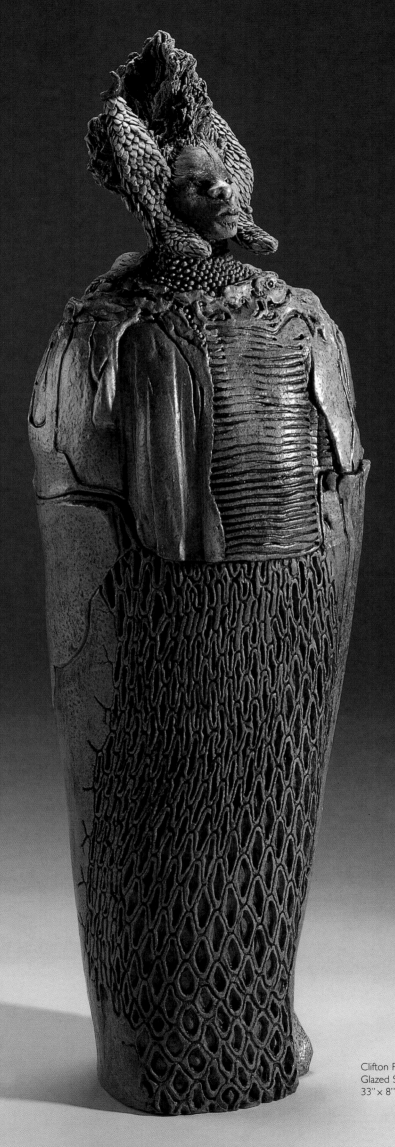

Clifton Pearson - *"Celebrated Figure"*
Glazed Stoneware,1998
33" x 8" x 12" mixed media

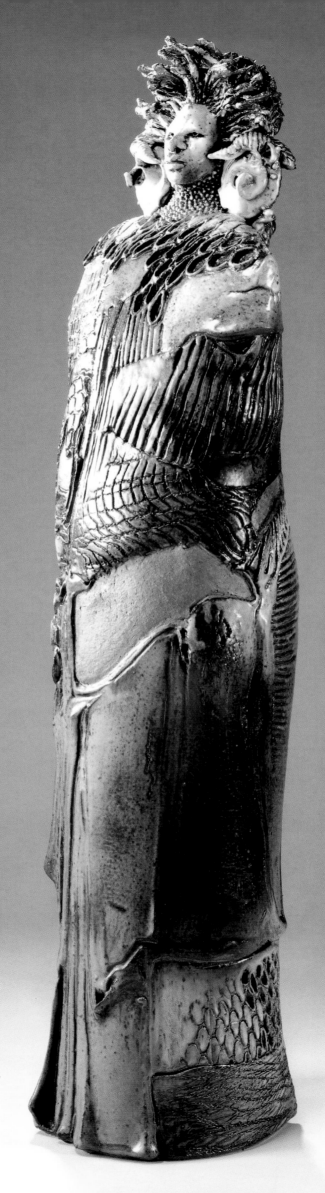

Clifton Pearson - *"Celebrated Figure"*
Glazed Stoneware, 2000
30" x 8" x 11" mixed media

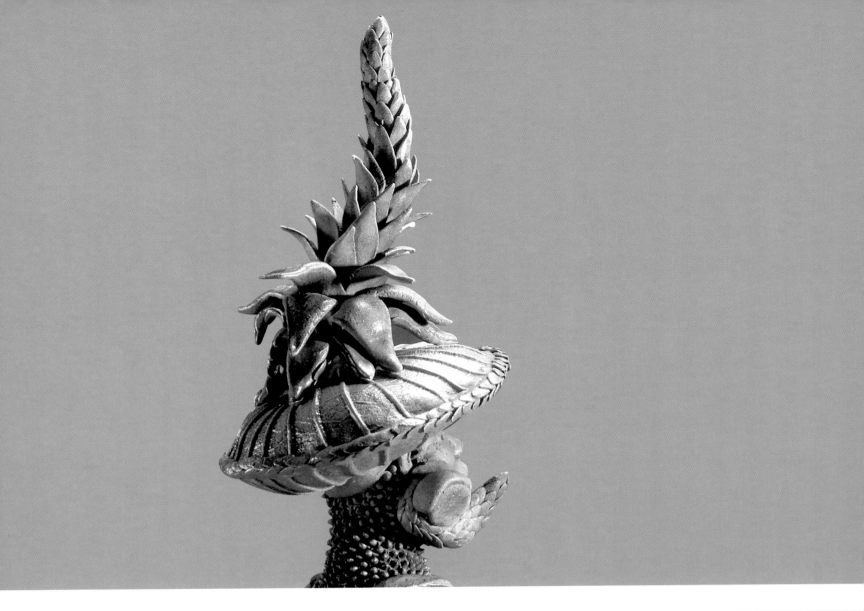

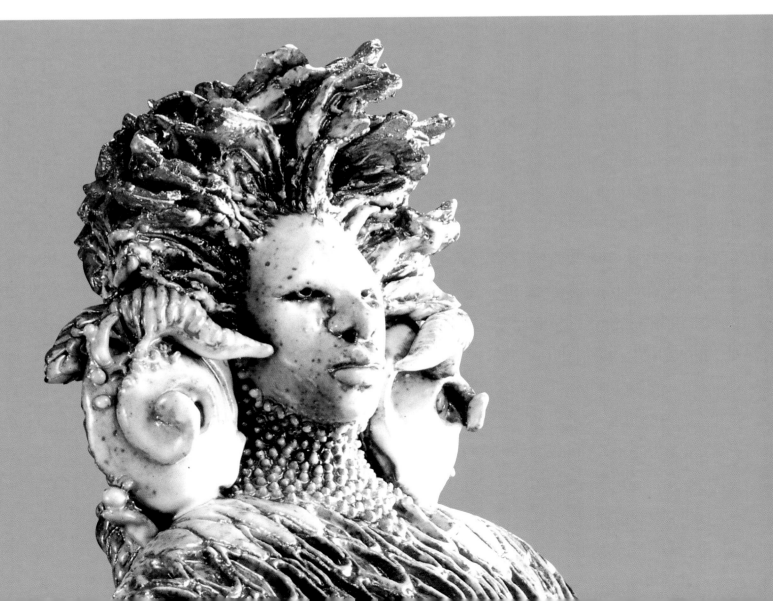

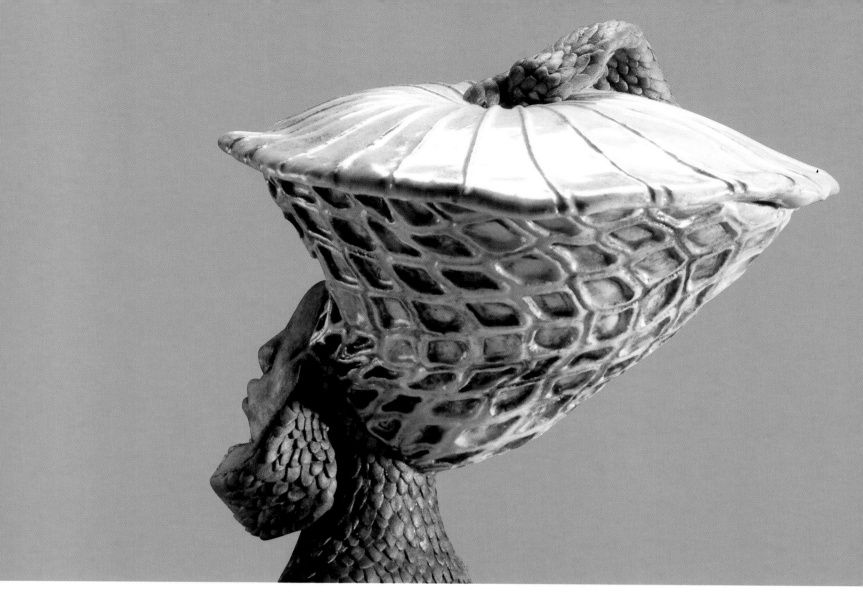

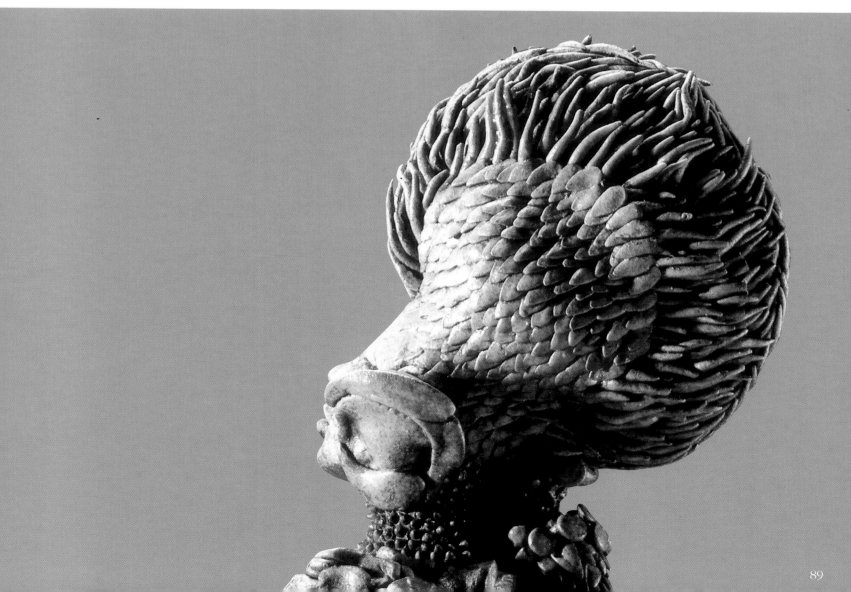

Steve Skidmore

DRAFTSMAN - ENGRAVER
(DECEMBER 12, 1951–APRIL 12, 1999, BIRMINGHAM, ALABAMA)

Steve Skidmore, God rest his soul, has tied knots and drawn circles around Piranesi, then torched the whole thing. Skidmore's Renaissance style of perspective, in his small architectural monuments as well as the larger masterpieces, is ever refined by the tightness of his line, by sheer quantity of quality. An ever-present threat of nature drifts euphorically and obsessively into a symmetrical death veil hiding his fears. It is the elegance and diversity in black and white that elevates his draftsman's skill into a masterwork of art.

Nall

Until recently my father, Dave Skidmore, had a sign shop in Birmingham, Alabama. He studied lettering from an early age and worked as a sign painter all his working life. His influence, and the influence of Frank Fleming, an artist in Birmingham I met in 1973, and Nall Hollis, an artist from Alabama I met around the same time, must be considered the strongest, because they were the earliest influences on me, and because it was in the world of their work and their expectations that I began to form my first judgments about my own work.

I use drafting pens and ink to create a very tightly layered line surface. My work is focused on "architectonic" fantastic landscapes. The structures I depict are in flux between construction and destruction—existing at once as pseudo working drawings, at various stages of completion, use, and dilapidation—visually melded together to retain all the possibilities of the structures' existence.

Steve Skidmore

Steve Skidmore - *"Room with window"* - 1986
Rapidograph on illustration board - 14" x 9"

Steve's work, most of it simply black drawing ink, or occasionally gray or sepia, on illustration board or white drawing paper, has a cross-hatched fecundity to it. His drawings are filled with wings, leaves, beams, tendrils, roots, and branches, overgrowing the stately, imagined architectural structures. An acid-vision intricacy animates the work, as images swirl into one another. It is a world as well of sinews, tendons, fibers, muscle tissues; of snakeskin, feathers; of a filmy though sharply seen visionary world intricate in its complexity and neatly claustrophobic in its packed immediacy and interconnectedness. "Steve's spiritual obsessions are sexual in their translations," writes Nall, "filled with the haunting qualities of an El Greco within the architectural elegance of a Piranesi. He unites

visual imagery to a literary legacy one may describe as Southern Gothic". Perhaps Steve's gothic world bears an off-rhymed relationship to a tragic or decaying world in ruins, though that ruination occurs simultaneously with the process of regeneration.

The drawings show us—they do not necessarily celebrate, perhaps they consecrate—the single intricate body common to plant, animal, and building. A webbed intricacy of interwoven substance, a structural dance of matter. We feel Steve's obsessive attention in the filled frame of the drawing. We see the drama of the transmutation of substance, as plant tendril and building beam interweave, simultaneously a story of decay, ruin, and fertility, as the simple polarities of black ink and white paper become charged with Steve's idiosyncratic vision. As in the simple compelling form of the musical canon, Steve's work has a hypnotic quality based on gradual modulation and precise calculation. It is a vision that extends love to the world of matter, through a focused attention to a set of recurring instances; it is also a vision with a certain stern quality of wrath. A laugh at vanity; a harsh disavowal of the merely contemporary or trendy. Steve invites us into his imagined worlds, but he does not do so in an overly eager or solicitous manner. We feel at once the labored, stubborn, suffered integrity of his drawings. We must meet the work on Steve's terms. To do so is to enter into an intensely realized vision made with the utmost care and sincerity. Oddly, his black and white world, as we stay with it and fall into its web, becomes a richly sincere meditation, especially when we realize it has taken a life to make manifest that vision.

Hank Lazer
University of Alabama, Tuscaloosa

Nall - *"Portrait of Steve Skidmore"*
1999 - 87cm x 75cm x 4.5cm mixed media

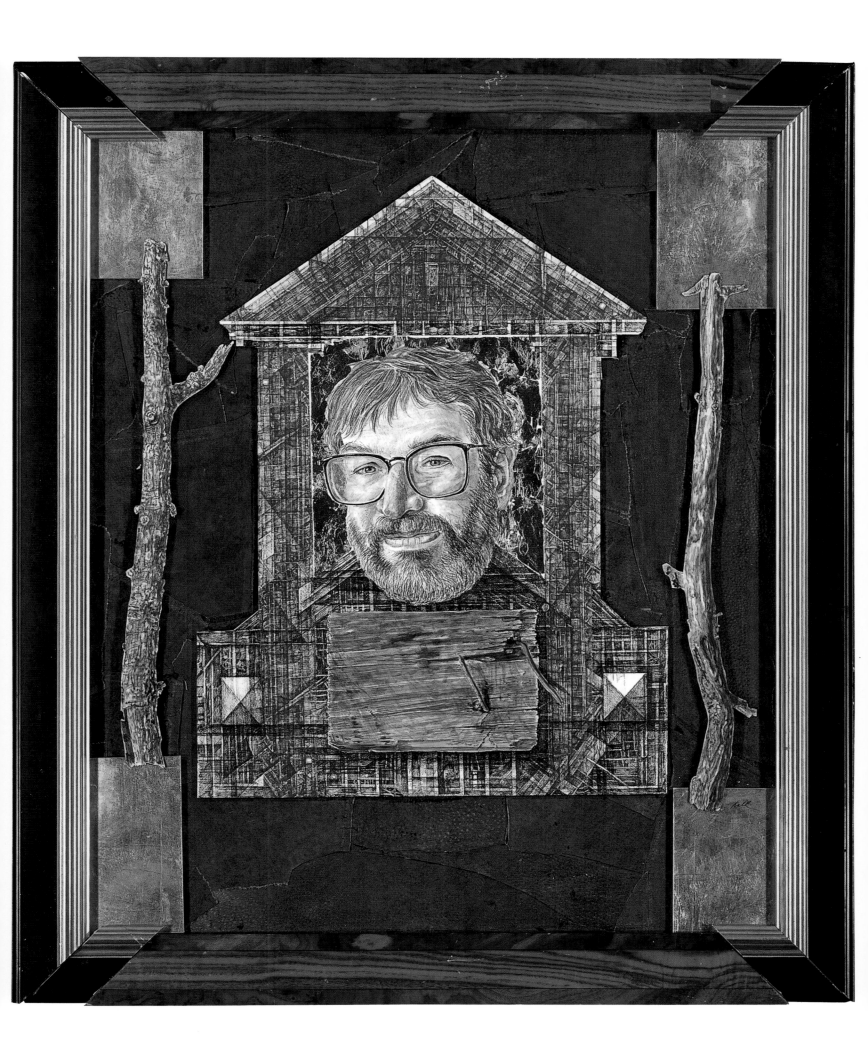

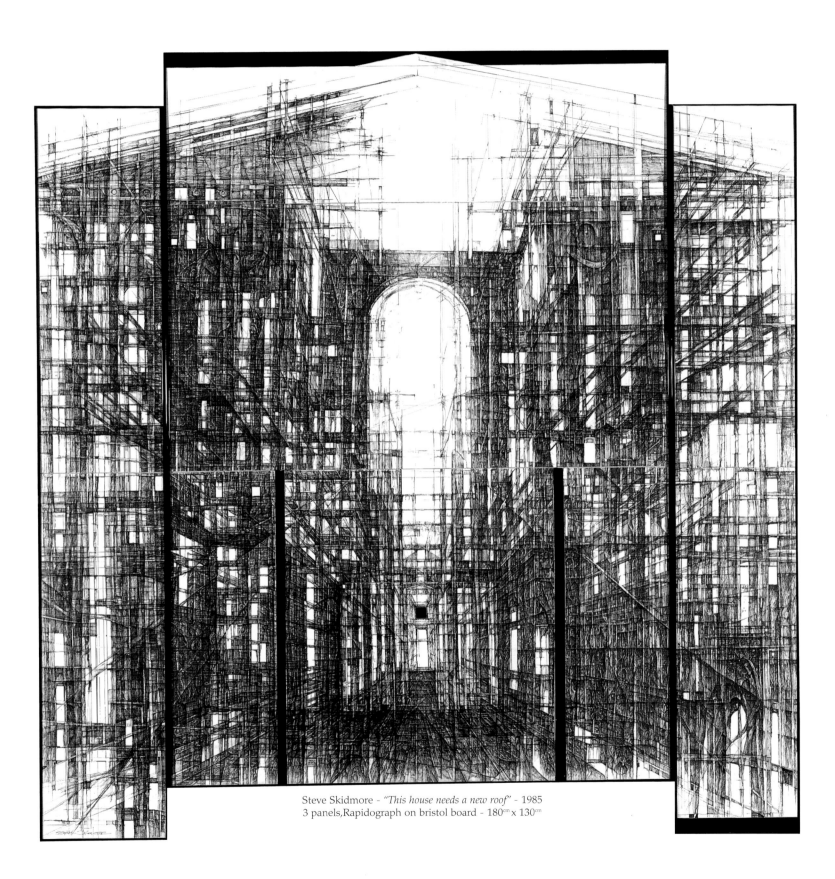

Steve Skidmore - *"This house needs a new roof"* - 1985
3 panels, Rapidograph on bristol board - 180ᶜᵐ x 130ᶜᵐ

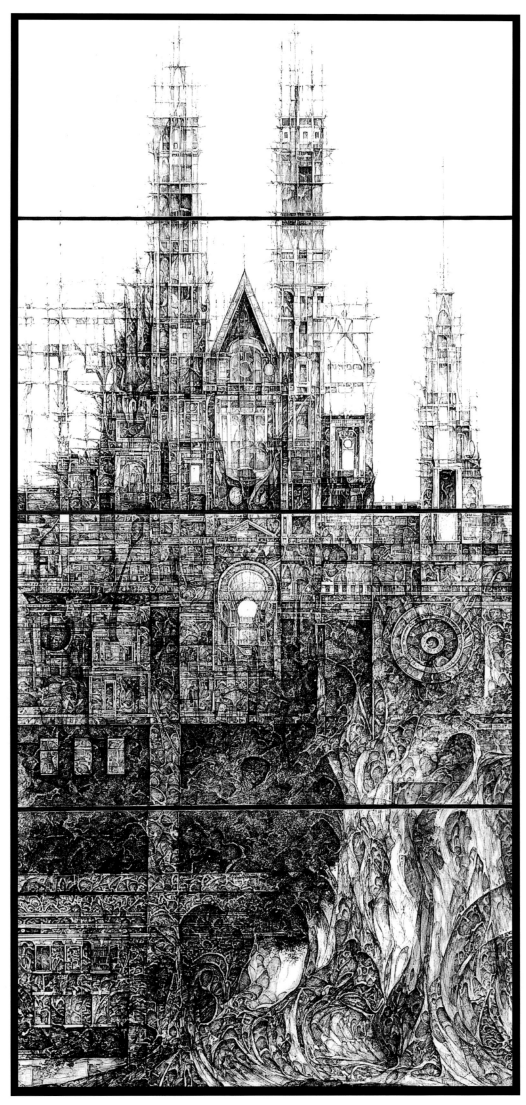

Steve Skidmore - *"Gothic Cathedral"* - 1981
4 panels, Rapidograph on bristol board
184cm x 77cm

△ Steve Skidmore - *"Aorta"* - 1979
Rapidograph on bristol board - 30cm x 77cm

▽ Steve Skidmore - *"Diptych"* - 1983
2 panels,Rapidograph on bristol board - 152cm x 204cm

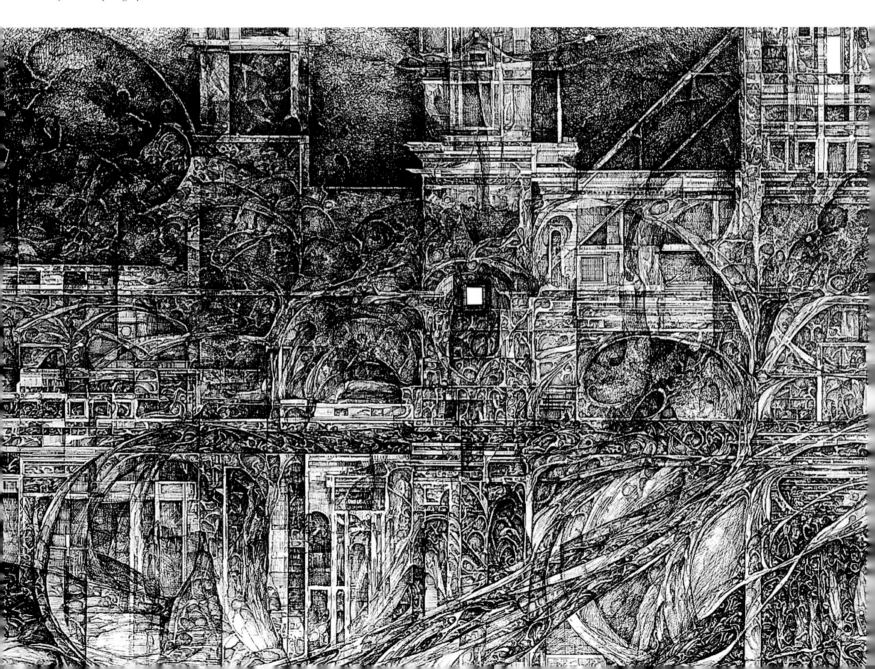

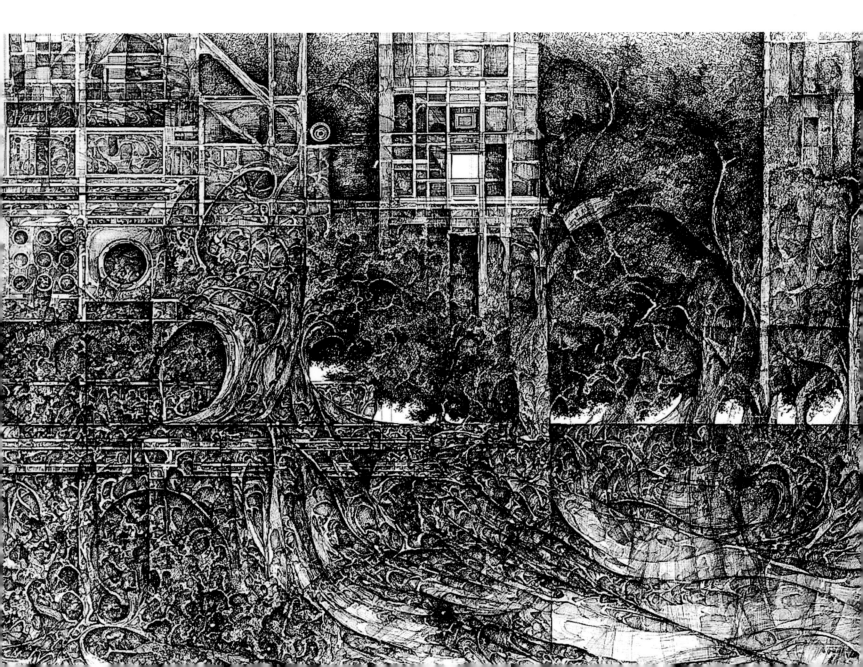

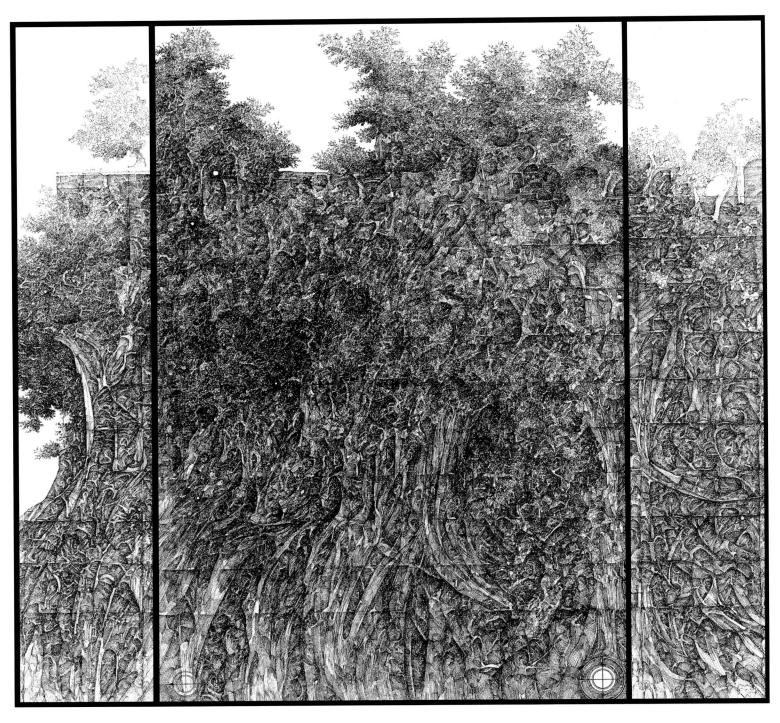

Steve Skidmore - *"Triptych"* - 1983
3 panels, Rapidograph on bristol board - 76cm x 81cm

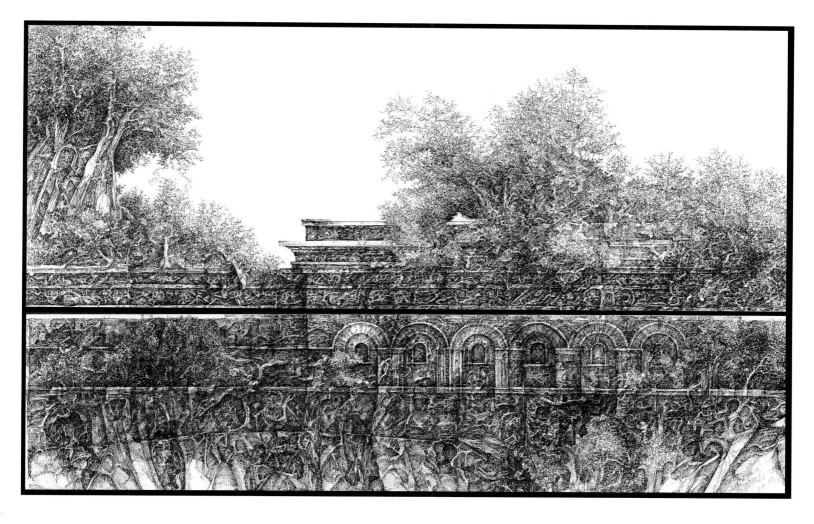

Steve Skidmore - *"Diptych"* - 1983
2 panels, Rapidograph on bristol board - 76cm x 81cm

Frank Fleming

SCULPTOR

(JUNE 17, 1940, BEAR CREEK, ALABAMA)

I love Frank's work. We use the same symbols, but instead of drawing in pencil, he molds in clay. His branches metamorphose into chairs. His animals are stacked, or carry flowers, or intimidate the viewer by sitting on a corn cob, wrapping a sensuous tail around its phallus-shape. Frank's work is erotic, and pure Alabama. His genius as a craftsman, with rich detail, seduces the most unsuspecting and naive audience, like Alice in Wonderland, and, like an extremely good children's book, is X-rated and sophisticated. Thank you, Frank, for bringing into 3-D our Alabama roots, the Southern symbolism which will influence generations.

Nall

Sculptor Frank Fleming takes his inspiration from the land around him. A visit to his studio is an opportunity to see an artist who is immersed in his environment—inspired by the quiet beauty of nature and the creatures who share his garden space. His farming childhood in north Alabama engendered a love of the outdoors, and an enduring love of animals. Fleming attended school at Florence State College, where he discovered an affinity for art. He received an MA from the University of Alabama in 1969 and hoped to teach art; however, when he was unable to find a teaching position, he returned to school to study for an MFA. It was in 1972 that he became familiar with the nonfunctional ceramic sculpture of Peter Volutes and David Gilhooly, and he turned his attention to work in porcelain.

His subjects are largely animals, many of them endowed with clothing or characteristics. They are frequently conceived and created in groups, their collective action suggesting narratives or fables. There is also a strong current of Southern humor in his work, with an emphasis on the "tall tale" or the eccentric strangeness of an animal like the catfish.

In recent years, Fleming has begun to create works that have been cast in bronze. This medium carries significant weight in art history, because many of the greatest works of art that survive from antiquity are bronze sculpture. Fleming's works are invested with the noble character and association of this metal, with an ironic twist when something as pedestrian as a piece of okra or a frog is the subject of the cast.

Frank Fleming lives and works in Birmingham.

Margaret Lynne Ausfeld
Montgomery Museum of Fine Art

Frank Fleming - *"Catfish Plate"*
19" Diameter x 2" Deep △
Unglazed porcelain

Nall - *"Portrait of Frank Fleming"*
1999 - 106cm x 76cm x 8cm mixed media ▷

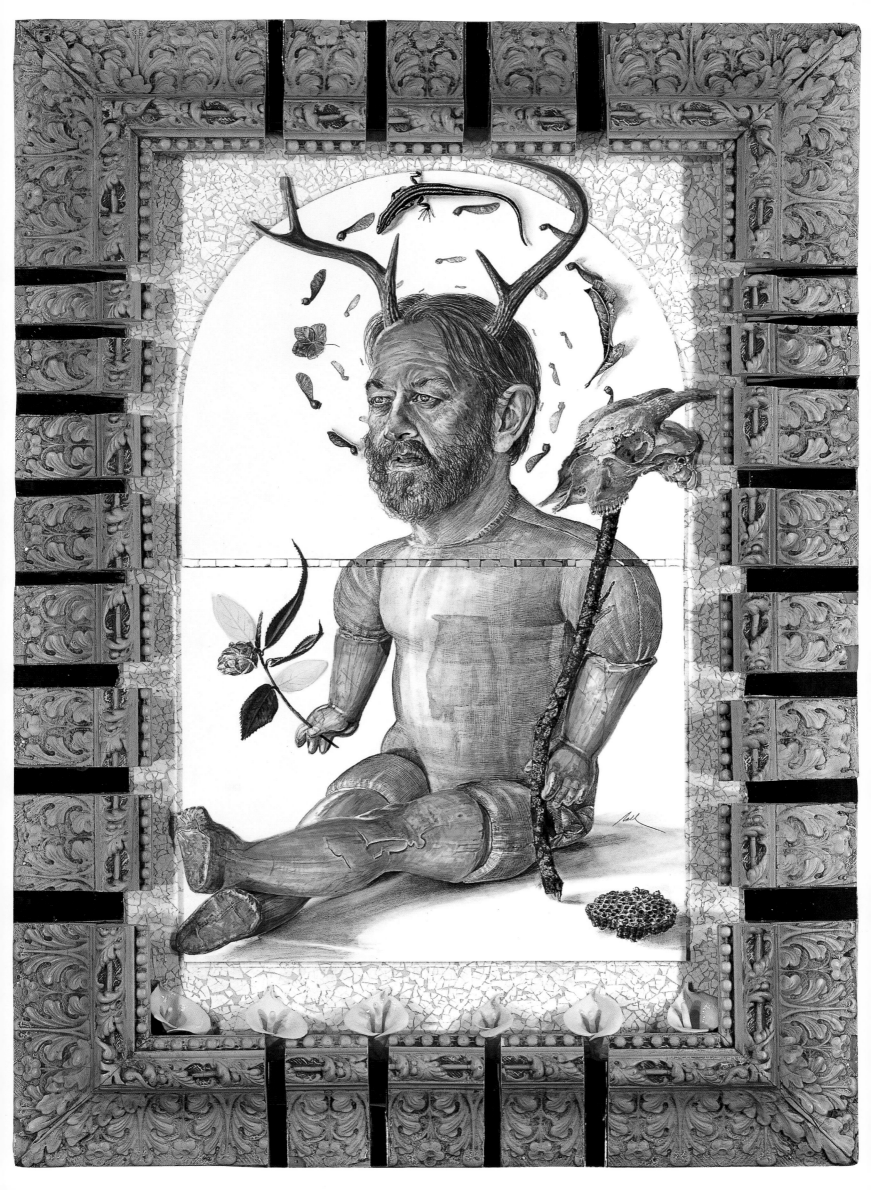

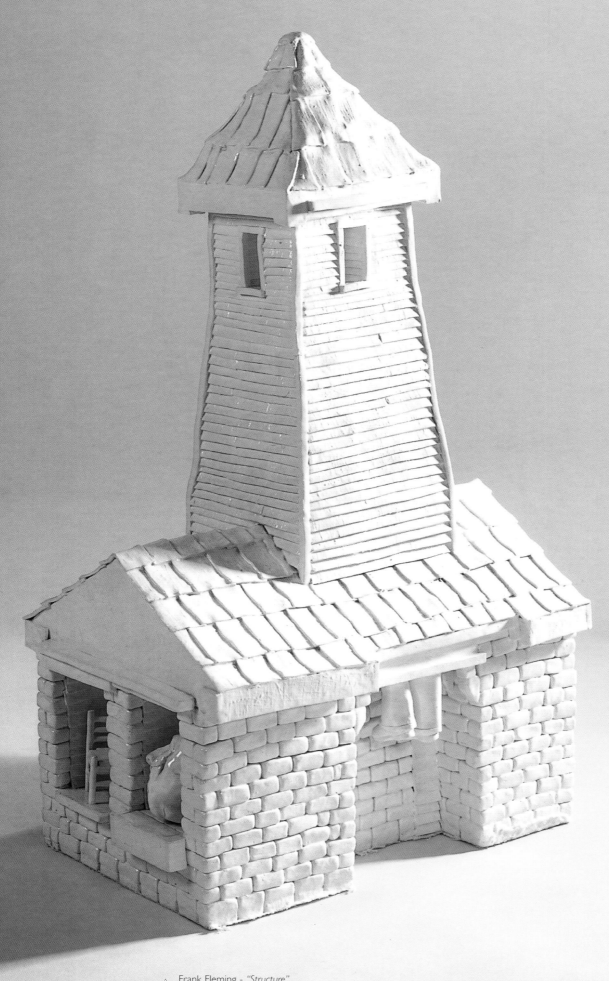

Frank Fleming - *"Structure"*
Glazed porcelain
1976 - 22"× 14"× 10"

Frank Fleming - *"Breakfast of Champions"* - 7"x9"
"My Mother's Chair" - 23"x9"×10"
Unglazed porcelain - 1997

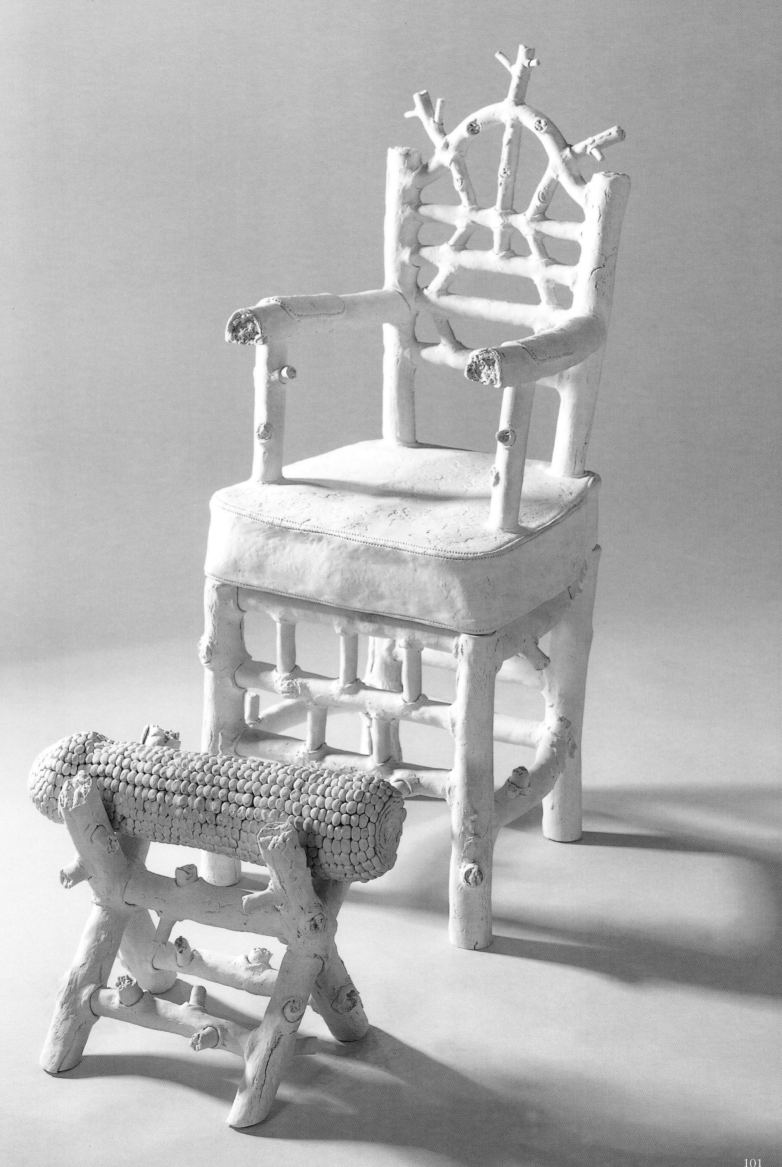

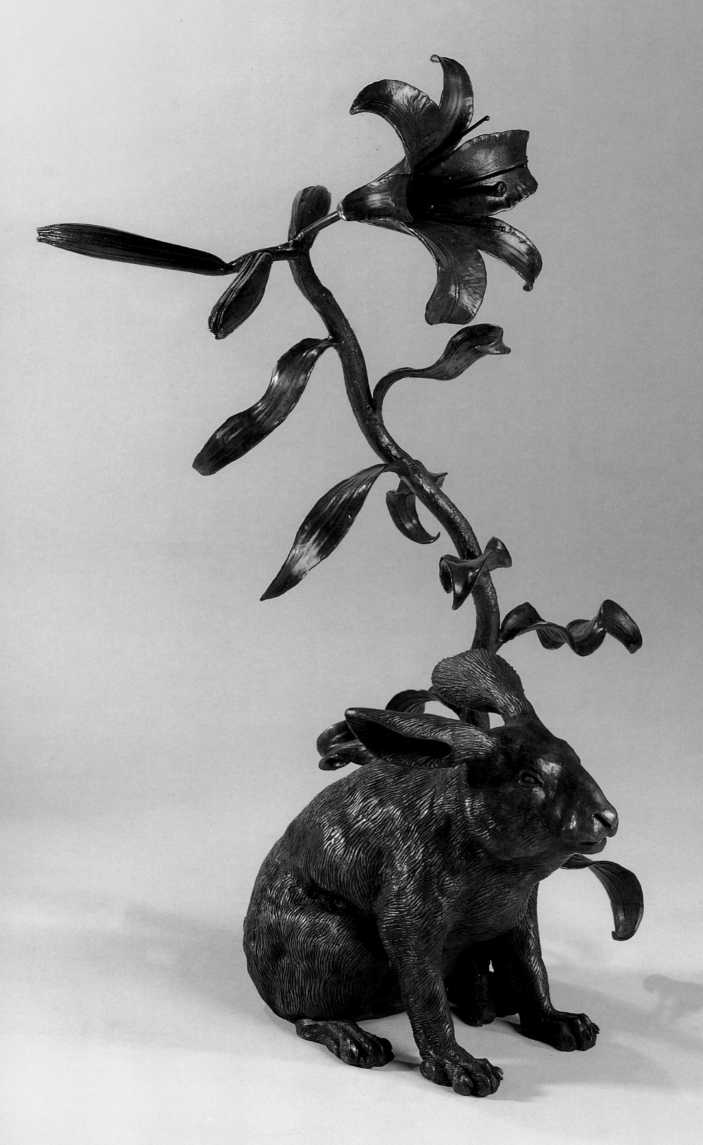

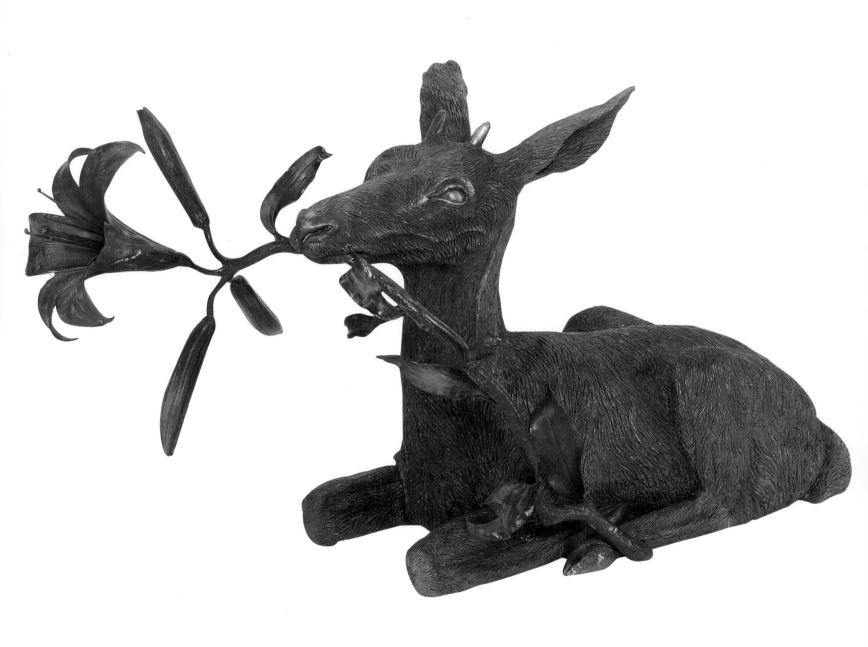

Frank Fleming - *"Deer Fountain"*
Bronze - *1999*

Frank Fleming - *"The Lily Thief"*
1999 - Bronze - 23"x13"x11"

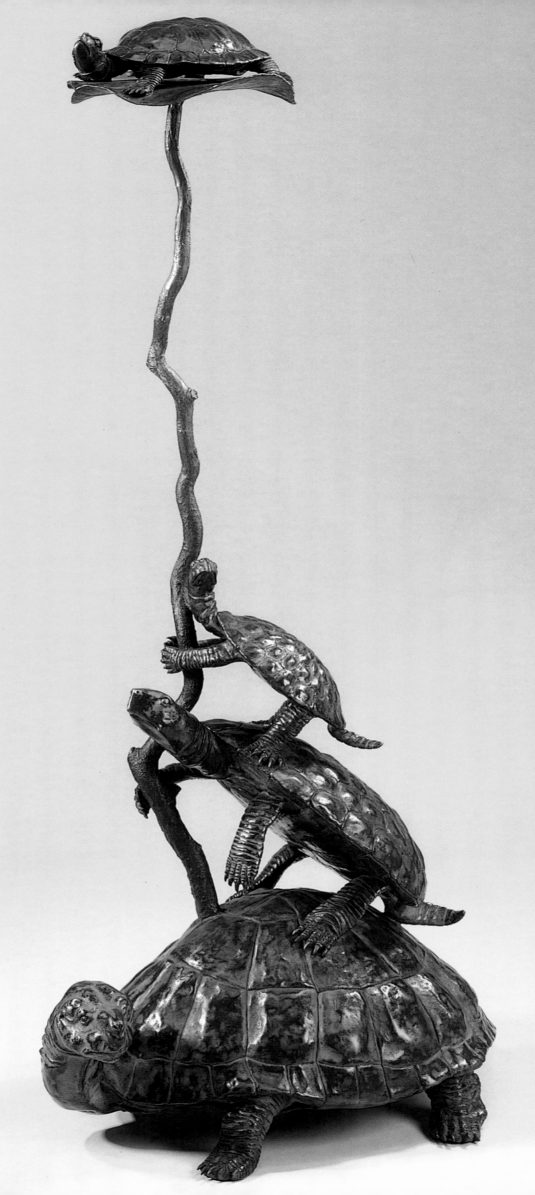

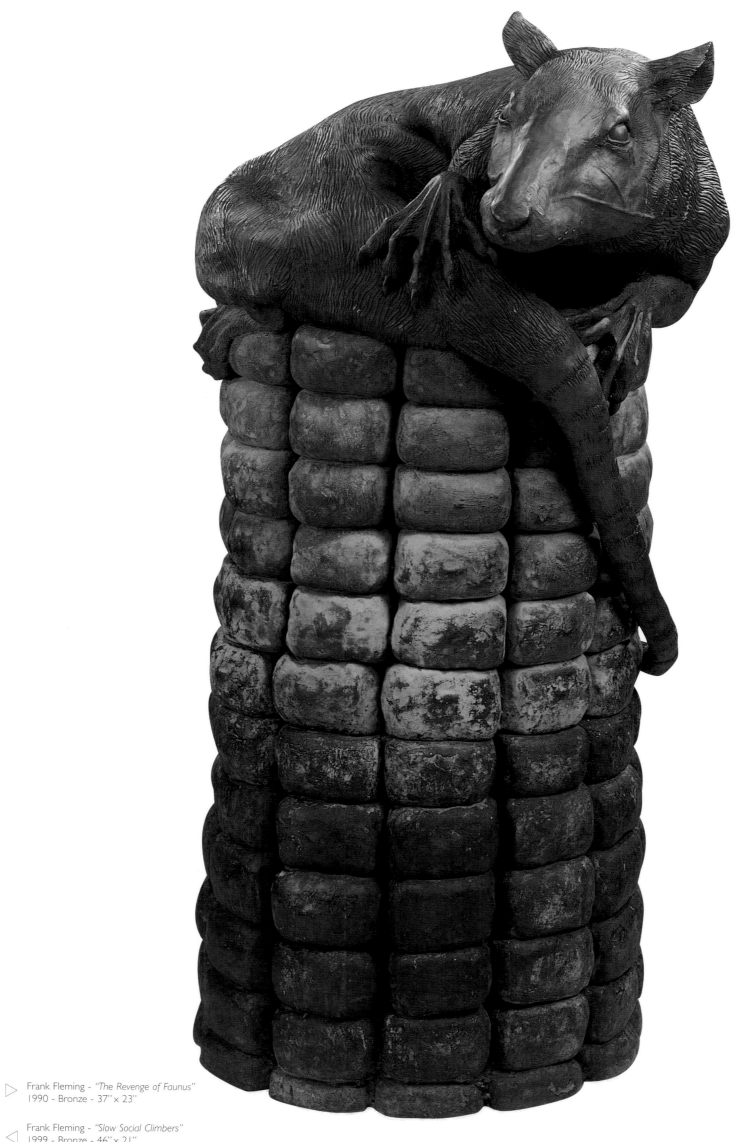

▷ Frank Fleming - *"The Revenge of Faunus"*
1990 - Bronze - 37" x 23"

◁ Frank Fleming - *"Slow Social Climbers"*
1999 - Bronze - 46" x 21"

Nall

PAINTER, ENGRAVER, DRAFTSMAN, DESIGNER, ARCHITECT
(BORN APRIL 21, 1948, TROY, ALABAMA)

The enormous sense of passion and wonder that one experiences while in the presence of Nall the man is superseded only by being in the presence of his art. There is no escape. Only a cadaver could not be moved by witnessing one of his works of art; and even then, if you look long enough, you will rediscover the two jeweled tears of pain and pleasure tracing their perfect, parallel lines down the face of the corpse that hides in your mother's mirror. This is not Dali or Warhol or Mossa. This is bone and flower and flesh. This is Nall. This is all Nall. You may blink, close your eyes, or turn away, but you will never see the same again.

Charles Ghigna
Alabama poet

How to explain the phenomenon that is Nall? In the 1830's there was a night where they say a million silver comets were falling; stars lit up the Alabama sky and turned the entire night as bright as day until morning. This was a night for Nall, just made for Nall.

Being a writer, not a visual artist, I am certainly not qualified to comment on art with any authority. I would be hard pressed to draw a straight line. Therefore I can only make a literary comparison to describe my emotions at seeing Nall's work for the first time. When I was sixteen, I picked up a copy of Ayn Rand's "Atlas Shrugged", opened it to the first page, and it grabbed me by the throat and pulled me in, and did not let go until I had finished it. I did not understand a lot of it. I was certainly over my head with the philosophy, but the one thing I understood was that Rand's passion to communicate was overwhelming. Nall's work has the same effect. It virtually and figuratively jumps at you, grabs you by the shoulders, shakes and rattles you to the bone. Love it, hate it, or understand it—that is not the question. Did it affect you? Did it reach you? Did it make you smile? Bottom line, did it touch

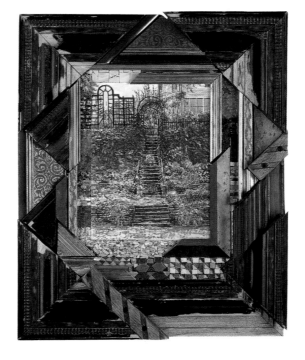

Nall - *"Sammon's Garden"*
1999 - 65ᶜᵐ x 53ᶜᵐ x 8ᶜᵐ mixed media - Watercolor mosaic

you? Was Nall the artist able to communicate something to you? And if all these questions were to be asked of a hundred people about Nall's work, I can guarantee you there would be one hundred loud Yes'es! He cannot by nature be ignored. Being who he is, Art itself, he is incapable of creating anything less than the raw power and energy that he is. One has a feeling that if he were locked in an empty room, he would grab air and use it to create. Nall is a born artist, bursting at the seams to create; even the usual boundaries of frames cannot contain him. Although classically trained, he leaps past all preconceived ideas and rules and shows us an original and unique complex world of contradictions. His visions are startling, shocking, violent, hot, sexual, complex, exquisite, whimsical, unforgettable, and terrifying. He is clearly haunted by the injustices of life, and at the same time overjoyed by its beauty.

There is an old wives' tale about people literally experiencing spontaneous combustion and burning up, leaving nothing but a few ashes. I laughed at this, but, being around Nall, you wonder if he could burn by the heat of his own energy. He attacks life with passion as if he could eat it. I am reminded of the moment when Dr. Frankenstein first sees his manmade human start to move and exclaims, "It's alive!" Being around Nall and seeing his work, one is left with only one thought. "It's alive!"

Again I confess my inability to dissect and analyze any artist's work, nor would I care to. I believe in the whole of the thing, but being a fellow Alabamian, I can see clearly that Nall's art reflects who and what he is. He was shaped by Alabama's red clay, Alabama's blood, and Alabama's passion. A restless man, who, being much braver and more curious than most of his Alabama brothers and sisters, has traveled and lived in places that most of us have only read about. And he has gathered it all up, brought it home and mixed it into his great big creative pot. He has added ingredients from here and there that have never been mixed together before, making a delicious, exotic stew. But the main stock is pure Alabama. And like Alabama, he is trying to come to terms with, and make sense of, a troubled past, moving forward and backward and sideways at the same time. Trying to mesh the insanity of life with the divine. And while Nall searches for the divine in his soul and attempts to reach out to touch God, he shows us a glimpse of the divine in ourselves.

Fannie Flagg

Nall - *"Nall in Alabama"*
2000 - 145ᶜᵐ x 116,5ᶜᵐ x 9ᶜᵐ mixed media ▷

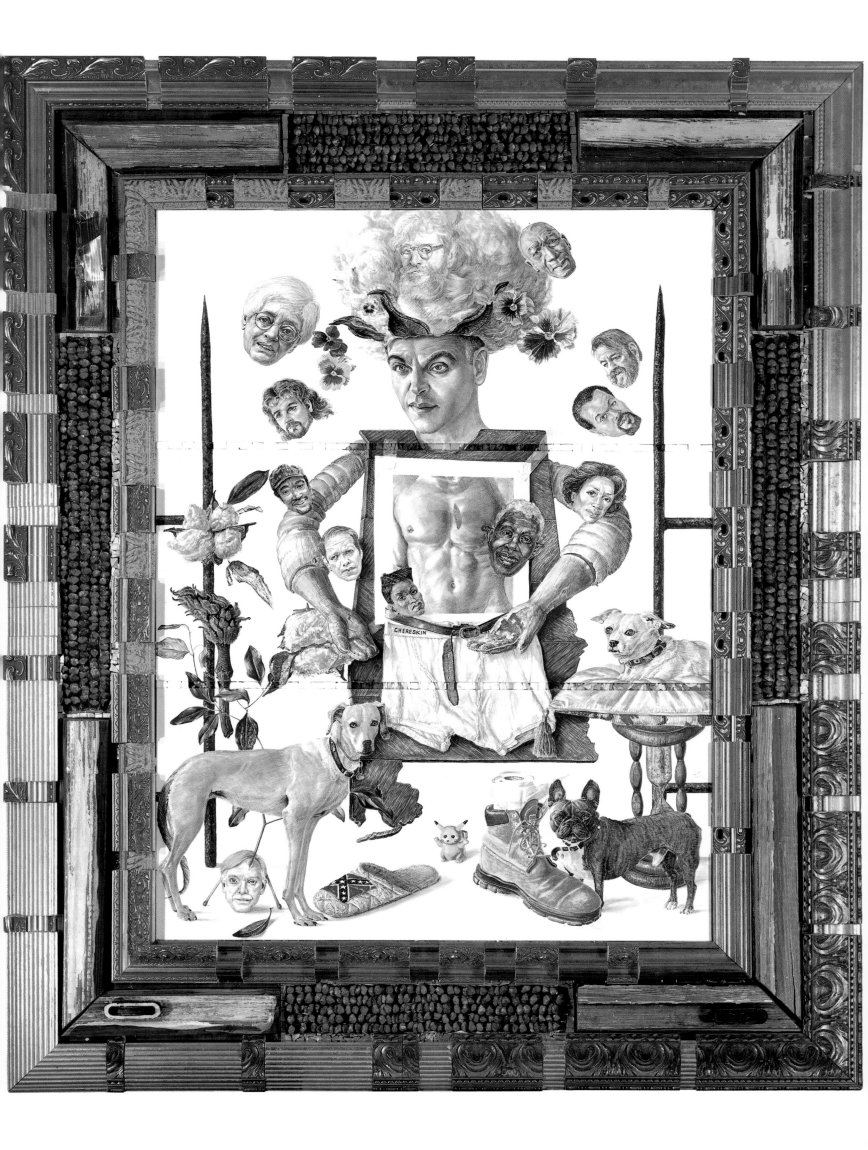

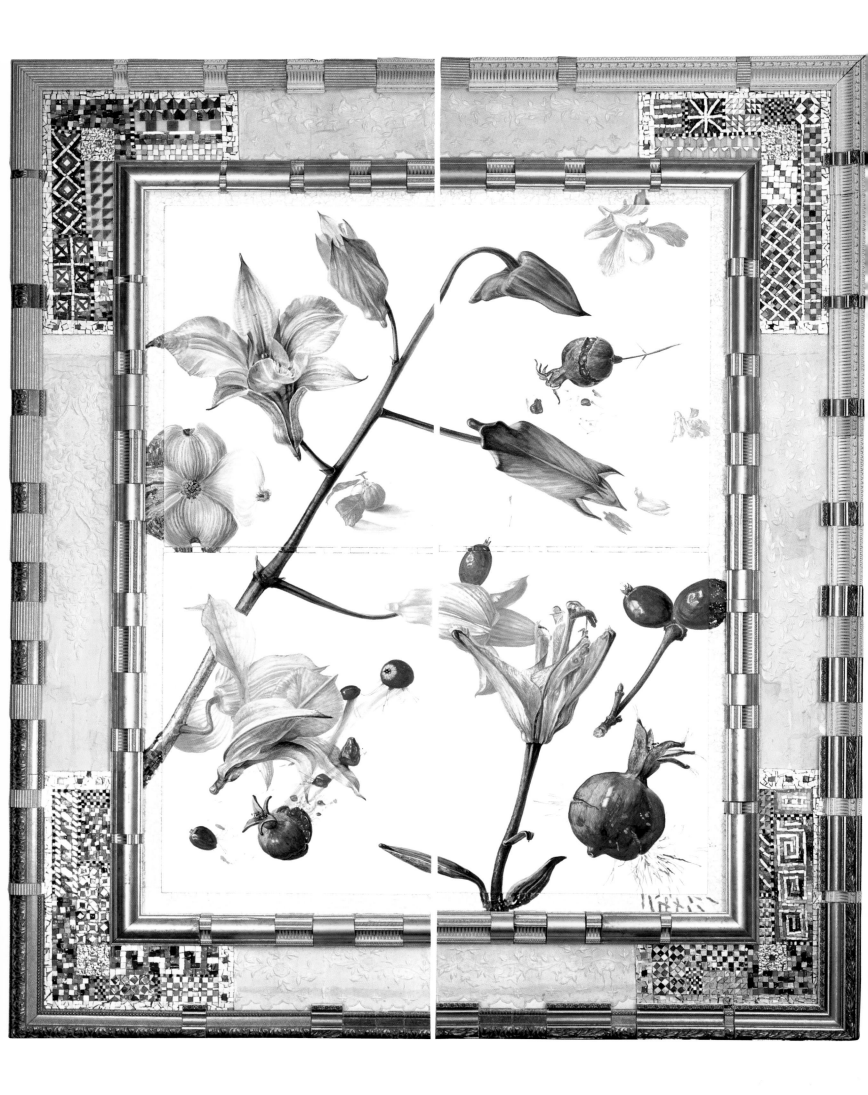

Nall - *"Alabama Renaissance"*
2000 - 2 Panels
180cm x 170cm x 12cm mixed media

108

"Alternative Southern Belle" is an homage to the black female of past centuries whose role, first in Europe and eventually in America, forever changed the nature of being. From grooming and hygiene to language and spirituality, the African woman (in America, the Mammy) has been a key figure in defining and determining our character, values, and even our blood. An undeniable presence of African blood within American Caucasian populations, while perhaps an uncomfortable reality to face, offers great understanding to who we are as Americans. We are located at a point in the history of America where one's sense of the truth is verified by behavior, a sense of purpose, and our DNA. Sensing this, Nall undertook the project of creating this special icon. His clever titling of the work introduces his use of symbol and metaphor that draw profound meanings from his subject's physical assemblage. Describing his work, Nall indicates that he builds his drawing, four and five layers of graphite upon an etched surface, a process he refers to as pencil painting, and integrates these into a composition of painting with watercolor. All of the processes used evolve manually. Working from the model, Nall develops the drawing of his subject. He continues by adding the frame element, a process referred to in his second-native French as "dans le cadre", often using collaging material from the subject's history into the frame or environment.

Bill Dooley
Director Art Department
University of Alabama
Tuscaloosa, Alabama

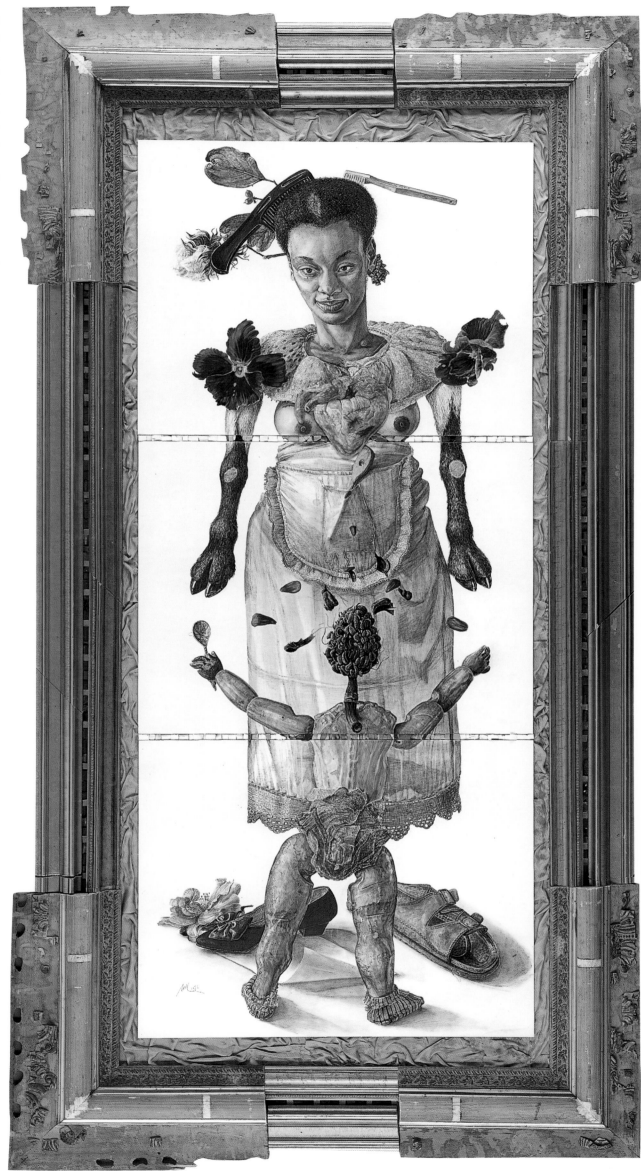

Nall - *"Alternative Southern Belle"*
1997 - 190ᶜᵐ × 90ᶜᵐ × 12ᶜᵐ mixed media

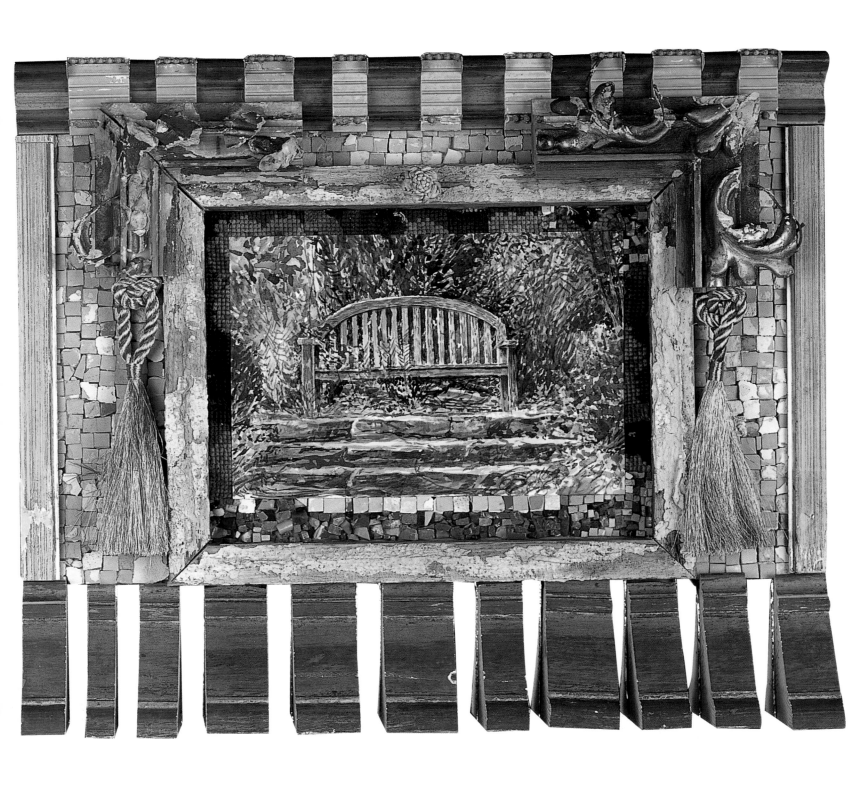

Nall - *"Sammon's Garden"*
1998 - 42,5cm x 52,8cm x 6,5cm △
watercolor-mosaic

Nall - *"Yellow Rose"*
1997 - 77cm x 65cm x 8cm ▷
mixed media

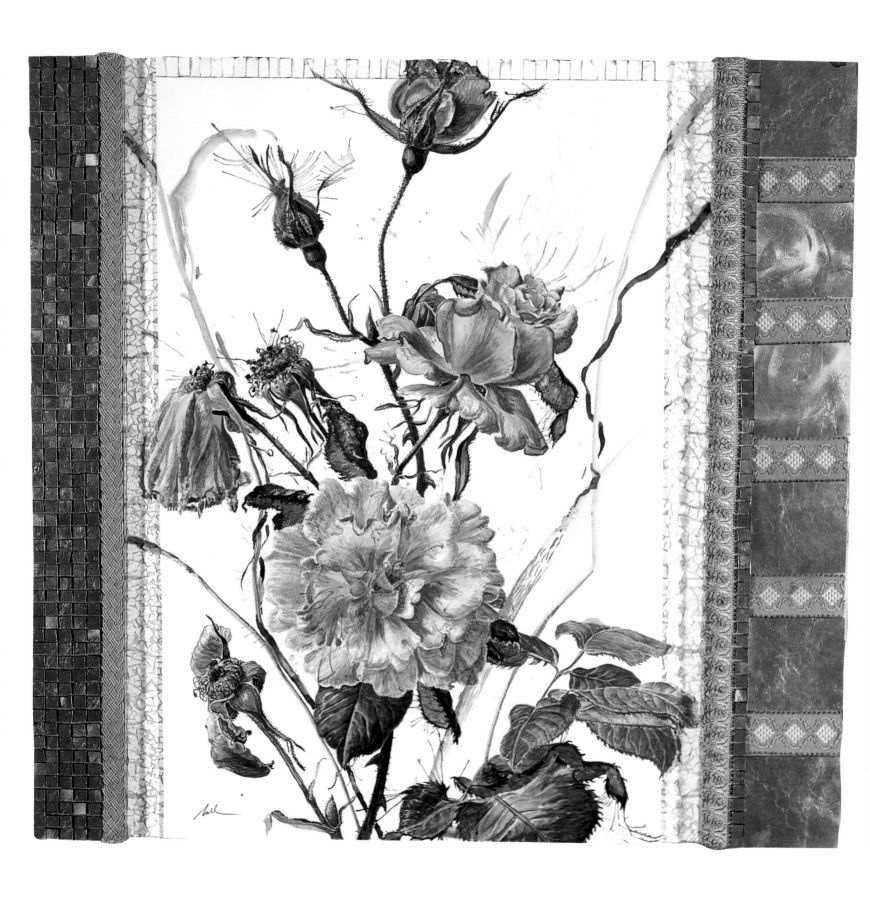

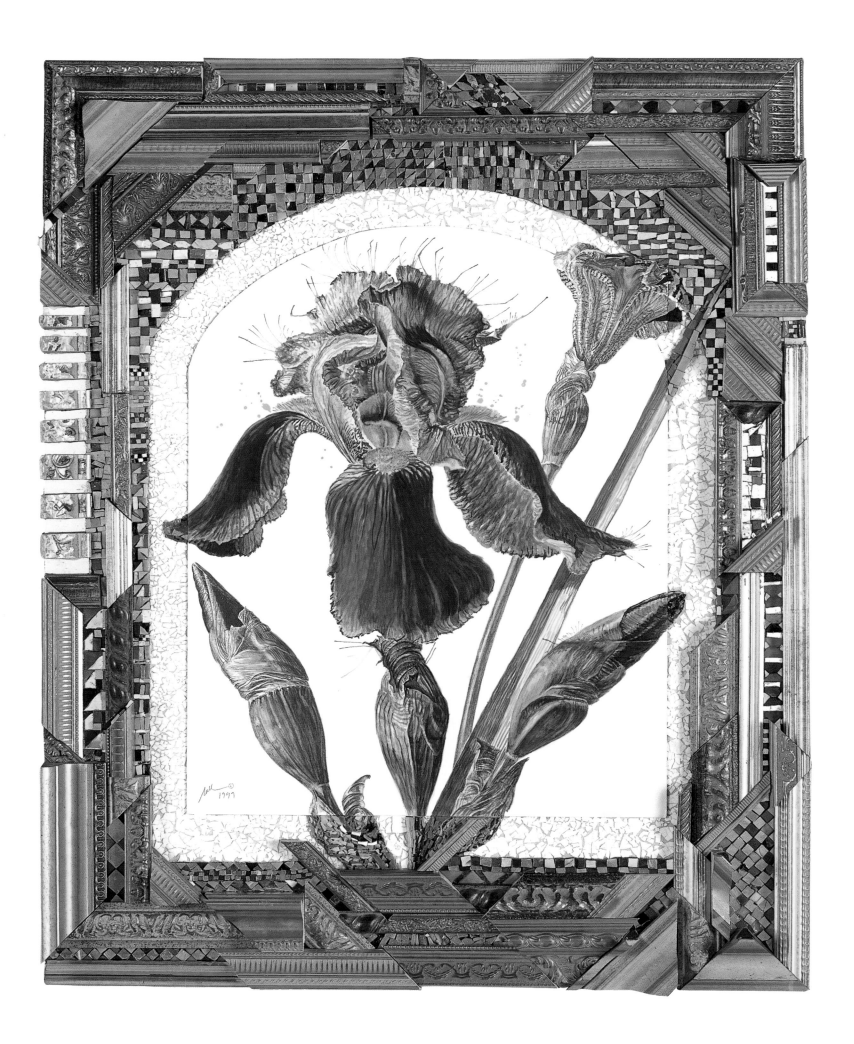

Nall - "Alabama Iris II"
1999 - 100ᶜᵐ x 80ᶜᵐ x 8ᶜᵐ mixed media
A lithograph of this work was realized benefiting
the Arab Mother's Club
Collection : Jack Warner

Nall - "Southern Belle" - 1998
Portrait of Anita Thomas
120ᶜᵐ x 90ᶜᵐ x 10ᶜᵐ mixed media

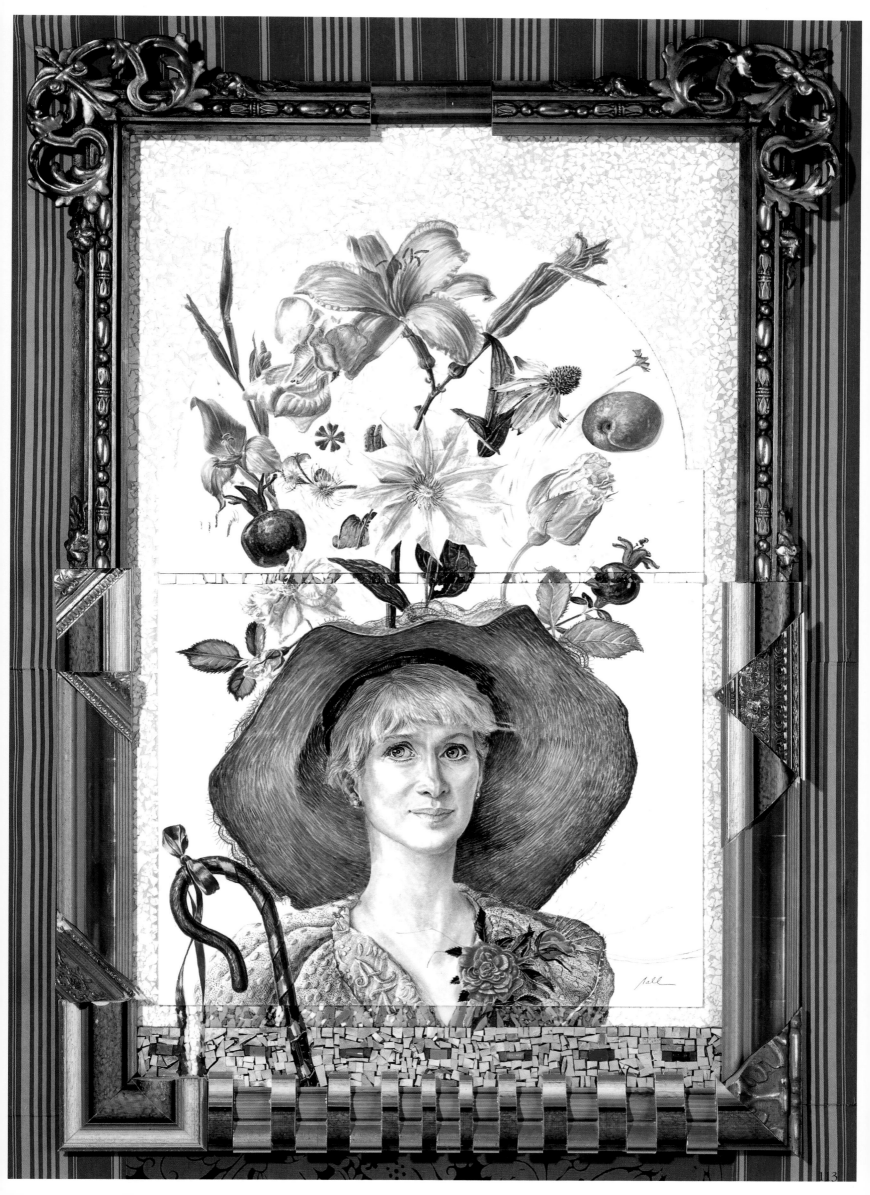

N.A.L.L. ART ASSOCIATION

VENCE, FRANCE

As always it is a great pleasure and an honor for me to chair a cultural event curated by the N. A. L. L. Art Association. After the brilliant opening exhibit "Mossa-Nall Dialogues" in 1997, the Museum of the N. A. L. L. Art Association has housed every year a very successful show, thus becoming a recognized meeting point among art lovers. "Alabama Art" will be, I feel confident, a unique event rendered possible thanks to Nall's exuberant genius, energy, and generosity. The European public will taste the magic, the poetry, the authenticity, the whimsicality, and the imaginary world of this Southern state through the works of its artists. Thank you, Nall, for bringing to us in the South of France, where you have established a part of your life, this millennium present from your Southern state.

Michel Pastor
Honorary President of the
N. A. L. L. Art Association in France

Created by the American artist NALL, the N. A. L. L. Art Association (Nature Art & Life League), offers an artistic training and creates a cultural life through exhibitions, conferences, concerts and seminars. The N. A. L. L. is open to artists of all callings : painters, sculptors, writers, musicians. . .

Situated on a 9 acre estate in a small valley in Vence, France, ten cabins for artists are sheltered under its olives trees together with a Museum designed and built by NALL.

NALL, worked for six years constructing his Museum, willingly describes himself as a "man of extremes".

For years, he has collected materials from all over the world which he then boldy mixes into each one of his works. The same thing goes for his Museum which vibrates with past centuries and styles. Color mosaics give way to mirror mosaics on the walls. The floors, painted in trompe-l'œil, blend

Photo - entrance to the museum of the Nall Art Association.
The museum was designed and built by Nall and the architect,
Alain Berp in 1995

with Indian sculpted doors from the XIIth, XVth and XVIth century.

The beams of the ceiling and of the fire place, overhung by Matisse tiles and facing a stained-glass window from the Cathedral of Algiers, are from the Gould residence in Cannes. In the courtyard, with Syrian mosaics dating from 100 A. D. a mirrored wall reflects the olive groves, with the Mediterranean Sea shimmering over the foothills of the Alps. A magical place and source of inspiration for his works.

"I am inspired by the spiritual and express with the material" confides NALL, who explains the presence of eyes and bones in the majority of his paintings : "The eye is the eye of God, watching us all the time-symbol of all religions. The bone is the structure and foundation of Mankind and is the symbol of Man's truth and all that will remain of him".

Agence France Presse- July 1997)

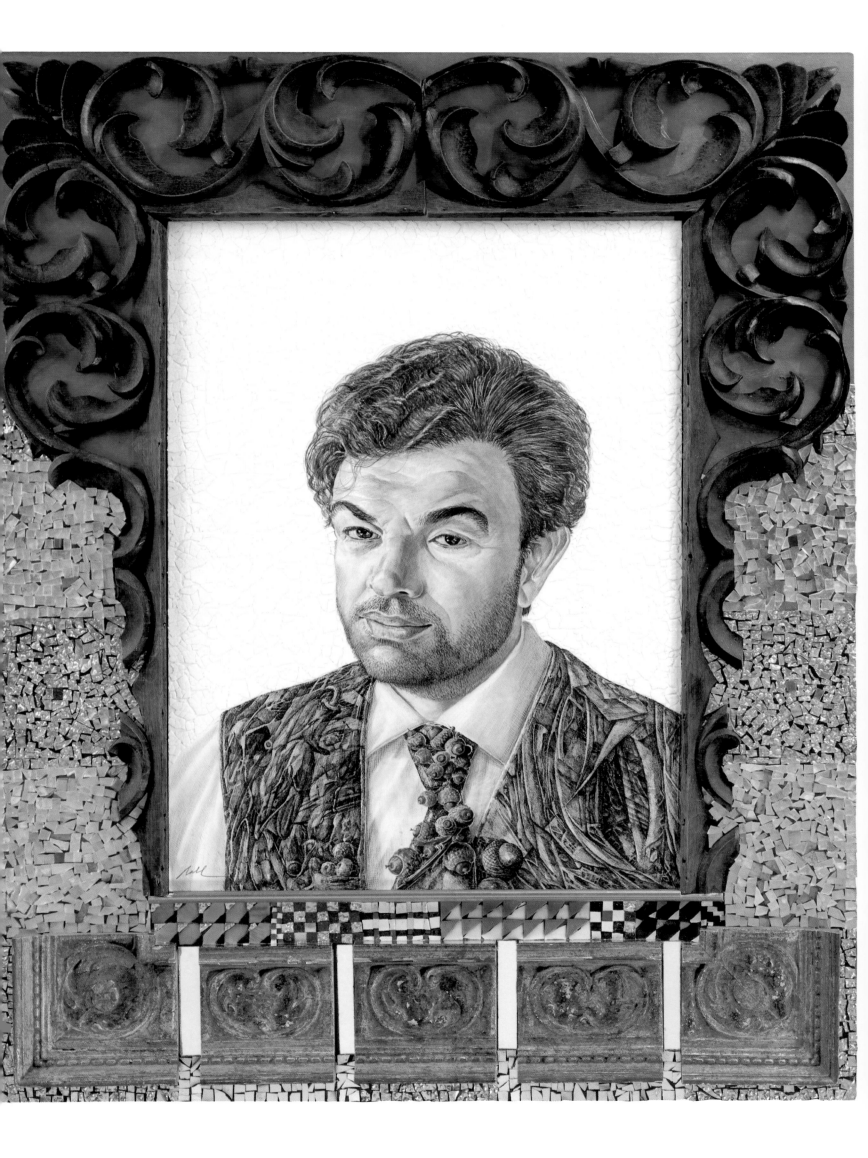

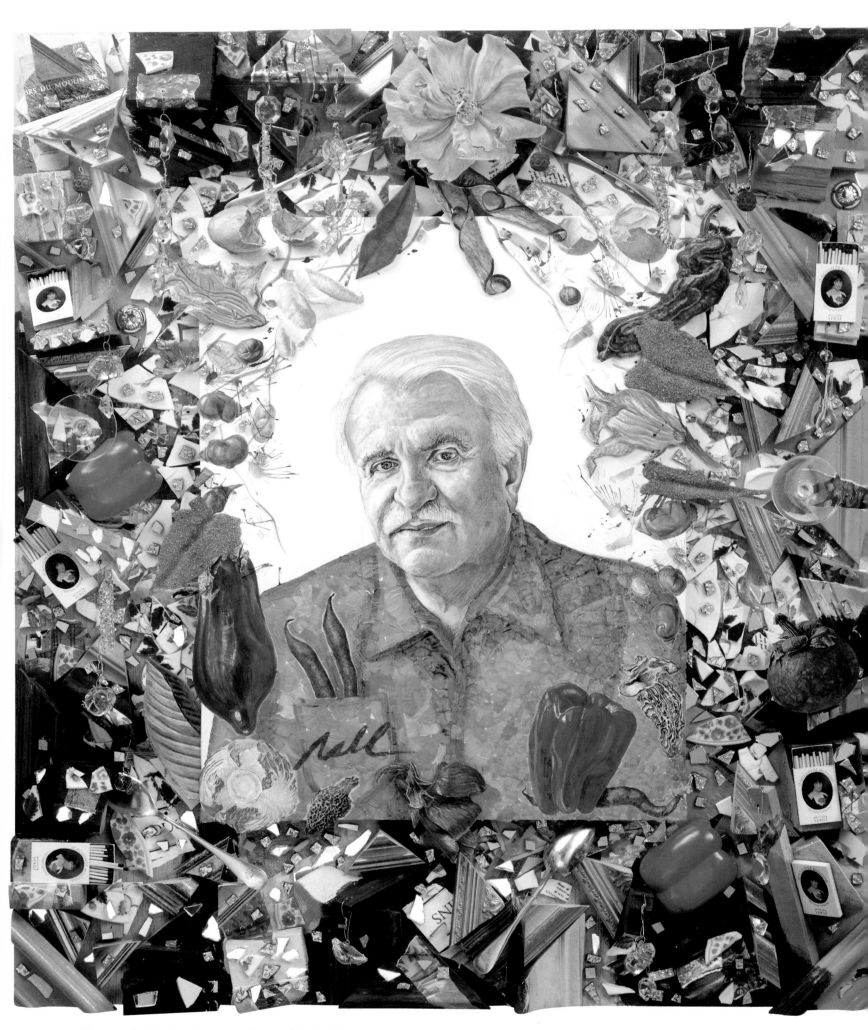

The art of cuisine is a long -standing tradition in France. For the grand opening of the Museum of the N. A. L. L. Art Asssociation
two of France's world famous chefs, Alain Ducasse and Roger Vergé, prepared the dinner Mediterranean style for the 250 invited guests.

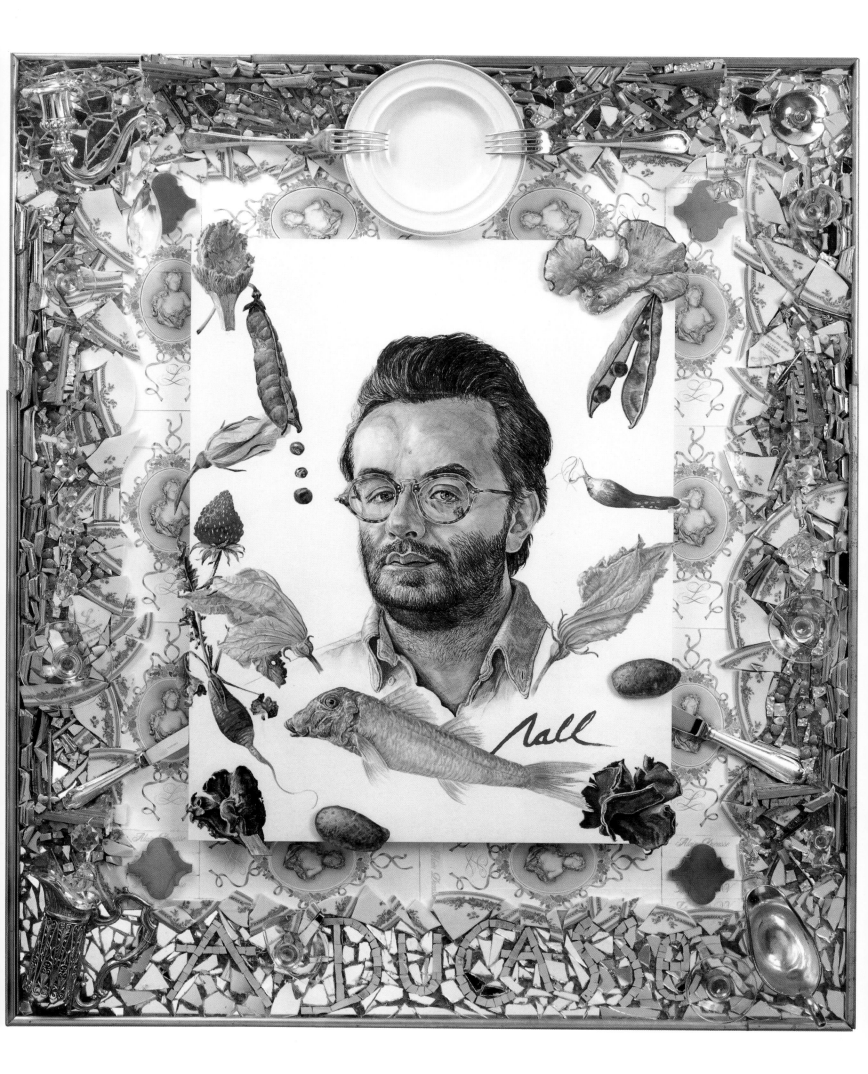

Nall - *"Portrait of Alain Ducasse"*
1992 - 100ᶜᵐ x 80ᶜᵐ x 8ᶜᵐ mixed media

Nall - *"Portrait of Roger Vergé"*
1992 - 100ᶜᵐ x 80ᶜᵐ x 8ᶜᵐ mixed media

1 - Dining room in the guest house.

2 - Entrance to the guest house and office.
 The farmhouse was built in 1605 and renovated
 by Nall in 1993.

3 - Nall porcelain *"Tuscia's Roses"* by R. Haviland
 and C. Parlon, Limoges, France.

4 - Bedroom in the guest house (Occupied by Dora
 Mae, the Chihuahua).

5 - Courtyard of the guest house.

6 - Dog room in the guest house.

7 - Postage stamp for Monaco and poster for the
 38th Festival of Television.
 Collection : H.S.H. Crown Prince Albert of Monaco

The City of Vence is delighted and honored to receive the exhibition "Alabama Art" and, through it, to pay homage to the culture of a Southern state. By showing these thirteen contemporary artists from Alabama, some in Europe for the first time, the Foundation N. A.L.L. initiates the people of Provence to a spiritual journey into a world filled with magic, passion, and poetry. A city of the South of France welcoming artists from the South of the United States is in no way a coincidence. Nall, the Southerner, adopted son of Vence, has given himself the commitment to be the inspired link between these two countries, and it is with immense joy that we shall allow him to fill our hearts with the soul of his Alabama.

Christian Iacono
Mayor of Vence, France

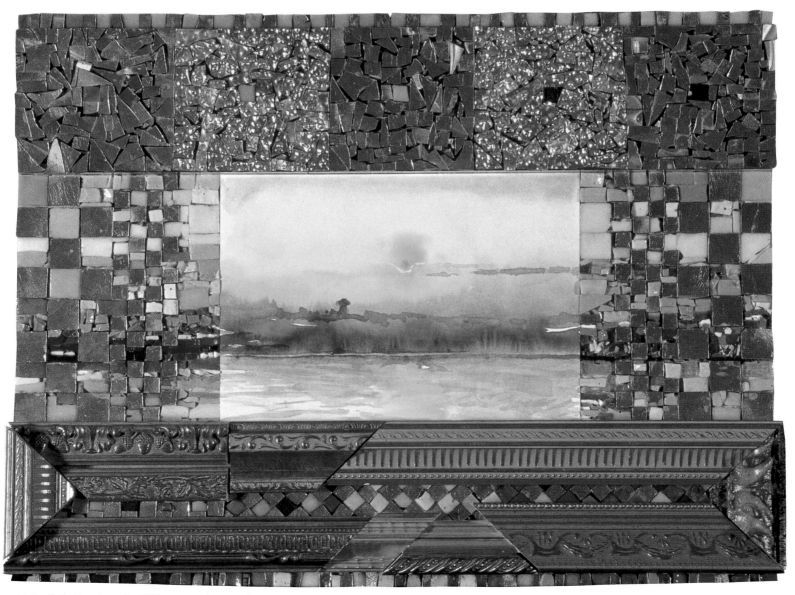

Nall - "Lake Tuscaloosa" - 1999 - watercolor-mosaic
Collection : Jack Warner

Tourrettes sur Loup, traditionally the home of many famous artists, becomes every summer a meeting point for many people who are interested and involved in the arts. Recently, its twelfth-century museum has presented and shown, with great success, Roussil for his jubilee, a selection of the best British photographers, and Trauner's movie world.

It is a great honor for our city to receive during the summer of 2000, thanks to the N.A.L.L. Art Association, this authentic and talented expression of art in Alabama. "Alabama Art" will allow us to discover the rich and secret aspects of Alabama's artistic heritage that have made this Southern state unique. I also trust that this exhibition will develop a better mutual understanding between our two countries.

Paul Ceuzin
Mayor of Tourrettes sur Loup, France

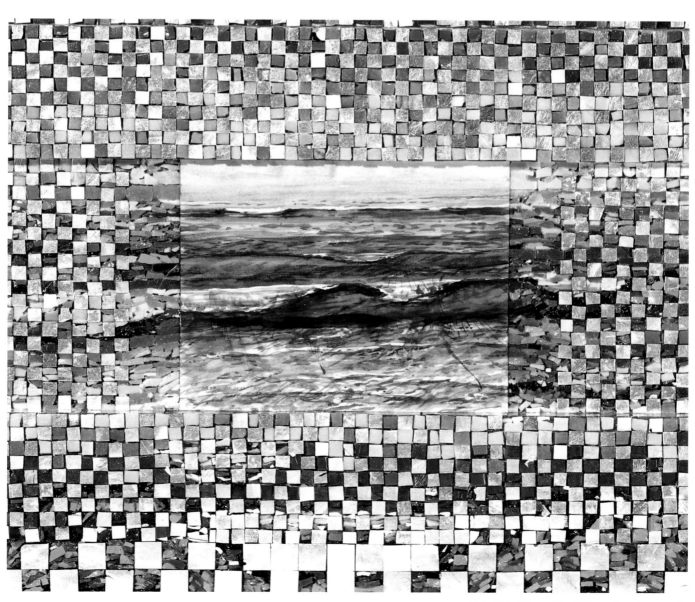

Nall - "Gulf Shores" - 1998 - watercolor-mosaic
Collection : Corley Chapman

ᴍ

The Montgomery Museum of Fine Arts is honored to collaborate with the Nall Foundation in presenting this unique exhibition of works by some of Alabama's finest artists. As this project demonstrates, Alabama's artistic talents are increasingly attracting the attention of national and international collectors and audiences. These art works represent the intellectual inquiry, technical facility, and creative spirit that are consistent with the best in contemporary expression. Whether in Alabama or France, such images are universal in their appeal, unhindered by geography or language.

Mark Johnson
Director
Montgomery Museum of Fine Arts

Charlie Lucas - *"Wind Blowing Through my Mind"* - 1996 - 13" x 13" x 7"

Al B. Head

Nall is a kindred spirit with many artists from Alabama who have drawn inspiration from the mystical and illusive culture that is unique to the Deep South. This spirit has roots in a romanticized land filled with images and allusions of southern belles, plantations, fields of cotton, magnolias, and codes of chivalry. "Old South" images are as much surreal as real, and artists coming from this heritage of cultural contradictions also carry with them the spirit of the poor, the oppressed, and the "common folk" who had much to do with building the character of the state. Native artists, those who have traveled afar and those who have stayed in Alabama's changing culture, tell the stories of our state with graphic images.

Nall is part of an artistic legacy that speaks honestly and passionately about Alabama in a way that provides texture to one's understanding of the state's culture; its people, its landscape, its traditions, its politics, its language, and its unique Southern "attitude". Alabama artists' work is indigenous in many ways, yet universal in others. Their work speaks of struggle and celebration, of hope and despair, of the familiar and the unknown, of the past and the future, of home and of faraway places, and of painful truth as well as the sublime. Collectively, Alabama artists speak from both isolation and broad experiences. Some chose to stay at home and have remained as constant as the red clay on a country road winding through a timeless landscape. Others are like the aroma of confederate jasmine that disappears after summer, only to return when the season is right.

This exhibition reflects the essence of creative expression that springs from Alabama.

Thomas, and the wonderfully enigmatic "Alternative Southern Belle" all illustrate the depth of his talent and complexity of his artistic maturation. Nall insists on working from life rather than photographs, thus, maximizing the viewer's exposure to the essence and soul of his subjects. In a visual journey to understand his surreal interpretations of character one sees a depiction crafted in a way that transcends mere likeness and stylization. Nall constructs a bridge of communication between his own worldview and that of the person being represented which often creates both a tension and harmony of thought. The result is a multi-faceted, multi-layered work that is often unsettling, and provocative, yet, always astounding. There is nothing ordinary about the way in which Nall communicates through his art. Nowhere are these qualities more visible and profound than in the thirteen artists portraits that are the centerpiece of this "Alabama Artist" exhibition. In every detail of his work it is clear Nall has strong ties to these artists and the source of their creative spirit. The imagery reflects great nuance and symbolism, indigenous not only to these individuals, but to Southern culture. The portraits tell an important story of each artist, of Nall himself, the place they all call home. The stories are not simple or trite, instead are almost literary in illustrating the Southern paradox of time, place and people. Much like the story quilts of Yvonne Wells, the vanishing landscapes of William Christenberry, the photographs of Kathryn Tucker Windham, and the tin sculptures of Charlie Lucas, Nall's portraits tell a story of Alabama. Those familiar with this eclectic grouping of artists and work are struck by the

Mose T. "Worthog" - 1980 - 88ᶜᵐ x 63ᶜᵐ - House paint on composition board

The artists whose work is presented epitomize the state's rich cultural environment. The work speaks for itself. It does not require context to be appreciated, although some context brings fullness to one's understanding of the artist's motivation and inspiration, which is often subtle. I think it is with confidence, sensitivity, and pride that Nall is sharing some of Alabama's best artists with an international audience. He knows in his bones that his fellow artists have been nurtured by rich soil. Nall has heard their creative voice and has now given that resonating sound a much larger stage. Nall's feelings regarding these artists, perhaps is best reflected in his portraits of them.

Nall's portraits in general stand out as the culmination of his vision, artistry, flare for story telling and insight into human spirit. In these works Nall challenges the viewer to look at the persona of his subjects through a prism of different angles, illusions and symbols. His portraits of Prince Albert of Monaco, Governor and Mrs. Don Siegelman, Michael Pastor, Roger Vergé, Alain Ducasse, Anita

respect evident in Nall's tribute to his friends. For others just meeting these artists for the first time, the portraits are perhaps the first clue that a discovery of something special is about to take place.

Nall Hollis, a native of Troy, Alabama, has risen to the heights of the art world, yet still looks home for energy and inspiration. Now Nall shares the limelight with the work of his friends from his home state. His own art has gained a reputation for excellence far and wide but now, through this exhibition, his contributions have been elevated beyond canvas to an endeavor that lifts the recognition of his kindred spirits back home.

The state is grateful to Nall and his wife, Tuscia, for making possible this artistic spotlight on some of Alabama's best-kept secrets. A word of thanks also has to be extended to the Nall Foundation for a commitment to young aspiring Alabama artists, for whom nurturing at an early age is so necessary if creative potential is to be realized.

Al B. Head
Executive Director
Alabama State Council on the Arts

123

Acknowledgments

Thank you, thank you, thank you, N.A.L.L. Board members, artists, writers, photographers, models, printers, apprentices, editors and all of you who haved bared your souls and contributed to this book. This list is too long to repeat here, but the names are recognized throughout the book. To Michael Hall, Vania Camerini, Emilia, Enzo, and Paula Parrish, who have taken care of the houses, dogs, cats, flowers and the Foundation's other numerous necessities. Your passions have been collected, sorted out, and with the grace of God and the hard work of many I hope you have been done justice. As in all endeavours there are driving forces who ignite and fuel, and clean up humanitie's messes in order to go forward. A heartfelt thanks to my dear wife Tuscia, who has made my dream come true, to bring together the South of France and the South of the U.S.A. She has breathed their perfumes and absorbed the essence, and in doing so has become more Southern than Southern, she has done so out of choice. A special thanks to Al and Caroline Newman for seeing this long-overdue collection through, and Trulli Imprimerie for extending their participation. Allowing more time it could easily have included more of Alabama's outstanding artists.

NALL

I am indebted to my friends who have given their enthusiasm and support to this project :
H.S.H. Crown Prince Albert of Monaco,
Don and Lori Siegelman, Governor and First Lady of Alabama,
The Montgomery Museum of Fine Arts,
The Alabama State Council on the Arts,
Black Belt Press of Montgomery, Alabama,
The Birmingham Museum of Art,
the Honorary Committee of the N. A.L.L. Art Association in Vence, France,
and the Honorary Committee of the N.A.L.L. Art Foundation in the United States of America.

Executive Committee of the N.A.L.L.

United States		France
Nall	President	Nall
David Cromwell Johnson	Treasurer	Tuscia Nall
Corley Chapman, Glen H. Conn	Secretary	Alain Berp

Honorary Committees

N.A.L.L. FOUNDATION **United States**		N.A.L.L. ART ASSOCIATION **France**
Lori Allen Siegelman	Honorary President	Michel Pastor
Sheree Aust		Princesse Beatriz d'Orleans Borbon
Peter Baldaia		Duchesse de Bedford
William Lakin Boyd		Barbara Bach
Jack and Jane Fiorella		Eric Blair
Ann and Bruce Garnett		Elizabeth Breaud
Dr. Jack and Janice G. Hawkins		Michel Desforges
Albert B. Head		Avery Glize-Kane
William H. Johnston, Jr.		Herbert and Cass Hart
Dr. Calame and Diane Sammons		Christian Iacono
Dr. Andrew and Donna Sorensen		Hilary King
Anita Thomas		Scott and Nancy McLucas
Jack Warner		Francine Pascal
		Catherine Pastor
		Alain Renner
		Marion Ross
		Ringo Starr
		Ivy Trippeer

N. A. L. L. Foundation
511, Adams St.
Huntsville, Alabama
35801 - USA
Tel - Fax : 1 256 5120021

Website : www. nall. org
E-mail : nall@nall. org

N. A. L. L. Art Association
232, Bd de Lattre - 06140 VENCE
Tél +33 (0)4 93 58 13 26
Fax +33 (0)4 93 58 09 00

Frank Fleming - *"Ceremonial Stick"*
1998 - 4'x5"diameter

Frame detail-relief by Bill Nance ▷

Nall

Having been born and bred in Alabama, the feeling of suppression and being "not as good as" has been a natural code of life. Transporting this low self-esteem has been important to the growth of, and extension of, the Southern soul and my art. But in fact this openness, generosity, and humbleness are enabling qualities of men. Having to scratch out a living in red clay as early settlers—no easy feat—and a work ethic of nursing one's self from the bottom, has strengthened the backbone of the Alabamian. This strength, plus a history of inbreeding amongst the masters and slaves during the Civil War period, has created a mixture of European–African–Native American "mongrel," like the dogs in the pound who have turned out quicker and "streetwise" in order to survive. The mixture of this multiracial hereditary memory has woven a rich fabric of the soul of the Alabamian. And this very self-suppression has screwed on a tight lid to the jar of insanity which is ready to blow—a volcano, erupting from soil trembling with richness and variety, reflecting new perspectives of sentiment. As decadence and the feeling of superiority weakens a culture, so does the effort of "struggling to be big enough" strengthen the little brother.

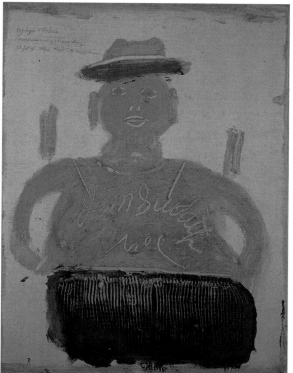

Jimmy Lee Sudduth - "Portrait of Nall" - 1999

These are thirteen Alabama artists selected because of their technique and symbols, their intense work ethic, and their raw sincerity of human sentiments: a fresh expansion of courage, humanity, and suffering. Injustice causes pain to both parties, and suffering leaves an imprint of expression. In each of these works I feel the tragedy and grandeur of great art, as I have felt in the literature of Southern writers, like William Faulkner, Tennessee Williams, Truman Capote, Flannery O'Conner, Eudora Welty, Fannie Flagg, Rick Bragg, and Charles Ghigna.

It gives me much pleasure and great pride to share this portfolio of art from the Heart of Dixie. Thirteen disciples of a land that speaks for itself and is one of the most preciously guarded secrets of the contemporary United States. This new breed of artists is not so concerned with media and career as with expressing, with exorcising a soul that has until now been buried deeply in racism and disgrace. How happy I am to see this body of work brought together; Southerners singing from both the black and white side of the fence, singing their same song about life, its struggles, passions, and joys.

True art — Through each technique, —sentimental and profound and wrung from the guts—sets the soul free, identifying what may seem like madness, but a brand of madness that makes life interesting. As violent as a tornado, tidal wave, or dry spell, as unpredictable as a beautiful woman's mind. This unity of artistic souls brings to mind the similarity of the Impressionists or Surrealists: painted in colors and symbols, visualizing and stinging in their awareness, but necessary in a time of a comatose public. The basic directions of the essential human being—life, love, passion, justice, fantasy, death—molded together with spirit and magic. These Southern symbolists have opened an awareness with their truth, told in a simple primitive, yet complex tongue, that reaches deep and thrusts out the myriad bouquets in life.

N.A.L.L. Art Association

From left to right : Avery Glize-Kane, Francine Pascal, Michel Pastor, H.S.H Crown Prince Albert of Monaco, Nall, Ringo Starr, Barbara Bach, Alain Renner, Tuscia Nall, Princess Beatriz d'Orleans Borbon, Mimi Momege, Michel Desforges. *Absent from photo :* Duchess of Bedford, Eric Blair, Elizabeth Breaud, Herbert & Cass Hart, Hilary King, Christian Iacono, Scott & Nancy McLucas, Catherine Pastor, Marion Ross, Ivy Trippeer

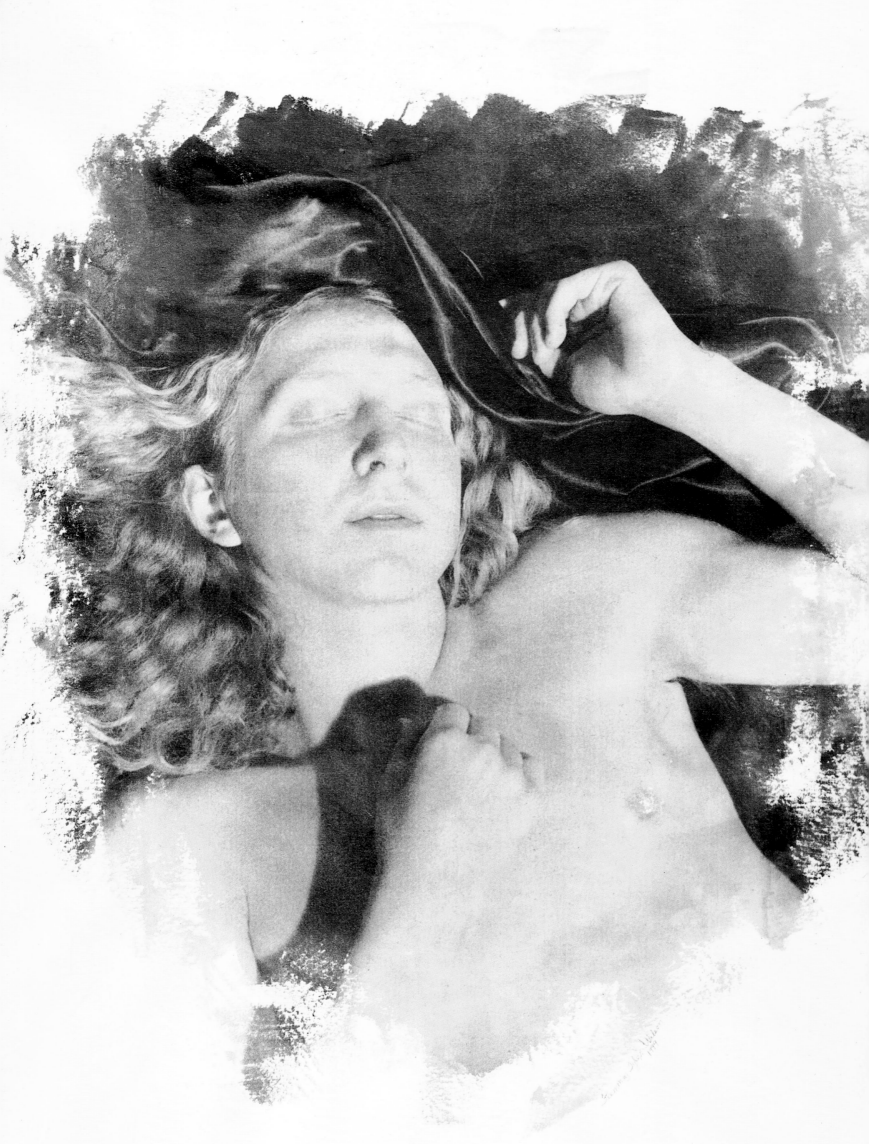

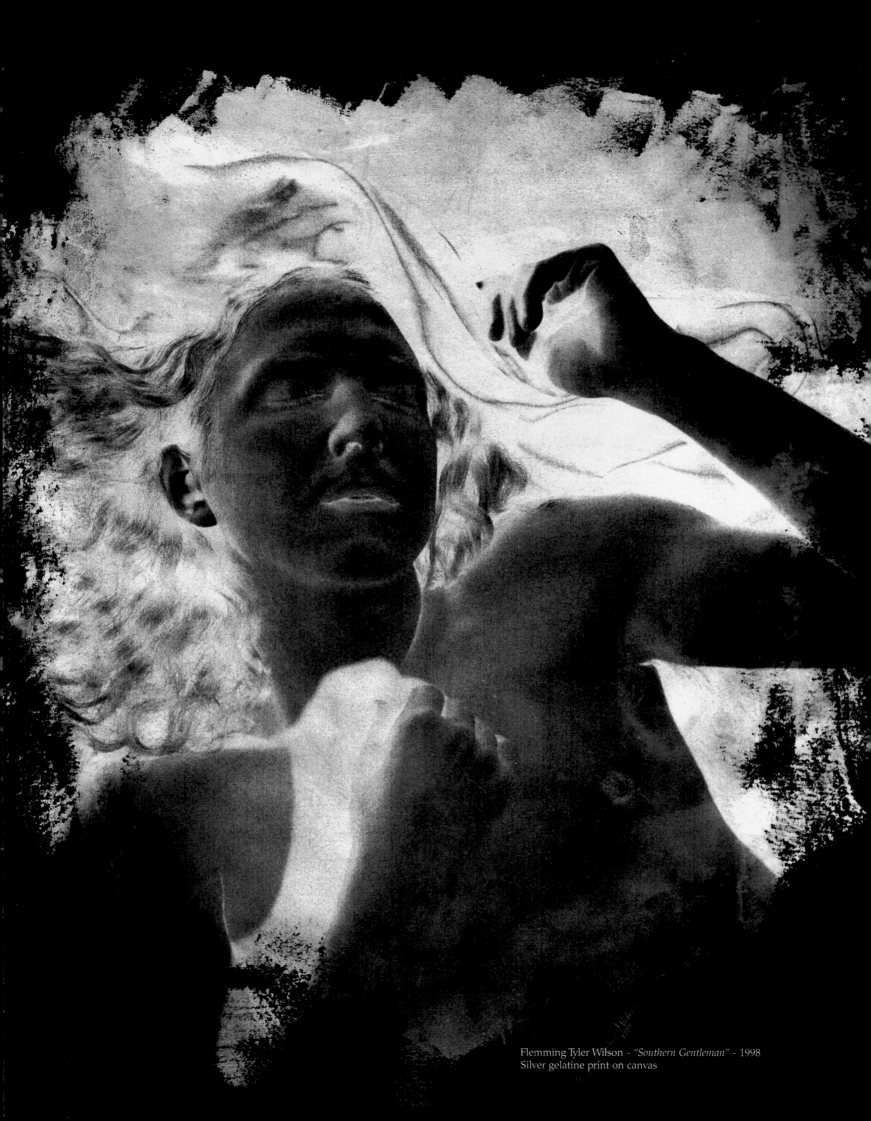

Flemming Tyler Wilson - *"Southern Gentleman"* - 1998
Silver gelatine print on canvas

127

Library of Congress Cataloging-in-Publication Data

Ektachromes furnished by :
Southern Living Magazine, Chip Cooper, Cecil Isbell (Quality Photos),
Danny Fafard, François Fernandez, Augerot, Claude Germain, Rick Anaura,
Solvi Dos Santos, Nora Feller, Roy Simmons, Bruno Bebert, Nall.

Layout, Jacket and Book Design by Nall
with Julien Trulli

Printed by
Photogravure & Imprimerie TRULLI
Vence, France
Tel. +33 (0)4 93 58 32 42
Fax +33 (0)4 93 24 64 70

Black Belt Press
610 North Perry St.
Montgomery, Alabama USA
Tel 334-265-6753 - Fax : 334-265-8880

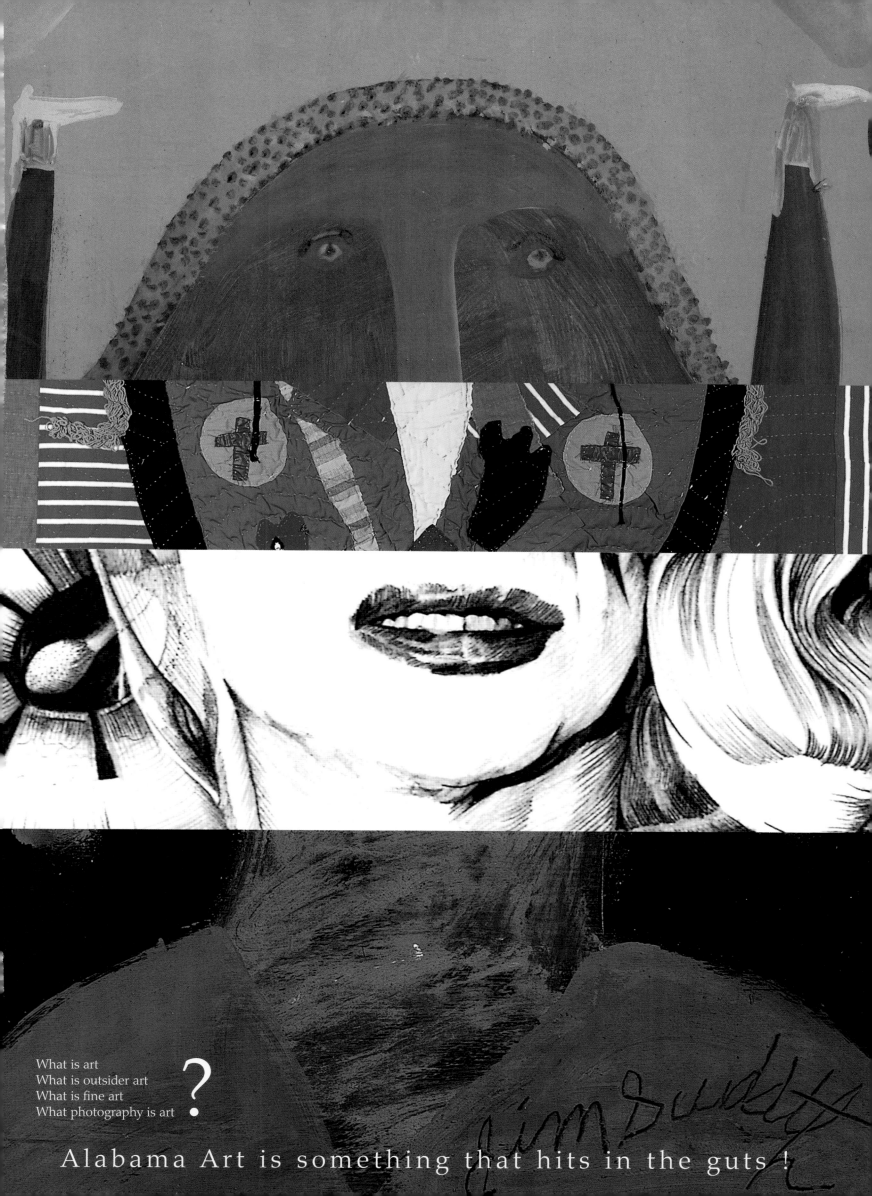

What is art
What is outsider art
What is fine art
What photography is art **?**

Alabama Art is something that hits in the guts !

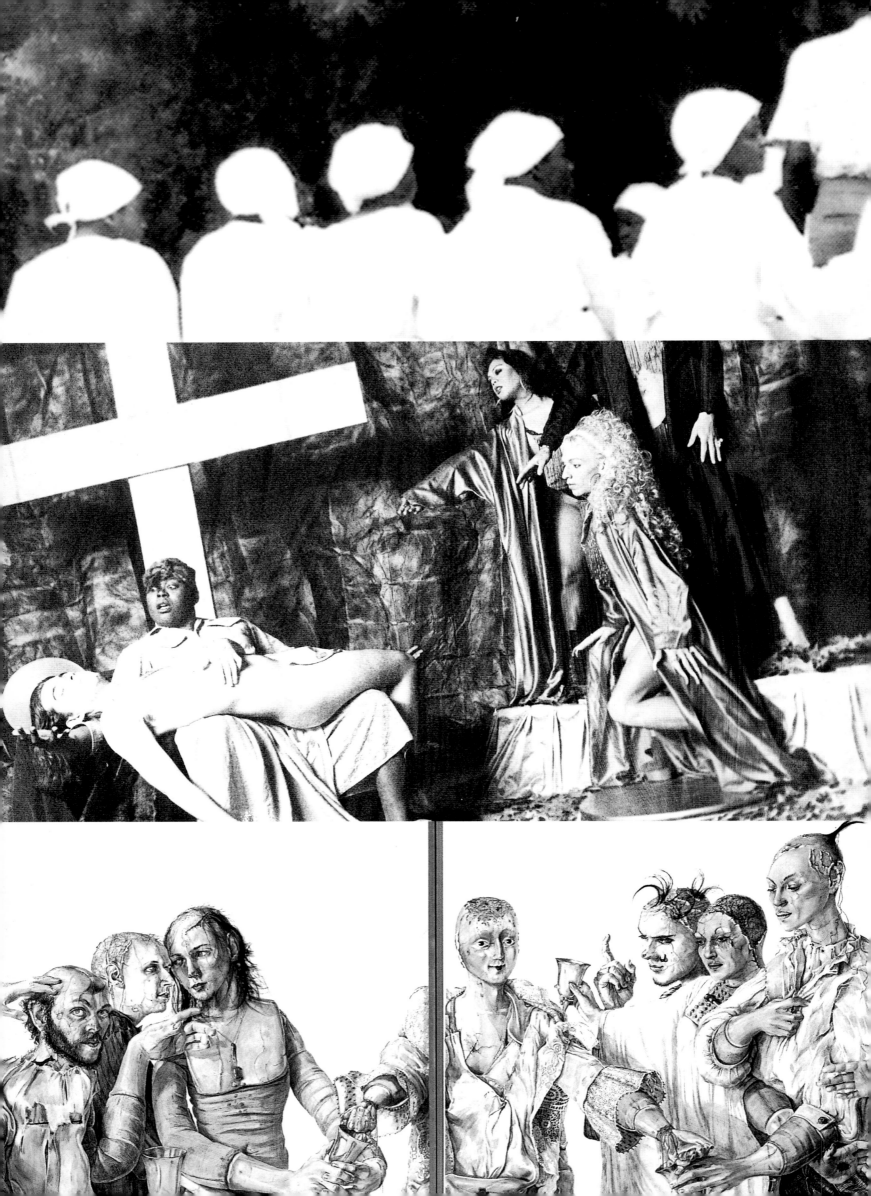